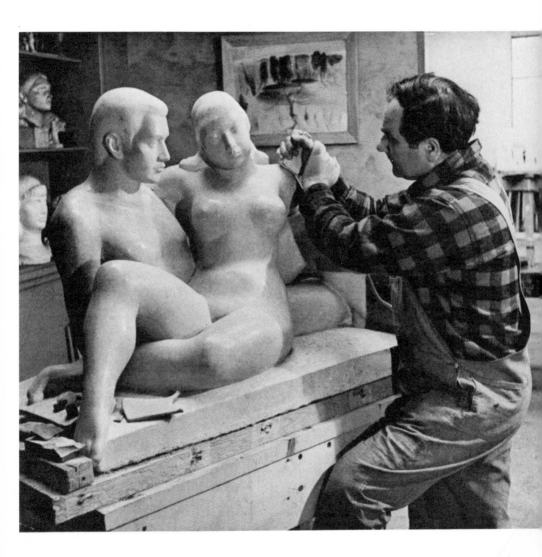

William Zorach polishing marble

Photograph Walt Sanders, Black Star

ZORACH EXPLAINS SCULPTURE
What It Means and How It Is Made

WILLIAM ZORACH

DOVER PUBLICATIONS, INC.
New York

Published in Canada by General Publishing Company, Ltd., 30 Lesmill Road, Don Mills, Toronto, Ontario.
Published in the United Kingdom by Constable and Company, Ltd., 3 The Lanchesters, 162–164 Fulham Palace Road, London W6 9ER.

Bibliographical Note

This Dover edition, first published in 1996, is a slightly altered republication of the revised and expanded work as published by Tudor Publishing Company, New York, in 1960. (The original edition was published by American Artists Group, New York, in 1947.) In the Dover edition, the list of suppliers has been omitted.

Library of Congress Cataloging-in-Publication Data

Zorach, William, 1887–1966.
 Zorach explains sculpture : what it means and how it is made / William Zorach.
 p. cm.
 Originally published: New York : Tudor Publishing Company, 1960.
 Includes index.
 ISBN 0-486-29048-4 (pbk.)
 1. Sculpture—Technique. 2. Composition (Art) 3. Proportion (Art)
I. Title.
NB1170.Z67 1996
730—dc20 95–36242
 CIP

Manufactured in the United States of America
Dover Publications, Inc., 31 East 2nd Street, Mineola, N.Y. 11501

THIS BOOK IS FOR MARGUERITE
COMPANION IN LIFE AND IN ART

ACKNOWLEDGMENTS:

● I would like to express my gratitude to all those fellow-artists and crafts-men who, throughout the years, have discussed art values and technical problems with me; and who have passed on to me art values and technical information that I may, in turn, hand along to a future generation — forging the link in the chain of art from generation to generation.

● I wish to acknowledge my indebtedness to the following publications for their kind permission to use material and illustrations from various articles of mine published by them: The Magazine of Art, The London Studio, Collier's National Encyclopedia;

● to the following companies, for permission to reproduce tools from their catalogs: The Granite City Tool Co., The Martindale Electric Co., Trow and Holden Co., Ettl Studios, and Dawson-MacDonald Co.;

● to John Spring, of the Modern Art Foundry, for checking the technical accuracy of the chapter on Lost Wax Casting;

● to William Petso, of the Basky Foundry, for checking the chapter on Sand Casting;

● to Fletcher Clark, for his formulas for Stone Casting;

● to Anita Wechsler, for an explicit description of her method of casting in artificial stone;

● to the following museums, for their assistance in obtaining photographs: The Metropolitan Museum of Art, The Whitney Museum of American Art, The Museum of Modern Art, The American Museum of Natural History, The University Museum of Philadelphia, The Philadelphia Museum of Art, The Peabody Museum, Cranbrook Academy of Art, The Freer Gallery of Art, The Museum of Fine Arts of Boston, The Fogg Museum, The Cleveland Museum of Art, The Oriental Institute of Chicago.

CONTENTS

LIST OF CHAPTERS AND ILLUSTRATIONS

Quest, Pentelic marble. William Zorach
Collection Wichita Museum, Kansas

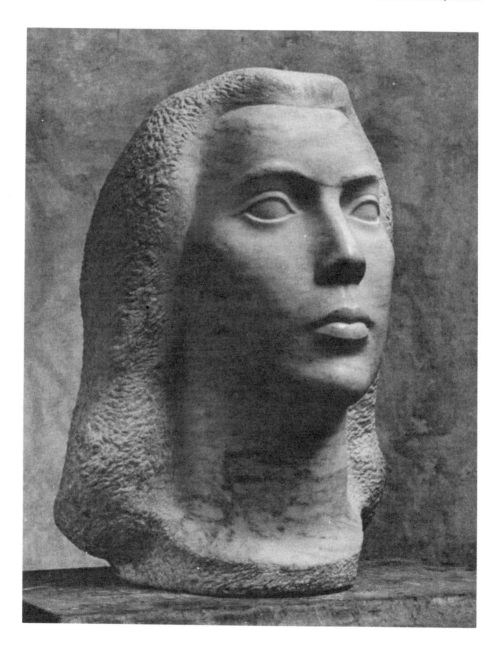

CHAPTER 1.

INTRODUCTION TO SCULPTURE

Art is a language; through it man speaks to man. The ages are no barrier, nor unknown and foreign tongues. Before history man used sculpture to give meaning to his surroundings, to satisfy his love of decoration and to express his relationship with the natural and the supernatural. Throughout the ages, sculpture has been a means of communication between men; a language, as is music and the spoken word. It is one of the great natural means of human expression.

As soon as primitive man found a way to cut stones into arrow heads and spear heads, he began to cut stones into shapes that had meaning to him. He would find a stone in which he visualized an object and he would grind down the surface with other stones or with water and sand, or devise a tool that would cut and carve. Another man would dig clay from a bank and form it into shapes and preserve them by drying or baking. Another would take wood or bone and carve it into an image that had meaning to him and to those about him.

A child naturally plays at modeling in mud and clay. A man loves to whittle. Women, baking in the kitchen, cut dough into shapes of animals and people. Sculpture in one of its many forms can be a natural outlet for all who like to work with their hands and to create forms out of solid substances. An artist is a person who has the ability to present forms so that they not only have meaning to himself but also have meaning to others; and which, without his vision, might never have been seen or recognized as beauty. To be a great artist, one must have an infinite capacity for work, an undying fire of creative desire, and the ability to express himself through the medium he has chosen. But to share in the joy that working in sculpture can bring, it is only necessary to have the courage to work and the patience to try and make materials take on the form the imagination dictates.

1

The traditions of craftsmanship are as old as the human race. As soon as one man learned to carve wood or cut stone, others wanted to do the same thing, and methods would pass from one to another. The less creative would always use and develop the forms evolved by the more creative artists. From the earliest times we find pieces of fine craftsmanship, but it is only here and there we find a work of art. The difference does not lie in the material or how it was treated but in the person who did the sculpture. An artist can carve a stone and under his touch it becomes alive—it has the power to stir the imagination. A workman who is not an artist can do a perfect job of carving yet the stone will remain dull and lifeless because no living art quality went into it. It is important to keep this in mind, and by looking at fine sculpture, learn to distinguish a work of art from a good piece of craftsmanship.

The methods used by primitive man were very much the same as those in use today. Fine sculpture has been done with the most simple and rudimentary tools. An artist can produce a work of art with a chisel and a hammer and a block of stone—or he can use the almost endless variety of tools that are being manufactured today. There are innumerable variations of the chisel—there is even the pneumatic chisel and one run by electricity—but the principle is basically the same as that used by the earliest sculptor. Whether he has many tools or few, whether they are elaborate or simple, the only thing that counts as far as art is concerned, is the power of expression he achieves through them.

In this book I will discuss the materials of art and the meanings of art, starting simply and returning again and again to each subject until I have covered the final technical phases which sculptors eventually need to know, but which merely confuse and hamper a beginner. I will explain how to model and carve freely small things in clay for beginners and discuss how to learn to observe form, how to organize relationships and how to achieve rhythms, how to see planes and fundamental structure. This, I will try to do in such a way that it will give a foundation for further work with clay, and for the making of sculpture in stone and wood.

I am giving specific information and instruction in this book because a student usually feels lost without this information and it is very hard to find. He sometimes feels so hampered by the lack of technical knowledge that it interferes with his ability to approach sculpture. But going into all this technical information gives a false impression of the true approach to sculpture. The real artist should approach art simply and by doing it. He should only look for information when he feels the need of it in his work.

One has always to have worked and found the need for the knowledge before it has meaning and can be assimilated. One has to take the tool in the hand and use it before one can realize what the tool can do. One of the fundamental qualities of a real artist is his unquenchable curiosity; he is always free to experiment with ideas and materials. In one sense everything has already been done or at least approached, but we can always develop a new and individual angle and contribute something to the art life of the world.

Rules can be given for modeling clay, for cutting stone, and for carving wood; but art cannot be produced by any set of rules. Art is not a cold-blooded working out of problems. The value of a work of art lies in the amount of life and expression that the artist puts into his work and the quality of that life and expression. This cannot be attained by repeating what other artists have done. Each artist must evolve his own forms. He must express what he knows and feels. He must use the materials at his command in such a way that his emotion or idea is communicated to those who behold what he has created.

What counts in any work of art is how much of what the artist wanted to express has actually found life and expression in his work. A man may be overflowing with emotions, intellectual or otherwise, and yet not have the power of expressing them or of putting them into form. He must know the language of sculpture in order to express himself in sculptural form, but he must also have something to say in that language of sculpture if his work is to have meaning, if it is to be art.

The handling of clay, stone and other sculpture material can be learned, just as anyone can learn to form letters and to write words and sentences. The principles of design, composition and organization can also be learned, even as one can learn sentence structure and verse and prose construction. But the production of a work of art in either sculpture or literature demands more than skill, more than knowledge. An artist must feel deeply and have a burning desire to create if he is to produce work that will be art. A terrific drive and energy and a great persistence to see a thing through are also needed, as is the courage necessary to discover in himself latent powers of expression.

A work is art if it expresses an art need. Some people do sculpture for some other reason than because they have a need for art expression. Some need money, some need social position, some need a sex outlet, or the satisfaction of popular acclaim. Sculpture that is made to fulfil any need other than that of art may be interesting, but it does not have an art life of its own. Art can be created only through an art need.

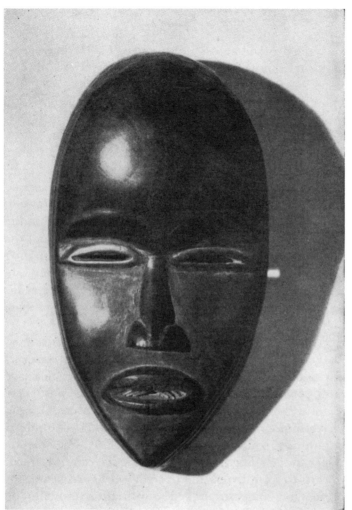

African Mask

Photograph Charles Sheeler

All primitive art was done from an inner desire, an art need. The only training was the tradition handed down from father to son. Such are the African carvings so greatly appreciated by artists and museums. These negro artists felt the need to express themselves and their relationship to the tremendous forces of nature about them so intensely that they developed a great and powerful art. Study the simplicity and strength of primitive sculpture. It has great purity and freshness. It is direct and honest and sincere. In other words it has the essential qualities that should be found in all art.

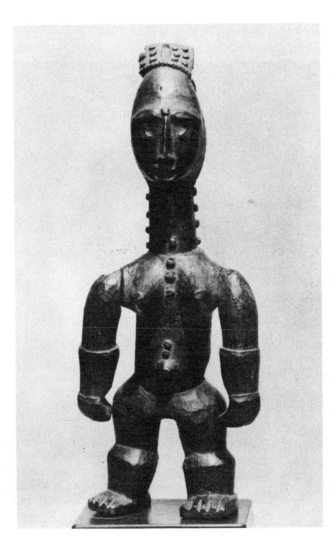

African Carving
Photograph Charles Sheeler

Formal art training is no necessity for an artist. When students came to Maillol, he gave them tools and asked them to start working. He felt that only in that way could they develop an inner understanding of what sculpture can mean. And then, of course, there was Maillol, working and answering questions.

To the average person, a piece of sculpture is something that is a duplicate or reproduction of some natural object such as a figure, a head or an animal. To those who understand art and its background, sculpture is a language that has a much greater range of expression than the mere repro-

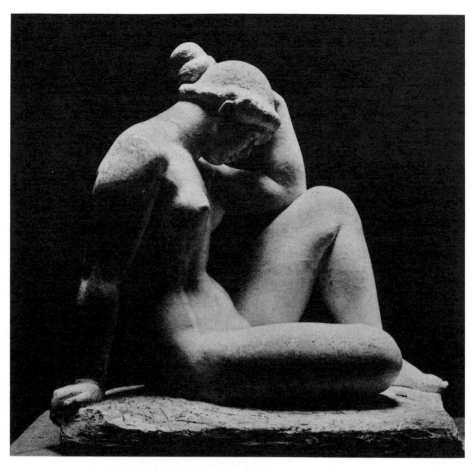

The Mediterranean, plaster. Aristide Maillol

duction of an object. At various times in history, sculpture has been used to interpret and express religious emotion, or to make monumental records of human achievements. It has also been made for the sheer love of expressing an appreciation of beauty and of form in itself.

What is "form in itself"? A simple explanation is to say that there is an appreciable beauty in an ordinary object formed by a craftsman. A tool or a simple form turned on a lathe can be a thing of beauty if made by a person of sensitivity and inherent taste. A sculptured object can be so formed that it will have a beauty apart from its association with living things.

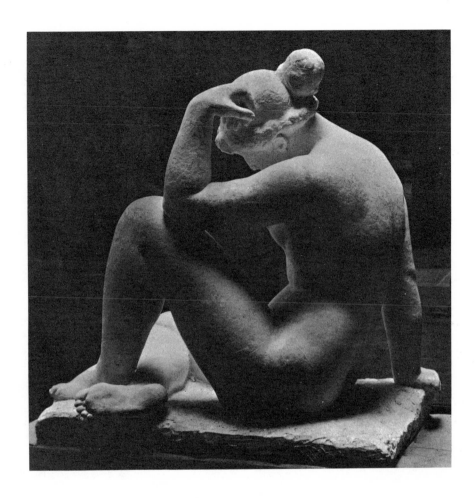

A billiard ball is a purely mechanical shape. A length of pipe also is just a round shape with length as well as roundness. These simple forms have no aesthetic or emotional value because they say only one thing "round." Each expresses only one kind of roundness. But when an object has a variety of shapes—round, thick, thin, narrow, wide—the use of that variety, handled and arranged by a person of talent, taste, and discrimination, can become a form that is aesthetic in itself.

A human body, a head, an animal—or any part of a human body—can be reduced to simple elementary forms and become a thing of sheer beauty. Such form can be used in sculpture in either a representative or an abstract

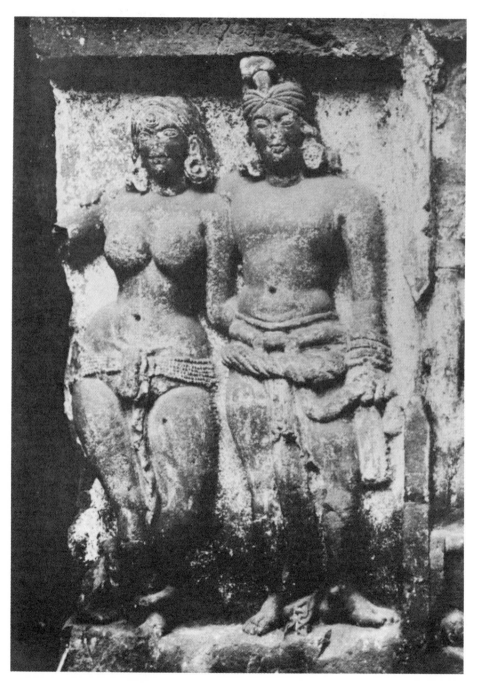

Royal Donors. At Karli, India; first century, B.C.
Courtesy Ananda K. Coomaraswamy

way; that is, it can be a recognizable reflection of nature or it can be a simplified equivalent of a natural form.

A healthy normal body is a thing of great natural beauty. That is the kind of beauty that was the ideal of the late Greek sculptors. However more than one interpretation can be made of the beauty of a human or animal form. As one studies history, one finds a great variety of interpretations. Each race and people has had its own way of interpreting nature and has made its own selection of the forms that, to them, had most meaning and beauty. They accentuated these, neglecting others.

The quality of a work of art depends upon the beautiful and discriminating arrangement of basic forms. To produce such harmonies of form, a sculptor must have experience and understanding; he must have developed his sensibilities by constant study and observation.

There are good works and poor works all around us—in museums and other public places—and it remains for each individual to distinguish the fine from the mediocre; whether he is naturally attracted to what is good or intellectually has the will to learn what is good art.

My aim in writing this book is to give the student of sculpture the benefit of my life's experience. It is also my hope that this book will foster a greater appreciation for the creative efforts of living men, so that artists will have a wider audience. I would like to help arouse a consciousness among people that it should be a part of their lives to own and live with sculpture and to realize the importance of art in their lives. One should never underestimate the art of the age one lives in. Art is a great civilizing influence and a perpetual living force towards beauty and good.

The idea of art is abstract. An instructor cannot teach art. He can only point a way towards understanding, give a clue to its meaning and help with tools and technical information.

I would like to make it clear at the beginning that I do not intend to lay down rules whereby anyone can produce a work of art, but I do intend to give practical help to anyone who wants to work in sculpture. I hope to make available for the beginner the essential and useful information that is so hard to obtain. I hope to put into tangible form the ideas and knowledge that come from experience, things that will help any worker in sculpture towards the realization of art and its meaning in life.

We can only do as much as we know. We can express only as much as we understand. Instinctive feeling—we may call it realization—is important. But knowledge also is important. By this I mean knowledge that comes

through working and through every other possible means of acquiring understanding. Each student should, of himself, seek for information of every kind that will point the way towards building up a broad understanding of sculpture and the meaning of art.

My early stages of mental and spiritual striving for an art ideal have made me very tolerant and interested in the early efforts of others who are seeking an outlet for their love of beauty and life. It is my hope that this book will help to develop innate talent and bring many to a realization of what art expression can mean to all of us. Art is a creative adventure that can bring a new significance and pleasure into life. To develop art there has to be living art and living artists. The nations that have neglected their living artists and worshiped the past have never enriched the world with art expression; they have left us only imitations and sterility. The nations that have appreciated and encouraged their living artists have left a rich heritage to mankind.

You who have the desire to model in clay, or carve in wood and stone, have a world of adventure before you. Through doing, you will come to understand the problems that other artists face. Through creating works of your own, you will come to know the beauty expressed by others. In every way your life will be enriched and your outlook broadened.

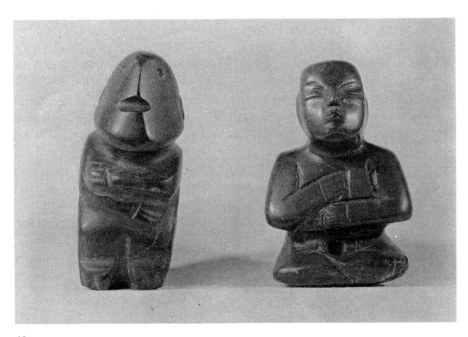

CHAPTER 2.

APPROACH TO SCULPTURE

At first all sculpture was carving. A man who wanted to make an image, chiseled stone into the form he wanted it to have, or he hewed and cut a block of wood into a figure. It is only within the past four hundred years that sculptors, who considered themselves artists, were content to make a figure in clay and let a craftsman reproduce the modeled form in stone through mechanical means. Before that time clay was widely used but not as a substitute for stone. Clay was modeled and baked, so that what the artist did was preserved in the same material that he used originally to express his idea. It was also used as it is today, to model something that was to be cast in bronze or some other metal. Such use of clay is entirely different from that of making with it a pattern to be followed by a stone cutter.

Because clay is more easily handled, I shall tell you how to work with it before I tell you how to carve stone or wood; but you should work with it realizing that it is clay, and not a substitute for any other material. It is so much easier and quicker to get the feeling of doing sculpture by playing with clay, modeling it, forming it, changing it, getting rough forms that are expressive even if you cannot carry them beyond the crudest state.

Modeling Tools and how they are used.

In modeling with clay, the sculptor uses his hands, the thumb being his most useful tool. You will see many different tools in the accompanying photographs; but a piece of sculpture can be made with the simplest tools. A little common sense and imagination will save the student a lot of money. I like fine tools and I find myself continually buying more of them. However all that is really needed is a paring knife and a stick of wood about one inch square and twelve inches long that you can cut into short lengths and split into various sizes.

On page 13, you will see drawings of little square blocks of wood cut

Early stone-carvings. Mexico
Courtesy American Museum of Natural History

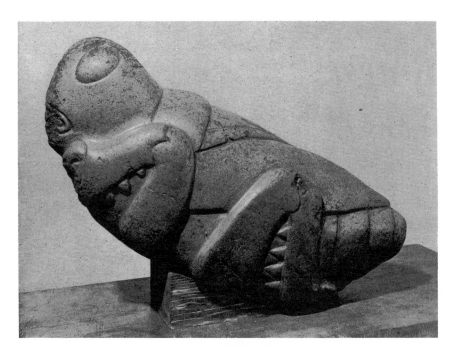

Grasshopper. Mexican stone-carving
Courtesy Magazine of Art

to various sizes and shapes or made into little wooden hammers. These (A) are useful for packing clay at the beginning and also along the way as the clay hardens. I have also drawn two pounding tools (B) made of hard wood which are useful for pounding clay. If you cut a wooden block diagonally (C) so that it has a sharp flat point at one end, it can be used for cutting and shaping, while the other end, left with a blunt rough-sawed surface, can be used to pack the clay.

After the clay is well packed into a solid form, a wire or steel tool shaped like (D) is used to cut planes and indicate the form. Each end has its own uses—the sharp bevel end for cutting planes and the round end for shaping and digging out hollows.

After the form has been cut, shaped and built up by applying lumps or pellets of clay, you can begin to smooth the surface with a scraping tool such as (E) which is made either of brass wire with teeth filed in the cutting edge, or of wire wound around a tool to form a toothed edge. You can also use a very inexpensive toothed tool made of wood (F).

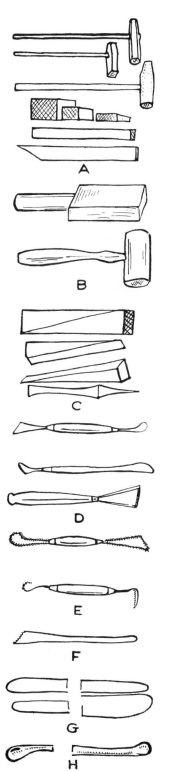

After the surface has been scraped to remove lumps and humps, clay pellets are added where it is necessary to build up the shape. These are pounded on and smoothed down with a tool such as (G), which is flat and flexible and shaped like a thumb. This may be made of boxwood or it may be made of steel. It is used to smooth or pat the surface, very much as you would use the thumb. The ball end tool (H) is used in hollow places such as eye sockets or ears.

What to look for in buying tools.

When choosing a modeling tool, the most important thing is to see that it is well formed. A good toolmaker has had experience with sculpture and has a talent for designing what best fills a sculptor's needs. Some sculptors like to make their own tools.

For shaping and hollowing you need a rounded end; for cutting you need a square or diagonal sharp edge; and for finishing you need a flat, thumblike tool that is shaped like a spatula.

Most tools serve two purposes because each end is a different shape. The cutting and scraping tools are similar in shape, having one rounded end and another that is square or oblique, but the scraper either has teeth filed along the cutting edge or fine copper wire is wound around both ends. These tools can be made of either metal or wood. The best metal tools are made of sturdy brass or steel wire; the best wooden tools are made of boxwood. In either case, each tool should have a certain flexibility and not be stiff or clumsy.

Good tools deserve good care. Each day after being used, a tool should be washed and dried and then oiled. This will do much to prevent deterioration of both wire and wood.

Modeling tools

Horses, terra cotta; early Iron Age. Cyprus
Horseman, terra cotta; 1000–6000 B.C. Cyprus
Courtesy Metropolitan Museum of Art

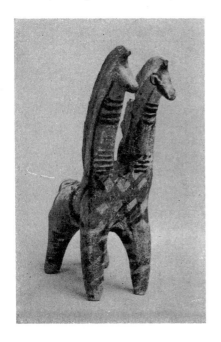 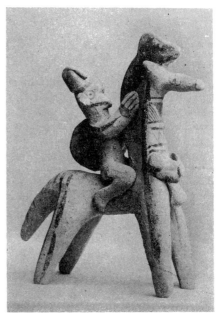

Clay and how to handle it.

There are two kinds of clay: moist clay, that is, natural clay dug from the earth, and modeling wax, or plasticine, an oily manufactured substance that does not dry or harden.

Natural clay can be found in native deposits and refined and made ready for use in the same way that primitive artists found it and worked with it. However it is much simpler to buy it already prepared. It usually comes in one hundred pound tubs ready for use.

The kind of clay I would advise using is firing clay. It is fine, evenly mixed, has excellent consistency and can also be fired.

Manufactured clays such as plasticine—which is usually given to children for modeling—are very valuable where small models or sketches are required or where it is not possible to take proper care of natural clay. It is also useful for building up huge monumental models because it does not need to be nursed or continually worked and moistened. However most sculptors find natural clay a much more sympathetic medium and prefer to use it wherever possible.

14

The first thing I would mention in regard to moist or natural clay is that it is essential to know how to mix it and keep it moist. This clay is usually moist and of the proper consistency for modeling when bought, but it should be removed from its wooden container and placed in an airtight and watertight galvanized iron can—the ordinary garbage can with soldered seams will do. To keep it in good condition, clay must be used constantly and mixed frequently. It should be kneaded much as bread is kneaded to keep it of an even consistency with no hard or dry spots.

If the clay becomes hard or of an uneven consistency, which happens when it has been used and portions have partially dried through being exposed to the air, it should be placed in the can, covered with water, and allowed to stand overnight. In the morning the water should be poured off and the clay made into balls. These balls should then be left to dry until it is possible to knead the clay into the proper consistency for use. Clay should not stick to the fingers. For modeling, the clay should be pliable, about the consistency of putty; not too wet and not too dry. Experiment with your clay. Handle it. Feel its bulk, its weight, its pliability. And as you work it with your hands, let it stir your imagination. Clay is a wonderful material in itself. It has certain properties nothing else has. Use your initiative to find your own ways of working with it.

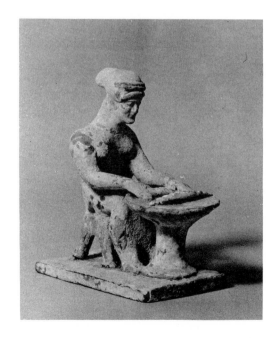

Woman making cakes, terra cotta;
fifth century B.C. Greek
Courtesy Metropolitan Museum of Art

Various ways of working in clay

The methods of working in clay can be grouped as follows:

Moulding with the hands.

The most simple way of working with clay is to take a mass of wet clay and mould it with the hands until it forms a composition or figure. You take a shapeless lump and give it the shape and form that you have in mind. This is a sketch. It usually has a romantic feeling, a form that seems to flow out of the soft substance of the clay. It is often full of unrealized promise. This is what most people think of when they talk of modeling in clay. It is an approach to sculpture but actual modeling in clay is something very different. It is very disappointing to the would-be sculptor to discover that it is not possible to mould clay in his hands at will; that clay will not support itself but must be built up on rigid armatures and put on little by little; that he cannot change it at will, that his original plan cannot be altered. But once he accepts these limitations, he will find it is a wonderful medium of expression.

The coil and pinch method.

A second way of working in clay is called the coil method. For this, the clay is rolled into strips that are coiled and pressed together to make a

hollow shell that can be squeezed or shaped into whatever form the sculptor desires. These pieces have to be built up slowly and carefully from the bottom, waiting for the clay to harden before building too far. This method can be varied by building up the hollow shape out of tiny balls of clay or out of sheets of clay welded together by pinching. The coil method is used when the work is to be fired into terra cotta.

Another variation of the coil method is to make figures or compositions out of rolls or snakelike coils of clay, building them up like a skeleton so that they support each other.

Cutting clay blocks.

The third method of working in clay is related to direct carving. It allows the same approach but in a medium easily handled and easily changed. Take handfuls of clay out of the bin and roll or knead them into balls. Then pound the rolls or balls together with a wooden mallet. Pound the clay into various shapes: make cubes, pyramids, spheres and rectangular blocks of various sizes.

As you work with each shape, make it of a size and proportion that might be interesting to carve into a head or a figure or an animal. Always

Terra cotta. Mexican
*Courtesy American Museum
of Natural History*

pound your block a little larger than the thing you want to make, and be sure to allow extra height and to plan for a base. While you are pounding the clay keep it moist. It should not be sticky on the surface but it should be moist enough to hold together so that you can pound it into a firm mass. When your shapes are well pounded and solidly formed, set them aside to harden under a damp cloth.

With a knife or wire cutting tool, cut the shape you have in mind out of the block. After the preliminary cutting the form can be developed by adding more clay either in pellets or sheets, using the thumb, fingers or special tools. You can cut away or add at will.

All these methods will be described in detail in chapter eight.

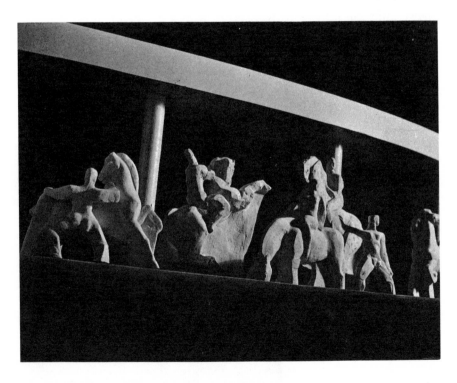

Fountain of Horses, carved in clay. William Zorach
Photograph Victor de Palma, Black Star

CHAPTER 3.

FORM IN ART

A sculptor must draw continually because this is the way he records what he observes.

Some people think that they cannot draw, but everyone can express an idea with pencil and paper, if only by making simple triangles, squares and circles. Simple shapes that are the foundation of drawing. Do not bother about details at first or about correctness; it is not necessary to be accurate in the way most people think drawings have to be. Drawing is a form of calligraphy similar to hand writing. It is a personal expression and should not be fussed with or worked over. Your drawings are your notes. They are the records you are making of your own ideas and observations. You need not make what most people call "finished" drawings of a thing, but you should make many drawing notes of what you see in nature, so that when you model or carve, you will know something about what you are trying to express in clay, wood or stone.

When I am in the country and I want to carve a rabbit, I take my pad and pencil out to the pen where there is a family of rabbits a farmer gave me. At first I just sit and watch them, observing how they move and how they are formed. Then I begin to make studies of them. I sit on the ground and put my head down on a level with the rabbits and I make drawings of what I see. Then I study them looking down from the top, and make more drawings. I study them from every angle until I know their forms, the roundness of the back, the triangular shape of the head, their long ears which are so alive, always alert to vibrations of sound; the position of the eyes, the shape of the mouth, the construction of the legs. I make notes of the design of each part and do drawings of the rabbits in endless positions. I save all these drawings so that when I start to carve or model a rabbit, I can tack them on a wall of my studio and they will bring back to me all that I have observed.

The important thing to remember is that it is better to make quick

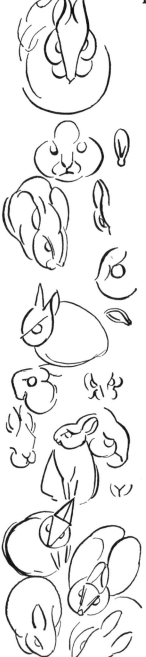

studies of living form in movement than to try carefully to draw a posed model. The important thing in drawing is to see the big, simple design or shape. Your drawings are not made to show to other people. They are your own notes, and even if others may like to look at your drawings, you must keep it in mind that they are the records that you are making of your own ideas and observations, and that they are useful when they serve to bring back to your mind what you saw and felt.

If you think you can't draw, try closing your eyes and drawing something that you have in mind. It is surprising how the hand will follow the idea, and how you will get the essence of the thing in such a drawing. When the eyes are closed, the mental image is not confused by the ineptitude of the hands.

Before carving my granite cat, I had had cats around in the city and in the country for many years and made hundreds of drawings of them. I knew our cat in all his ways and moods. I observed and studied him, making endless drawing notes each time I saw something that interested me. In this way I built up within my mind a knowledge of cats and cat forms. Then with a stone before me I began to evolve a cat fitting into the rock and expressing my knowledge and feeling and appreciation of cats.

Bunny, Maine boulder. William Zorach
Courtesy Whitney Museum of American Art

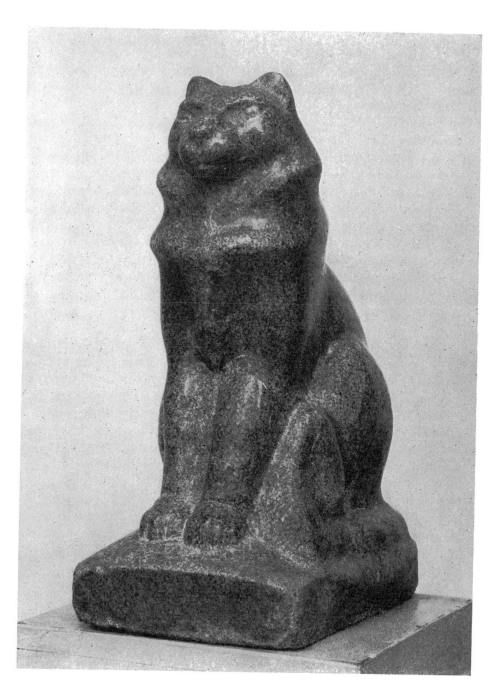

Cat, Swedish granite. William Zorach
Courtesy Metropolitan Museum of Art

Basic Form.

The world is made up of things that are round or square, long or short, curved or angular, sharp pointed or flat. Experience with form begins in the cradle when a baby first reaches out to touch things and learns that some things are round, and that others are flat and have corners. From seeing the things he handles, he learns to recognize form by looking at it— but his understanding of form comes through his sense of touch.

When a young child starts to draw, although he knows that a head has ears, a nose, eyes and a mouth, he often expresses the idea of a head with a simple round shape, just as he uses a square shape to represent the idea of a house.

When a sculptor starts to think of form, he also has to learn to recognize the simple shapes underlying the surface. All things can be reduced to either a round or square form, just as any outline can be thought of as being made up of curved or straight lines. These simple shapes which make up all things are basic forms. It is upon them that all structure is based.

The A B C's of the sculptor's language are very simple. All sculpture is composed of variations of a few basic forms; the cube, the sphere, the cone, the pyramid and the cylinder. It is important for the student to recognize these basic forms and to understand their relationships to each other.

Mechanically perfect shapes rarely occur in either art or nature. It is actually the endless variety of modifications to which basic forms lend themselves, that provides the range of expression possible to sculpture. If a sculptor were to use only simple mechanical shapes, he would be very limited. A block can be rectangular or diamond shaped. The sphere may be squeezed into an ellipse or an oval. It can be elongated or flattened so that its surface has many variations in curve. A cone can be a pointed curved horn shape or it can be an almost flat hummock form. A cylindrical shape may be straight or curved, round or elliptical, constant in its curvature or irregular throughout. However even such variation of mechanical shape is nothing to compare with the subtle modifications of basic form that can be used by the sculptor.

To learn to think in terms of basic forms is like learning to classify things. The recognition of simple relationships makes it possible to build up an understanding of the more complicated forms of the sculptor's expression. It helps the student to see the underlying theme or structure of a figure, and to express himself simply and forcefully.

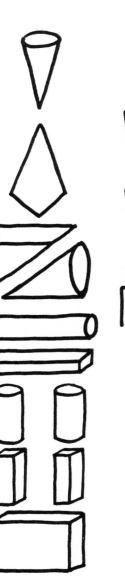

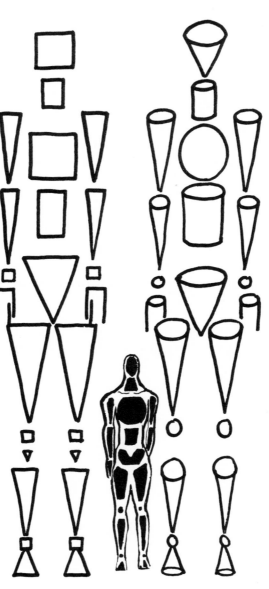

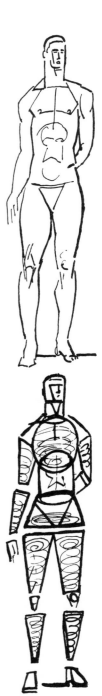

Abstract form.

When you look at a blank piece of paper it has no meaning. It suggests nothing except what it is, a blank sheet of paper. But if you draw a line on that sheet it immediately does something to the paper. It not only divides the space either up and down or crossways; but it seems to come forward, if it is drawn up and down; or to go back, suggesting a horizon, if it goes across the paper.

Draw an arc or a simple curved line on another sheet of paper. It gives a different sensation from that of either a vertical or horizontal straight line. Take another sheet of paper and draw a curve in the opposite direction from the first one, and you will see that it, again, gives a different sensation. Combine the two curves into an S, or combine two straight lines in the shape of a T on its side. Each will seem to suggest a different idea. Put the two curves on a sheet facing each other but staggered so that they do not touch each other. You will find that lines and shapes do register a sensation to the brain through the eye, even when they are not made to represent anything in nature.

Every form that we know originated either in a straight line or a curve. Out of the straight line came the triangle, the square, the cube, and all rectangular shapes. Out of the two curves put together come the circle and eventually the sphere. With these simple shapes you can create various sensations. Cut the circle in half and slide one half away from the other. Here is something quite different from the sensation of a simple circle. Then experiment with arranging an angle of straight lines and a curve. The more you do these simple line experiments, the more you will come to understand that such patterns give a distinct sensation just in themselves.

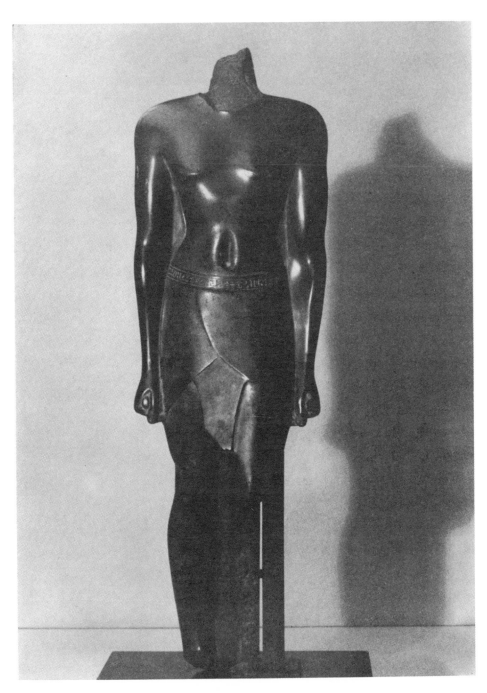

General Tja-hap-emu, quartzite; 378–324 B.C. Egypt
Courtesy Metropolitan Museum of Art

Horses. Chinese, 7th–9th century
Collection Robert Goldschmidt; courtesy Magazine of Art

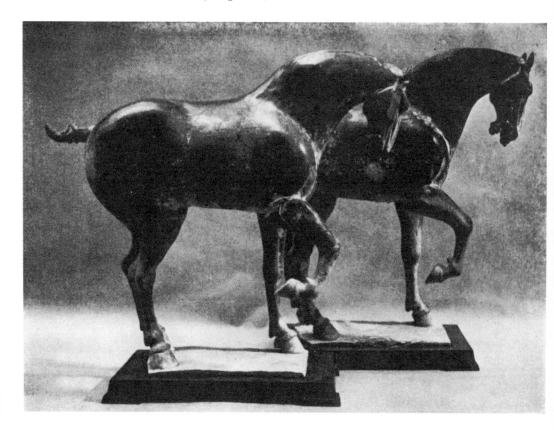

Analysis of a horse.

In studying a horse, I have found that there are certain simple shapes that express the idea of the basic forms that we see. Looking at a horse from the front, we see that the shoulders suggest a triangle that points upwards, while the hind quarters suggest a triangle that points downwards. Draw the triangle with the point upwards, the simple form suggested by the shoulders of a horse; then draw a second triangle on top of the first one but make it point downward as does the basic triangle of the hind quarters of a horse. Behind the triangle of the shoulders is the circle of the basket of ribs. Draw this circle through the six pointed star that was made by

the two overlapping triangles. Add a rectangle at the bottom to suggest the support of the two front legs, a small rectangle for the neck, an inverted triangle on top for the head, and add two little triangles for ears and you will have before you the basic form of a horse. If you want to make it look more like a horse, all you have to do is to carry the drawing further and fill in outlines of natural flowing forms over this framework. This gives you the essential structure for a very satisfactory front view of a horse.

The point of all this is not to show you how to draw a horse but to show that while each simple form that we can make with pencil on paper, using straight or curved lines can give the brain a definite sensation by itself, these same shapes will produce satisfactory representation when combined in relationships according to the scheme of nature.

The basic forms are the same in all types of sculpture. Every figure or group is composed of these same simple elements that are in themselves abstract. Some sculptors do not use these abstract forms to suggest things in nature. They use varying forms that are derived from cones, spheres, cubes, and cylinders, not in the relationships suggested by nature, but in relationships that have meaning because of their beauty, or interest and strangeness, or simply because of their power of expression.

The underlying structure of all art is made up of simple abstract forms that appear beautiful when combined architecturally and aesthetically whether the result is abstract or realistic; but it must be handled with discrimination and vision.

Analysis of a horse

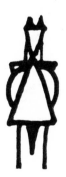 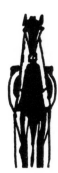 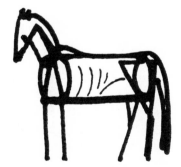

Drawings by the author, illustrating
application of his analysis of a horse

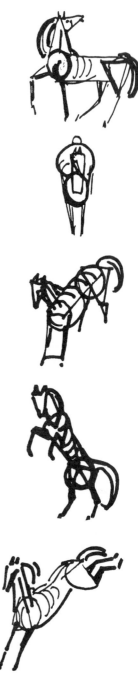

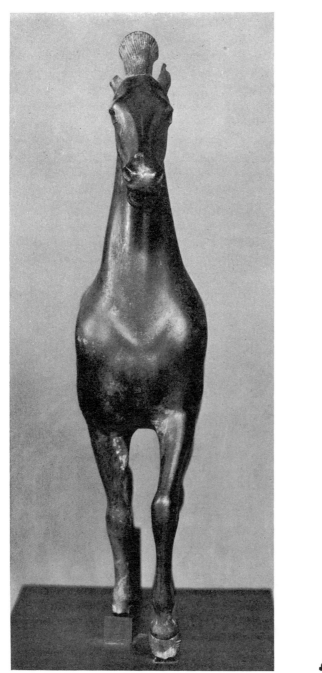

Bronze Horse. Greek, 480 B.C.
Courtesy Metropolitan Museum of Art

Aesthetic meaning in form.

As I explained in the introduction, a mechanical shape cannot have aesthetic meaning because it says only one thing; that is, round, or square or pointed or flat. But when a basic form is used to express an idea, every slight variation from the mechanical shape can have meaning. It is the ability of a person to feel the subtle relationship of every variation of form that gives him the power either to use sculpture as a means of expression or to appreciate the expression that others have intended to convey.

In nature we find a multitude of shapes. No two heads, no two hands or arms or bodies, are exactly alike. Nature is a heterogeneous mass of form and we consider something in nature beautiful only when we can see some harmonious relationship between its forms. The artist can see beauty where the average person sees only ugliness, because the artist is more sensitive to subtle relationships of form. He can select these relationships and harmonies out of the innumerable forms in nature and combine them into an art form.

The study of form is something that is never ended. Every sculptor no matter how skilled or how practiced he is in expressing himself in the language of form, must continually seek new and clear ways of art expression. He must continue to widen and enrich his vocabulary of form by becoming newly aware of the meaning of each subtle variation that the infinite source of nature provides.

I cannot too strongly impress upon you that, as long as you want to use sculpture as a means of expression, you must handle things, observe living beings, look at what others have done in sculpture and develop within yourself an understanding of the meaning of each relationship and each variation of form.

How to use analysis of form in drawing.

I would now like to enlarge on the simple analysis of the basic forms of a horse, since I am using this as a demonstration. From the fundamental forms of the two triangles for front and back quarters, the circle or cylinder for the rib basket, the triangle for the head and the rectangle for the legs, it is possible to construct a design of a horse as seen from any angle.

If you want to draw a side view, the same basic shapes are used; the upright triangle for the front quarters and the inverted triangle for the hind quarters are connected by straight lines and the circle of the basket of the ribs put in. Then a rectangle for the neck is added and the triangle

of the head put on. A rectangle serves as the base that encloses the legs and, with the addition of a curve for the tail, you have the basic structure of the side view of a horse. This structure can be treated realistically as the Greeks did, or left abstract as the primitives did or as some modern artists do today.

Both of these flat drawings give the essentials for the silhouette, but if you want to picture a horse in the round, you can use the same basic forms except that, instead of a triangle, a circle, and rectangle, you use pyramids, cylinders and blocks. Simply treat the cylinder of the torso in perspective and put in each form as a solid instead of a silhouette.

The margin illustrations will show you how these forms can be used to get the feeling of a horse in different positions. You can picture it as though you were looking down at an angle, by drawing the solid basic forms as each would appear from such a vanishing point. To get the feeling of a horse rearing, tilt the cylinder up so that it is seen from underneath, and rearrange the basic forms in the positions they would be brought into by looking up at a rearing horse.

Once the basic forms have been indicated, the minor forms can be added in their proper relationships. This is given, not as a formula, but as an example of a principle which can be applied to any thing. Such construction of a figure is architectural.

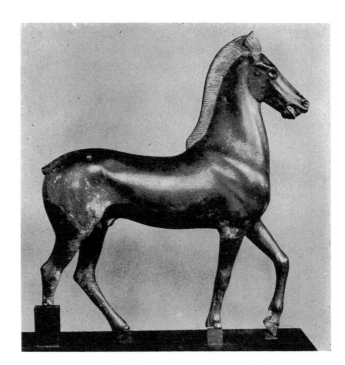

Bronze Horse. Greek,
480 B.C. Courtesy
Metropolitan Museum of Art

CHAPTER 4.

PROPORTIONS

THE RELATIONSHIP OF FORM—

Natural proportions.

A long neck is natural for a giraffe. You expect a dachshund to have short legs and a long body. A baby's head is larger in proportion to his body than is that of a normal adult. A woman is proportioned differently from a man. These are facts that we generally accept. Each of us has unconsciously set a standard by which he judges the proportions of a familiar thing.

People who think of sculpture only as a replica of nature, may be disturbed when they observe a stone, bronze, or wooden figure that has proportions different from those found in nature. They do not realize that since the beginning of time, artists have made arbitrary rules of proportions, called artistic conventions; and that even the sculptured figures that we are apt to accept as having "natural proportions" often do not repeat the relationships normal to nature.

Proportions as used in sculpture.

When we think of realistic proportions, as artists we think of the proportions used and handed down by the Greeks; yet statistics will tell you that one rarely finds a man with the exact proportions of a classical figure.

The classic Greek sculptors pictured a man as being eight times as tall as the length of his head. They assumed that the body was divided into eight natural divisions equal to the length of the head. Their standards are called "ideal proportions" because they were used to express ideal physical beauty, the Greek ideal. The Greeks did not copy nature. They organized the basic forms of the human body in a design that had what seemed to them, perfect relationships. The design of Greek sculpture is architectural, that is, it is built upon a consistent design plan.

Sculptors of different periods and of other countries have used different design plans to express their idea of the human body. For instance, the Greek statuette illustrated, which is from the century following the great Classical period, measures seven and a half heads; while the Aztec figure is only three heads tall, and the figure from the Belgian Congo is four heads high. Many Chinese, Egyptian, Gothic, Cambodian, Mayan and African figures may seem to us "less natural" because we are accustomed to the Greek ideal which has dominated Western art for centuries; but they are beautiful and expressive because the artists have used proportions that are right for their designs and express the ideals of their own race.

The point of all this is, that what is right from one point of view is not necessarily right from another. Proportions in nature are beautiful for natural things, but sculpture is man-made and its proportions should be governed by architectural relationships.

Ever since man has translated nature into art, there has been a question in the minds of many people as to what right an artist has to take liberties with human and animal forms. The artist's answer is: In the first place, when painting a picture or making a piece of sculpture, the artist is not dealing with flesh and blood but with material—stone, wood, clay, or paint—and because of this, he should have as much liberty as he wishes to take, to do whatever he wants to with the material. It gives him possibilities of expanding and enlarging his range of expression. In other words, it gives him a greater freedom and power.

Human beings react to form. Without any effort they enjoy what is sweet and pretty and obvious. They are delighted when form is natural or is a "speaking likeness." When form is explosive or dynamic, the audience is more limited. Yet people unschooled in art can respond to powerfully or beautifully realized sculpture, even when they do not understand it as an artist understands it. Sculpture is not an Ivory Tower for intellectuals. It is something that can have meaning for all people.

There will always be sculptors who will make the pretty and obvious, but there will also be sculptors who are fired with a desire to express the deepest aspirations of humanity, who are absorbed with a vision of new and marvelous possibilities of expression, who burn with emotion that only some exalted rhythm or some powerful distortion can express.

Diagrams showing how basic forms of the
human body can be designed with varying proportions

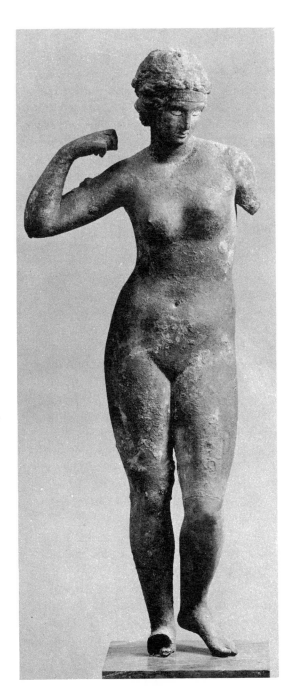

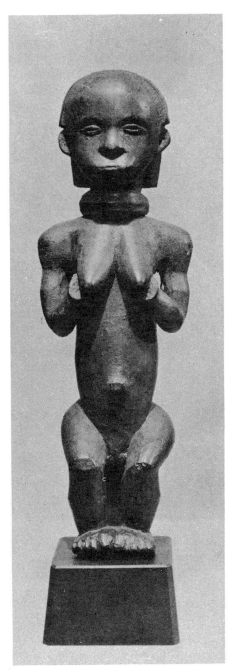

Aphrodite, bronze: fourth century B.C. Greek
Courtesy Metropolitan Museum of Art

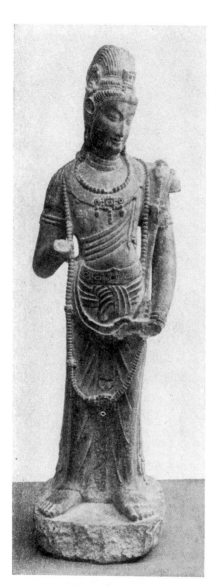

Bodhisattva, stone. Chinese
Courtesy Metropol tan Museum of Art

Distortion in sculpture.

The proportions used in drawing or sculpture often reflect the way people observe things. A child may make a picture of a man by drawing a head and putting it on a body that is only a single line, with other lines sticking out for arms and legs; or he may put in no body at all, but just draw a face above a pair of legs with hands sticking out at the side. He is probably drawing things he is most aware of.

Primitive artists emphasize what is most important to them. The eyes, nose and mouth are often made important and the head large while the feet and hands are diminished as being less important.

The Chinese are apt to emphasize the head and hands, while making the body comparatively insignificant.

The Gothic sculptors of the Middle Ages usually made a figure of a saint larger than that of a beggar or common person. In this way they indicated the relative importance of each figure.

This factor of relative importance produces distortion, or a wilful disregard of natural proportions.

Design is another equally good reason to modify realistic proportions. An Aztec sculptor, in cutting a figure out of stone, worked within a limited space. Starting with the head, the thing that interested him most, he would cut it first and then fit the other parts of the figure into the space that he had left. Having a good feeling for design, he would give the torso, hands, arms, legs and feet good proportions in relation to the shape and size of his stone.

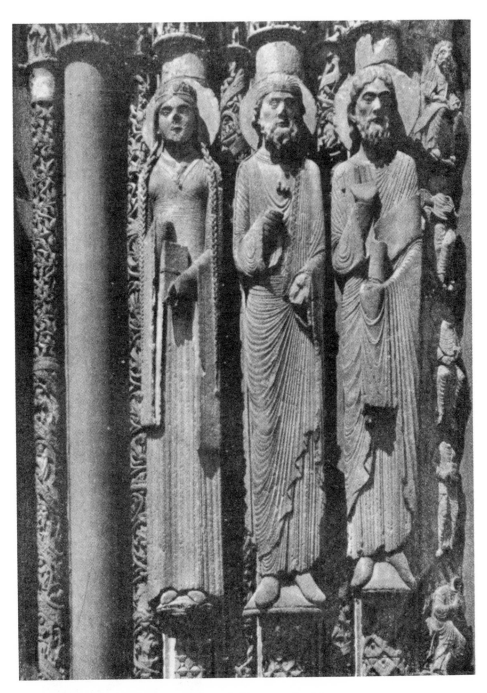

Ancestors of Christ, Cathedral of Chartres. Gothic

An African wood carver would take a stick and start to carve a figure. To him also the head would be of first importance and after carving it out at one end, he would find that he had to elongate the neck and body to make a satisfactory design within the shape of his stick. This problem of the African carver was similar to that faced by the Gothic stone carvers who made sculpture for the cathedrals and churches. If a figure was to go at the side of a doorway, they would fit the design of the human form into the shape of a column so that the sculpture would function as a part of the architecture. If he had a cornice to fill, a Gothic carver would create human or animal chimera, figures with proportions that would make a good design in the space.

The same consideration of material and space also governs much of the distortion used by contemporary sculptors. A sculptor will often adjust the proportions of his figure to the dimensions of the stone block he is cutting rather than try to repeat either the ideal proportions of the Greeks or the natural proportions of a human being. But while distortion has to be related to basic form or design to be successful, the primary reason for it lies in the artist's need to emphasize his meaning; to change, and select, and accent his conception; to create new and more powerfully expressive language. One of the fundamental qualities of a real artist is his unquenchable curiosity. It is his inalienable right to experiment with ideas and material.

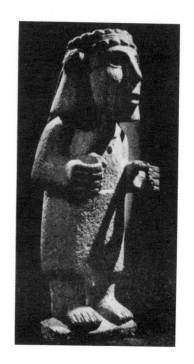

The thing to remember about proportions and what people term distortion, is that a thing is right if it is designed right and expresses what the artist meant it to express. The proportions of a human figure, an animal or any living thing are what they are because they serve a natural function. In the same way the proportions of any sculptured figure are right when they function in an art way, that is, as related parts of a good design.

Aztec Goddess of Flowing Water
Courtesy Magazine of Art; photograph Morisette

CHAPTER 5.

ANATOMY

The skeleton is the architectural or structural base of any body. A certain amount of study of anatomy is good for a sculptor; it increases his knowledge of human and animal forms by familiarizing him with the functions of muscle and bone structure. But the study of anatomy should always have as its object the increasing of knowledge of the way form functions, never with the idea of correcting one's figures. They have to stand on their own as works of art, with or without anatomy.

It is not important for a sculptor to study anatomy as a physician or surgeon would; but a simple knowledge of the skeleton—where bones join, how they move, what function each has—is valuable. What is very important is to learn to know and to see where certain bones, such as the collar bone, join the skeleton and what their shape is; to learn the shape of the basket of ribs, the pelvis, the shoulder blades, the skull, the cheek bones, the jaw bones and most important of all, the spinal column. All these project through the muscles and show hard and sharp under the skin. They give a clue to the bony structure of the body.

A human being or an animal is alive. Its forms are fluid and beautiful; entirely different from the material that an anatomist deals with. A good way to study anatomy would be to refer to anatomical charts while looking at a living model. The charts help to analyze what is seen in the living form. They help the student to trace the attachments of the muscles and to see how the body is constructed, if studied while the model is asked to move around, to tighten and relax his muscles. The student can see how each part analyzed in the chart functions in the living body.

Nature is alive and good art in any medium also possesses a life of its own; but the ordinary study cast is a lifeless thing just as anatomical models and charts are lifeless. The difference between looking at nature and looking at a photograph, a chart, or an antique cast, is like the difference between seeing a beautiful fish, translucently alive in a pool and seeing a dead fish with sunken eyes and drooping fins in a fish store.

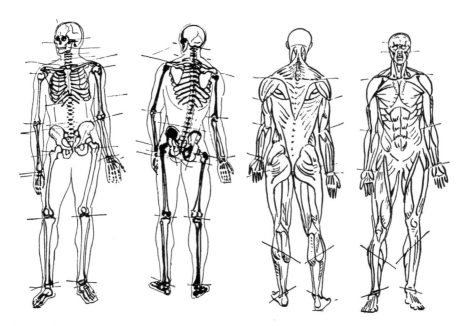

Anatomical drawings of the muscle and bone structure of man;
note direction of lines drawn through essential structure

The student meets with similar trouble when he studies the muscles of
a model who is holding a pose. The model's muscles begin to look like
something hanging on a skeleton, or even something hanging from the
ceiling. The mature artist usually has trained himself to see beyond this
and utilize what he needs but the student cannot do this and is completely
misled by what he sees before him. To overcome this in studying the
human figure, it is always good to have the model move, walk up and
down, move the arms, and stretch and use his muscles to keep them alive
and active. It is also good to have a model lie down in various positions so
that the form can be studied from different angles. Look up at the model
from below—get up on a step ladder and study the model from above
—study the model from every angle and in various lights, both natural and
artificial.

The same things should be considered in studying animals. You will
find that there is a great deal of difference between individual animals.
Some have distinctly beautiful form, others are almost formless or at least
excite no interest in an artist. It is largely a matter of whether or not their

muscles have been used. Animals are more beautiful in their wild state than they are in the Zoo. There is a great contrast between a horse that works and one that stands idle. The beautiful animal is one whose muscles are alive, flexible, taut. There is a beautiful shape to the chest of an active horse, a marvelous design to the hind and fore quarters.

It may be exasperating to try to sketch a moving creature; it is easy to sit down in front of an immobile object and study it. But if we make the effort to draw living, moving figures and animals, we find we can do much more than we think possible. It is better to make quick studies of living form in action, even if the drawings can be nothing more than a line or two that indicate what was seen, than to painstakingly draw a stiff or dead thing. In sketching I often write the description of what I have drawn or a note on the drawing, in this way labelling the fragmentary notes that might mean much to me later. The words with the drawing recall more to me than either one alone.

The study of anatomy should be incidental to the study of animals or

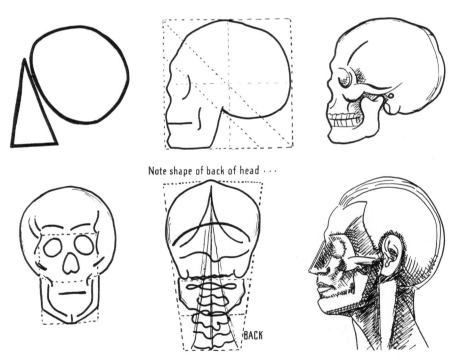

Note shape of back of head · · ·

BACK

Diagrams showing construction of head

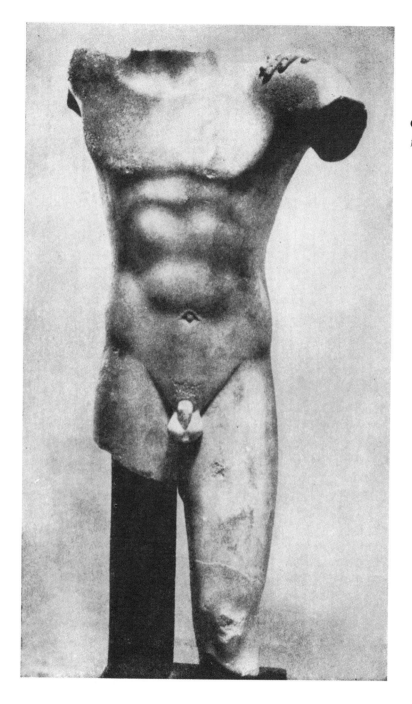

Greek Torso
from the Acropolis

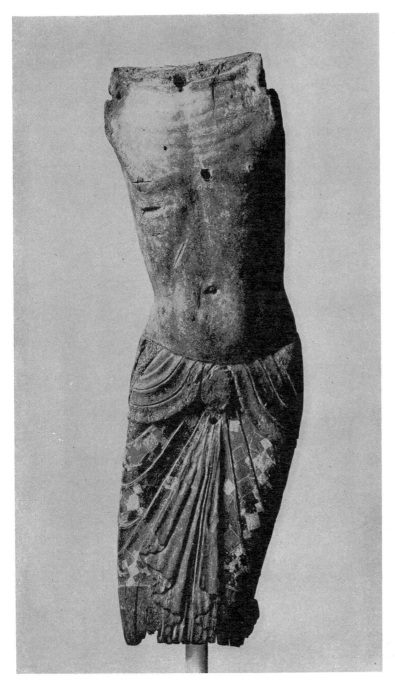

Gothic Torso, wood;
twelfth century. French

*Courtesy Metropolitan
Museum of Art*

humans. With some animals it is more important than with others. For instance, knowledge of anatomy does not help much where the form is largely concealed by fur as it is with a long-haired cat. It is more important to see the form of the animal as a whole than to know the bone and muscle structure, unless the bones and muscles are what give character to the animal as you see it. An ability to understand basic relationships of forms is more essential than knowledge of anatomical details.

For the student who wishes to go into the study of anatomy more thoroughly than I have outlined here, I would advise studying the following books on the subject: *Anatomy in Its Relation to Art,* by George McClellan; *Studies in the Art Anatomy of Animals,* by Ernest E. Seton Thompson; *Art Anatomy,* by Dr. William Rimmer; *Anatomical Diagrams,* by James M. Dunlop; *Drawings by Leonardo da Vinci; Anatomy for Artists,* by Reginald Marsh.

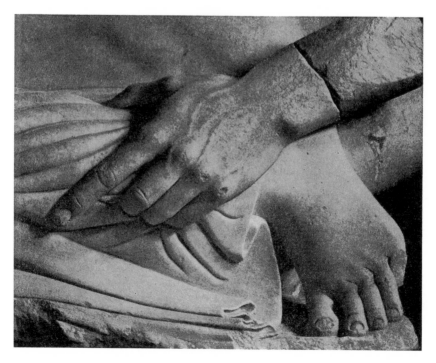

Detail of Temple of Zeus at Olympia

CHAPTER 6.

RHYTHM

Rhythm is continuity—flow—an untiring, non-monotonous movement. A swing has movement but not rhythm. A see-saw has movement but not rhythm. The ticking of a clock and the swinging of a pendulum are movements but have no variety—they are monotonous.

In rhythm there is a variety of movement and also a combination of variety of movement flowing in different directions; there are combinations of curves or swings; in and out, around and back, up and down, forward and back, long and short. Rhythm is produced by the selection and combination of various shapes and forms, and by the arrangement of them in a harmonic pattern or design, either two- or three-dimensional.

Rhythm is an innate creative quality that can be brought out and developed. It is an essential in painting, sculpture, music and the dance; a quality without which any art is lifeless and dead.

Rhythm is most clearly apparent in the dance which is expression projected through the correlated and rhythmic movement of the human body —an ephemeral expression which, in sculpture, is put into permanent form.

The quality of rhythm is that which is an integral part of a piece of sculpture as opposed to a photographic or matter-of-fact copy of a natural object. Rhythm is produced by a selection of masses, lines and spaces that are arranged within a limited area to give a feeling of movement and life. It is a factor by itself, apart from the natural object or the literal interpretation of it. Rhythm results also from repetition and the following up of a movement.with variations.

One can best explain rhythm as a relationship of form. It results when a person of taste and feeling inter-relates forms, great and small of various dimensions and shapes, into a harmonious whole. It is, as it were, creating order out of chaos—a personal and individual order—balancing form against form, direction against direction.

Rhythm in sculpture is the element that makes it possible to express

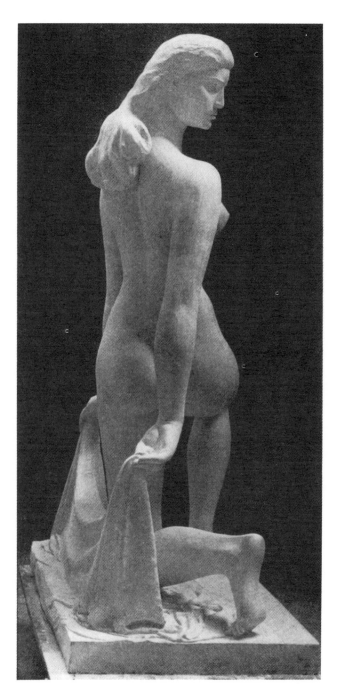

Spirit of the Dance,
Radio City Music Hall;
from the original plaster model.
William Zorach

Photograph Pincus Horn

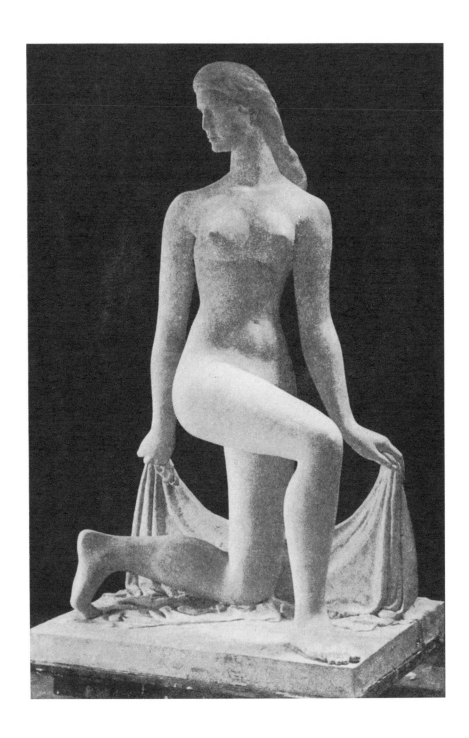

movement in a static art. It is the only means of expressing movement in sculpture but it is also a component of all art whether expressing movement or complete repose.

Basic rhythms.

The simple elements of rhythm can be expressed in line. Take a pencil and a sheet of paper and experiment as I have done in the margin. You will find that a wavy or zig-zag line gives a simple wave motion, the pulse and flow in measured beat. Repeat a simple curve or straight line and see how the repetition of that single element gives a monotonous beat. Try combining two or more elements and observe that more of a feeling of rhythm is given when there are both variety and movement.

I have noticed that the basic rhythm most often found in nature can be expressed by a curve, a straight line and a reverse curve. Try different variations of this rhythm motif and see how it can be used to express the rhythm of the waltz—the swing, the pause and the return movement of a golf stroke—the rise, break and fall of a wave in motion as water moves from crest to crest. Apply it to human forms and see how it can be made to express the rhythm of an arm, a leg, a head. Observe how a variation of this basic rhythm, with additions and repetitions, forms the theme of both pieces of Chinese sculpture reproduced.

There are many different rhythm themes but, basically, most of them can be reduced to some variation of a movement around, down and back— that is, swing, rest, and counterswing. This is as true in sculptured form as in the dance, as true in painting as in life. Always there is movement, stability, movement. Rhythm is a cosmic force.

Rhythm cannot be created by formula. It results from feeling movement and expressing that movement through the shape and direction of

Basic rhythm diagram

46

planes, lines or masses. Rhythm is achieved by arranging each part of a form in such a way that beautiful relationships are established, either on a flat surface or through space in a three-dimensional form.

The most simple forms can have beautiful rhythm. A head may be extremely simple yet have subtle relationships of curves and straight lines which weld the individual features into a rhythmic whole.

In the group of "Playing Dogs" by Hunt Diedrich, you will find the basic rhythm is composed of two movements—similar to the movement of a wave. This basic rhythm gives the impression of a continuous movement. The rhythm goes on and on with no tiring lags. The straight lines shoot forward and back but the rhythmic flow holds the attention within the sculptured form. The eye follows the play of planes and lines—in and out, following the subordinate planes and direction of masses. The whole is developed from an infinite variety of simple repetitions of similar harmonious movements.

In the "Dolphin Fountain" by Gaston Lachaise, one finds that the movement or rhythm is also based on the wave theme. However in this group the movements are shorter and more staccato. The lines of the bodies create a continuous flow and although the noses of the dolphins tend to carry the eye out of the group, the tails and fins carry the eye back again. The movement is perpetual and the total rhythm is built up from an infinite variety of lesser rhythms.

Study the diagrams which show how the simple basic rhythms of each sculpture have been supplemented and enriched by added subsidiary rhythms that repeat the basic motif. It is the interweaving of all these movements and rhythm elements that gives life and vitality to these works. Although they are cast in bronze, the impression created is a ceaseless movement.

Compare the two Chinese figures with the analysis of their rhythms in the margin. I have analyzed details and also shown the flowing rhythms of the head and neck of the Han horse; I have also drawn the simple basic rhythms of the chimera and shown how it is supported by supplementary rhythms.

Rhythm is also a spiral, mounting and descending. It is up and out and into with the straight line serving as a division point or as a core to the spiral. Rhythm in sculpture is like the sense of direction in East Indian dancing, it flows through the body in different directions and pulses and indicates a spiral. It is three-dimensional. It can be achieved in the full curve of surfaces or in the linear pattern of edges that outline the form.

What the cubists and abstractionists do is to disregard the naturalistic placement of rhythms and to rearrange the placement abstractly. If you understand the basis underlying art, cubism is no mystery to you, nor does it disturb you.

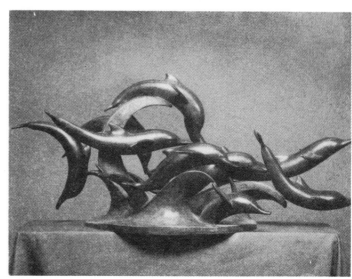

Dolphin Fountain. Gaston Lachaise
Courtesy of Whitney Museum of American Art

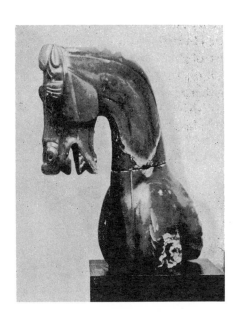

Jade Horse. Chinese, Han dynasty, 206 B.C.–220 A.D.

Eumorfopoulos collection;
photograph courtesy Metropolitan Museum of Art

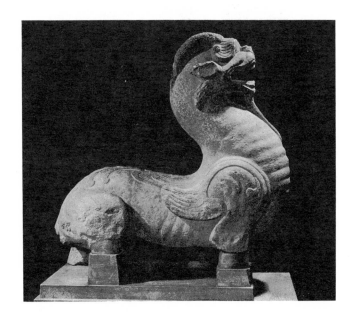

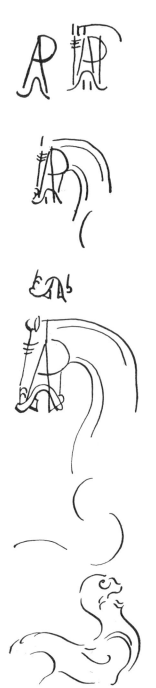

Chinese Chimera; third century

Courtesy Magazine of Art

All this is analysis. No artist starts out with analysis. An artist first creates a work before he or anyone else analyzes it. But the fact that the same basic rhythms are found in art of different origins means that our sense of movement is a deeply rooted one, that it is universal.

I hope I have made it clear that an artist does not base his work on an arbitrary pattern. This analysis is simply for the clearer understanding of the language of sculpture. Read about these things and think about them. Try to see and understand the use of rhythm in the works of others. But when you do your work don't have them in mind; have your mind on what you are trying to do, to express. Let what you have learned come out through working, not by forcing it or thinking about it. If you have absorbed this knowledge it has become part of your equipment. You can only use as much as you feel and know.

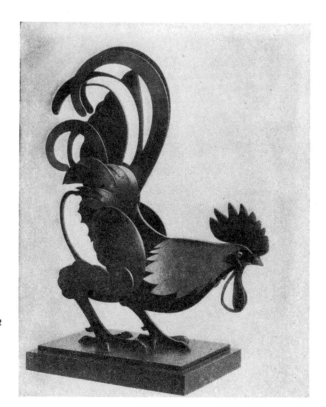

Rooster, wrought iron.
Pablo Gargallo, 1930
Courtesy
Metropolitan Museum of Art

CHAPTER 7.

DESIGN

Science tells us that the form and character of life are based upon the arrangement and pattern in the germ cells. In the same way the ultimate character and form of a work of art are based on organic structural pattern or design.

This basic structure is something with which the artist can take infinite liberties. Through arrangement or rearrangement of elements, any form can become a realistic, fantastic or abstract expression, but in each case the essential factor is the artist's plan or design.

These basic principles existed in the art of ancient Egypt, in that of China, of Greece and all other countries. They are the common denominators of all great art, whatever its period or place in history.

Design means creating order out of chaos. It means establishing relationships so that various elements seem to belong together. Without a unifying structure, a work of art or even a life, is meaningless. It may have certain qualities, but it does not have the feeling of unity holding the various forces together, which is necessary to us as human beings. Just as we speak of an aimless life as one without design, so we find certain pieces of sculpture do not hold together because the sculptor has not established relationships that have meaning.

By design I do not mean arabesque; I do not mean pure decoration or mere ornamentation. I think of design as a great, unifying, rhythmic pattern. Out of this grows the flow and interplay of minor forms and rhythms, all of which are held together by the larger plan so that a living entity is created.

It is difficult to explain this without seeming to be mystical. The best explanation of what I mean can probably be found in the illustrations. Look at the different works of art reproduced and see that there is a compactness, a unity which is felt even if it is impossible to analyze what produces it.

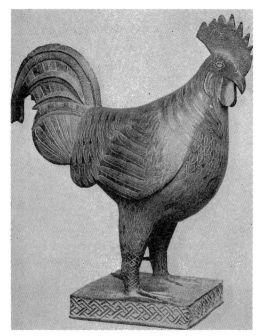

Bronze Cock. Benin,
classical period—1500 A.D.

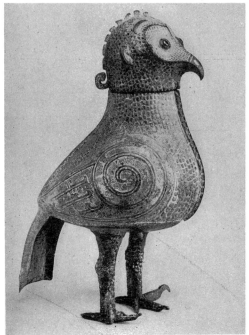

Wine Vessel. Chinese, Shang dynasty

Water Buffalo. Chinese, early Chou
Courtesy Fogg Museum of Art

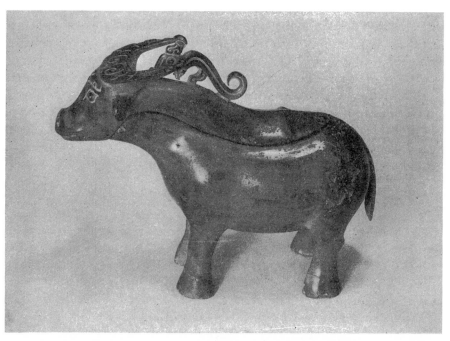

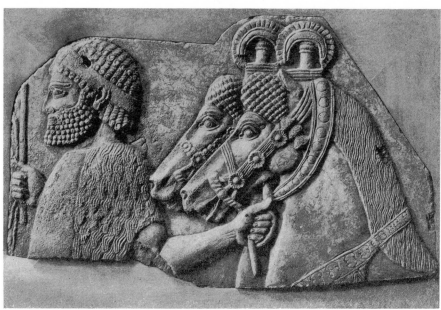

Relief from the palace of King Sargon II. Assyrian
Courtesy Metropolitan Museum of Art

We feel such things instinctively. Most of us are born with a sense of discrimination; that is, with taste and feeling. But to be born with this quality is not enough. What is even more important, is to have the capacity and strength of character to develop this quality to the highest degree of power. An artist must be able to express his conception of design so that it will have the power of carrying over his message of beauty to the world and become a great civilizing agent and elevating instrument.

A great piece of sculpture is first of all based upon a fine, a great idea. The element of design is important because it is the structure of the idea, but it must be remembered that design is a starting point, not the objective.

The sculptor should utilize all knowledge of idea, design and materials to bring his inner thought to a successful expression in permanent form.

The most important thing in art is the expression of the individual. Even when, as often occurred in the past, artists worked within a close tradition, the living quality was the projection of the personality of the sculptor who embodied in his work the ideas most deeply felt. The greatest contribution an artist can make is to project his personal feeling towards life through his medium of expression.

You should experiment, try different ways of working, find what is right for you personally; seek out the way in which you can best express what you have to say in sculpture. The instructor can assist by suggesting ways of working, by helping you to handle material and by urging you to explore ideas of your own; but you must develop yourself and your own powers through working, working, and then working.

Throughout this book I will continue to stress fundamentals of form and basic construction; and I will always keep on repeating that the most simple and direct way is the best. I shall also continue to talk about design, rhythm, proportions, and the elements of art, but I hope never to impose upon a student any formula or even to suggest one to him. Any academic formula is a poisonous, penetrating dye that will forever creep up through an artist's work and nullify the living qualities. Always seek for what is great in sculpture. Never look for superficial tricks or clever ways of doing things. Even if they fascinate you and seem a pleasant solution of your difficulties, avoid them. In looking at the sculpture of any age or any country, try to get the essence, not the mannerisms. Never imitate.

Whenever you can, study fine examples of Chinese, Egyptian, Assyrian and early Greek sculpture—not from the point of view of copying or imitating them, but searching for the great quality of reverence, sim-

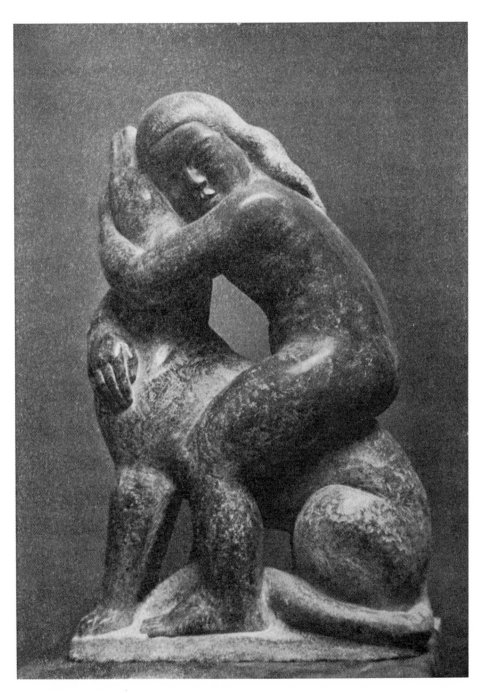

Affection, York fossil. William Zorach

Collection Munson Williams Proctor Institute; photograph Peter Juley

plicity and unity of form contained in these great works. I also advise studying African and Mexican art for the direct power of expression, simplicity and design, as well as for their amazing architectonic proportions.

Don't just study the past. Keep your eyes and your mind open to what is going on around you in the world of life and art. Never accept anything unless you can see it that way, either a new form of art or an idea. Never take the spoken or written word as the ultimate truth; there is never an ultimate truth. Always keep an open mind, be willing to discuss but always make your own decisions. Do what you, yourself, feel is true in art and learn by your own mistakes.

Art forms are influenced by conditions surrounding the artist; the accepted ideas of his time, his mode of living, even his personal evaluations and the materials he has at hand.

Certain things take place in a human being and certain political ideas arise in the world. There seems to be a parallel between them, not always caused by one or the other, but running along side by side. Waves of thought and activity sweep over the human race, sometimes being manifested more in one field than another. Art is subject to these waves as well as are social philosophy and economics. Art ideas, good and bad, spread like a conflagration. Test them, study them, sift them, be sure they are true and sincere and not false, before you accept them. Appreciation is colored by the excitement and illusion of new ideas; test them, for the illusion wears off and in the end true values remain.

Our art is colored by the emotional, social, and intellectual aspects of our environment. It is also colored by the physical and geographical aspects of our environment, even in these days when communication is so swift and isolationism has almost ceased to exist. These factors still influence the artist's imagination and his choice of subject matter. His experience is reflected in the way he sees a design and in the relationships he stresses in his work. It should be this way; an artist should draw his material from himself and the life he knows. Yet great art transcends any period and has an eternal and universal appeal.

A sculptor does not create the same form or idea for bronze as for wood or for stone. Each material has a character and quality of its own. Your design forms should grow out of your findings and experience with materials. A work of art is always, in a sense, autobiographical.

A form acquires aesthetic meaning when it has emotional content. When this emotional content is lacking, sculptured form is cold. It becomes merely an arrangement of shapes and masses. Much abstract sculpture

Head of Moses, Labrador granite. William Zorach
Earl Hall, Columbia University, New York

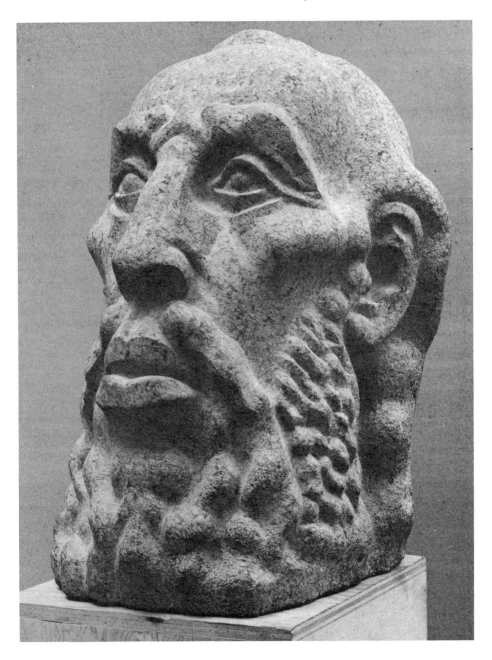

done today is formal and intellectual and seldom reaches the higher aesthetic expressiveness.

Emotional or aesthetic content is something that is felt. It cannot be produced by rule because it is the outgrowth of the artist's own spirit. Rhythms can be intellectually conceived, but to have aesthetic meaning they must be emotionally felt and almost unconsciously expressed. Aesthetic quality is something that cannot be consciously acquired, as it is an innate quality of the artist himself. It results from creative feeling which is developed only by richness of experience added to an inherent and instinctive quality. It is as important to develop latent powers of emotional feeling as to acquire skill in expression.

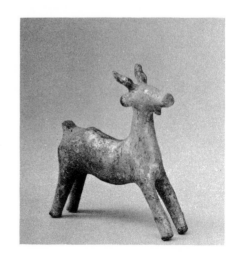

Animal, terra cotta
covered with gold leaf.
Prehistoric Greek
Courtesy
Metropolitan Museum of Art

CHAPTER 8.

WORKING WITH CLAY

Composing with clay blocks.

Pound several small blocks of clay into various shapes and sizes and experiment with them in an abstract way. Try putting together a flat square block, a tall thin block, a sphere and a cone. See what sort of interesting arrangement you can make with them. Pound other clay blocks into various shapes and sizes, such as cubes, cylinders and pyramids. Select some of these according to your taste and see how interesting a composition can be made with them. Substitute similar shapes of varying proportions and experiment further until you get a composite form that has an interesting relationship between its parts.

Such a composition, built up of basic shapes, makes an abstract arrangement. If it is well composed, it will be attractive in itself, without suggesting any natural form. Such an abstract composition can be considered for itself or it can be used as the basis for the cutting of a human figure, animal or group. Try this with one of the abstract clay compositions you have made. If it suggests a person or living creature to you, cut it so that the suggestion is strengthened. If the oval block has suggested a face, cut and shape it so that it will have more the semblance of a face. If a group of blocks suggest a figure composition, cut and model it so that it will clearly develop the suggestion.

If the proportions of your abstract forms are well related, the proportions of the figure made from your composition will be interesting whether or not it is realistic. You have built up an architectural form and this same design will still be satisfying when the basic design is translated into an expression of something seen in nature.

Instead of cutting a figure from a single block of clay, try building a figure out of two or more blocks, each of which can be carved into the form of a single part. For instance, a figure of a horse can be built up with one large block that is cut into the shape of the body and legs, and two

smaller blocks, one for the head and one for the tail—or you can build up the legs, body, neck, head and tail by using a separate block for each. You can make the blocks stick together by moistening the surfaces that come together and pressing the clay firmly until it adheres. Should a joint seem weak, you can reinforce it by sticking a toothpick into one block and forcing the second one over the protruding point.

When you have the crude figure built out of clay blocks, cut and pound and shape the clay. This method of building a figure is a good way to work when you are studying proportions. The blocks themselves must be in good relation to each other before you start carving and finishing. This way of approach makes it easy to keep your forms simple and forces you to relate the important masses before you can become involved in fussy details.

If you want to do a group instead of a single figure, pound blocks for each main mass and put them together to form the composition. Then cut each block in the composition so that it has the particular form that you want it to have. Make sure that what you have in mind is a unit that is complete in itself whether it is made up of one or a dozen figures. The individual figures in a group must be in good relationship to each other just as the individual parts of a single figure should be related to each other to form a good design.

In forming preliminary ideas, pencil or ink drawings are valuable. Draw the general masses until you have a clear idea of the relationships of the forms that make up the group. Then pound your blocks into the basic shapes and masses suggested by your drawing, build your composition of these shapes; then cut and pound the rough model into the completed form you want.

Three Abstractions after Brancusi

Carving clay blocks.

Before you start to seriously carve in clay, you should make a drawing of the idea you wish to work on. It is always necessary to have an idea clearly in mind before starting to work even if you change the idea as you go along. Suppose you wish to carve an animal; look at the studies you have made, refresh your memory of the animal. Then make a simple outline drawing of a side view; make another of the front view, and still another of the back view of the animal in the position you plan to use in your clay model. These are the silhouettes that you must keep in mind as you work on your clay. Be sure that your drawing shows a shape that will stand up without support when it is carved in clay.

To me, drawing is very important. It is the means whereby I capture the fleeting beauty of movement and gesture and make available for future use my observation and sensitivity to the life around me. Before starting to carve a horse, I go out into a pasture and watch horses; I see how they move and stand and act. I study them from the front, and from the sides and from the rear. I make drawings of the whole animal, drawings of the legs, the hoofs, the ears and the tail. I notice the shape of the hair on the tail and the direction in which it grows. I observe and make notes, always taking into consideration the basic forms. I study the construction of the legs, shoulders, knees and fetlocks. I observe the way the neck comes out of the body, the way the head sits on the neck, and the way the tail continues the spine. In making these studies, what I look at is the big elemental shape, not incidental details. I may not use these notes—or only some of them—but I have acquired a knowledge and familiarity with a horse that make it possible to work freely and with sureness. I do not have to continually question what a horse is like; I can concentrate on expressing my idea with freedom and power.

Once I found a beautiful greenish stone that in

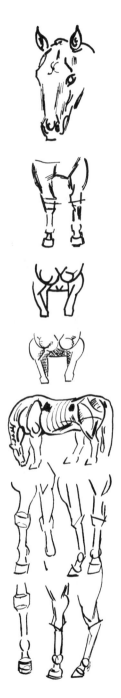

Studies of a horse
from the author's sketchbook

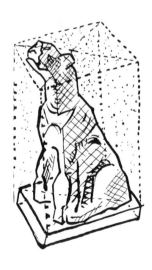

color and form suggested it should be used to carve a frog. Now I didn't know very much about a frog. I caught one and put it in a glass bowl. Then I made many drawings and studies of it so that when I came to carve the stone, I knew what a frog was really like, what forms were in its body, how these forms were related, how it moved and functioned. This studying of a thing is not with the idea of reproducing the animal. I use my imagination and my knowledge to create an idea or impression of the animal. I take whatever liberties seem right to produce a work of art. It is important to see the big simple design of the work from every angle.

Silhouettes are exceedingly important for sculpture because they give a clue to the character of a form. A good silhouette from the front, the sides, the top and the back, will give you the essential shape of anything, and when you have a good silhouette, the rest usually begins to come to you. A sculptured figure will be interesting, even though carved very crudely, if its silhouettes are good.

To cut a figure from a clay block.

To carve a figure from a clay block select a block that has about the proportions of the figure you want to make; but be sure that it is taller than the figure so that there will be room at the bottom for the base. The diagram shows how a figure should be visualized within the block.

Draw simple outline silhouettes on the clay of the figure you want to make. Use any sharp pointed tool, draw the side silhouette on both sides of the block. Then draw the front to back silhouette on each end of the block. When this is done, start to slice away the excess clay as shown by the slanting lines in the diagrams. Use a knife or cutting tool and cut across the block, first from one side to the other, then from end to end, until you have cut down almost to the silhouette lines. In doing this, keep your cutting simple.

Diagram showing how a figure should be cut from a solid block of clay

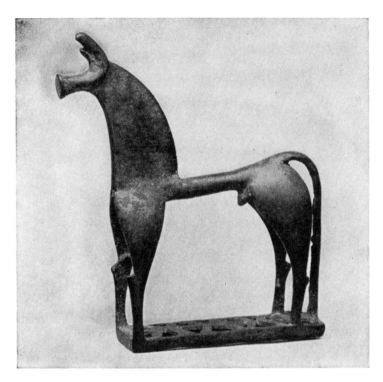

Bronze Horse. Greek, eighth century B.C.
Courtesy Metropolitan Museum of Art

Do not try to put in details. If you are doing a standing figure, leave some clay between the legs so that the body will be supported.

When you have blocked out the animal in this way, take either little wooden hammers or blocks of wood, and pound the figure all over to get the feeling of solid form into it. As you pound the clay you will begin to feel the figure more and more. Then continue your cutting, to bring the figure closer to the form you have in mind. Think of the surfaces or planes and keep your cutting simple.

Refresh your memory of the animal by looking at your drawing notes or by looking at the animal. Then carefully study the form of your clay figure. Recut parts that do not satisfy you; or, if you have already cut away too much, add more clay by making pellets and pounding them on so that they become part of the solid clay form. Then you can recut the parts

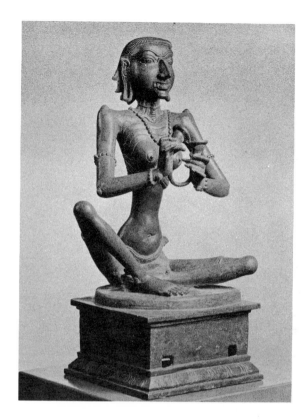

Karaikkal-Ammaiyar, bronze
13th-14th century. India

*Collection William Rockwell Nelson
Gallery of Art*

where the clay has been added. Repeat this process of cutting, pounding, adding clay, and cutting again until you get the form you want.

After you have made your first cutting, you will probably find it difficult to go on. Let your clay stand uncovered for a few hours; or, if you want to put it away for the night, cover it with a damp cloth or a piece of oilcloth. The next day you should find your clay always a little harder, not too dry or too wet. Now you can go on cutting and shaping. Do not let fussy details creep in. Keep the figure simple. Preserve the feeling of basic forms that you had in your mind originally. In cutting, continually watch for interesting rhythmic planes. Hold these planes; do not lose or destroy them.

Modeling.

Instead of pounding clay into blocks for cutting, pile up a mass of moist

clay on your modeling stand and start shaping it with your hands. Squeeze and push the mass. Cut away parts and add fresh clay. Shape it until the mass assumes a desired form.

In doing this you will discover what consistency clay must be to work easily, how moist it must be kept to be pliable, how large a mass will stand up, and so forth. These are the problems that must be solved as you go along, and the more you experiment and rely on your own ingenuity, the better it will be. The important thing is to have courage and not be afraid of making mistakes. Do not depend on other people, find things out for yourself, it will give you confidence as well as knowledge.

Later on I will explain how to build up large forms by putting layer after layer of moist clay upon an armature (a skeleton of wire and lead that is held by a steel support) but first it is important to become familiar with handling clay. Everything you learn through this free modeling in clay will help you later.

It is a good thing to have an idea clearly in mind when you start to model a figure, just as you did when cutting blocks of clay; but you can also play around with clay, letting the clay suggest ideas as you work with it.

When you have a mass of clay on your modeling stand and are working with your fingers, study the mass from time to time to see what it suggests. Often the accidental forms in the clay will stir your imagination, much as do the forms found in clouds, in rock formations or in foliage.

Dove, terra cotta. From Sardis

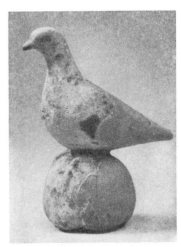

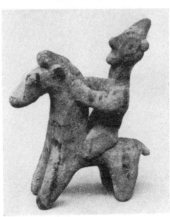

Horseman, terra cotta.
Archaic Greek
Courtesy Metropolitan Museum of Art

Leonardo da Vinci told his students to look at embers in the fire to find suggestions for compositions and to seek inspiration in cracked and crumbling walls. Such things stimulate and release the imagination, just as do the stars in the heavens which man has always thought of as arranged in pictorial patterns.

In pushing and pulling your mass of clay about, things will suggest themselves. As the clay seems to take form, you can emphasize what you want to and eliminate what you do not like. In this way a personal and original composition is often found. You cut away and add, reshape and change until you have developed a figure that is interesting and expressive. But don't forget that the more you have studied nature and made drawings of animals and people, the easier it will be to develop a figure in clay.

This is the way that children work; but it is also the method used by Michael Angelo and Rodin. Do not worry about being correct in details, do not try for finish; the value of things done in this way is their freshness and spirit, not their completeness.

After you have modeled the suggestion of a figure, you will probably find it difficult to go on because of the condition of the clay. Let it stand uncovered for a few hours to set, or wrap it in a damp cloth and set it away over night. The next day the clay will be hard enough to go ahead with the modeling.

With a fresh eye, you will see where you want to cut away parts or add clay to build up the shape. As your sketch pro-

Statuette, marble. Cyclades, about 2500 B.C.
Courtesy Metropolitan Museum of Art

gresses, your mental image of it will develop and you will see more clearly what you want it to be. Carry your sketch as far as you can, using your fingers as tools. But when you reach the limit of your ability to develop it, stop; keep the figure alive and simple and fresh. Don't let an attempt at detail spoil the original feeling. Detail should appear in your work only as your growing knowledge makes it a natural addition to your work.

Another way to make sketches in clay is to build up a sort of skeleton with small rolls of clay. Make the pieces support each other, some serving as legs, others as arms, bodies or whatever you have in mind. In a sense this is drawing with clay.

Heads.

Before building up and modeling a life sized head on an armature, I assume that you have studied and observed heads, that you continually study and observe heads, making notes and drawings. That you draw the people around you, members of your family, friends, women on the streets, children at play, that you never stop observing and making notes of what you see.

Think of the basic design of a human head. Try to find the basic

Pottery Whistle. Mexico
Courtesy American Museum of Natural History

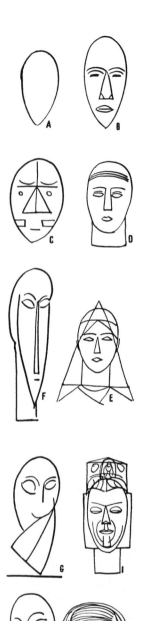

(A) Basic oval form of head.

(B), (C) African masks—contrast of realistic and fantastic treatment.

(D), (E) Archaic Greek heads—ideal conception of realism.

(F) Modigliani—elongation of forms.

(G), (H) Brancusi—simplified ovals.

(I) Chinese—oval and square forms.

(J) Egyptian—oval and triangular forms.

structure. Think of the shape and mass of the face and jaw in relation to the dome of the skull. Study these relationships from the front, from the side, from the back, and even from the top. Try to analyze and understand the basic rhythms and the basic designs.

Observe how one person differs from another. Study the different proportions of a man, a woman, a baby, a young child. Have a sketch book and make notes of things you see, make notes of things you remember. Observe and draw continually so that when you begin to model a head or a figure, you will have the forms and essential design in your mind.

If you feel timid about drawing, suppose you first put down a triangle, try drawing a circle over it, then put a square over that, then divide the square down the center. You will find that you have made a form that can be carried further to suggest a head. Complete it with a few more simple lines to indicate the eyes, nose, mouth, neck and even shoulders.

The front view of a head can be expressed with the simple basic form of an oval, yet a great range of expression can be given by varying the

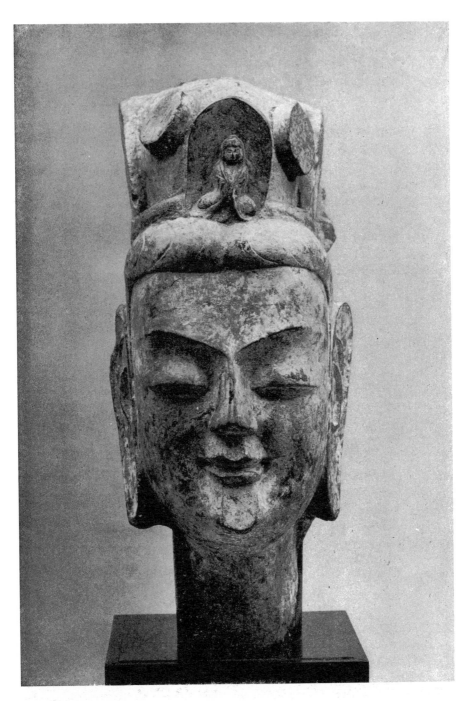

Chinese Head
Courtesy Metropolitan Museum of Art

proportions of such a basic design. Make a number of ovals; squat, elongated, pointed, squarish, and see how each suggests a different type of person. Then in each oval divide the space into eyes, nose, mouth, eyebrows, cheeks, chin, and hair line. The expression will vary in each oval and with each change of proportions, in other words, with each different design.

The artist can take infinite liberties with the arrangement of the elements of any form. Any change in relationship, no matter how small, affects the expression and the character of a work of art. If an artist has the quality of greatness, his arrangements of elements will produce a living work of art. If he has not these qualities, the results will be the usual meaningless things of which the world is already too full.

Study the drawings in the margin. Each shows the basic design of a head that is a work of art. Even in a simple analytical diagram the expression is revealed, whether realistic, fantastic or abstract.

Pottery Figures. Mexico
Courtesy American Museum of Natural History

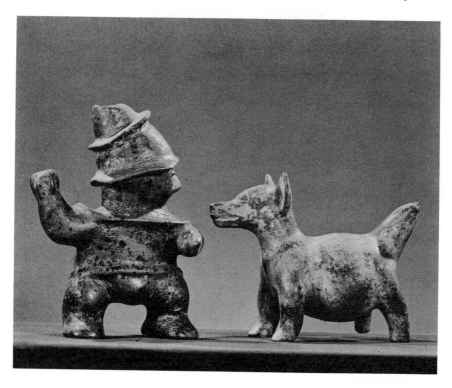

Terra cotta.

The way to preserve permanently a figure modeled in clay is to fire it or bake it in a kiln. It then becomes terra cotta.

When you have worked on a sketch several days, it will have begun to harden; this you control by spraying with water and wrapping with wet cloths. But when you have completed the figure, let it stand uncovered to dry; only watch it that it doesn't harden too quickly. You can control the drying by alternately covering it and exposing it. If it hardens too rapidly it will crack.

After the clay becomes fairly hard, hollow out the bottom so that the clay is not more than an inch thick. A solid mass of clay is difficult to dry and difficult to fire.

The actual firing of clay is a specialized process. I would advise you, if you wish to preserve your figures as terra cottas, to take them to a kiln for firing rather than attempt it yourself.

There are various ways of handling clay for firing. The simplest is to model a figure or group of figures on a stick that is afterwards pulled out to leave a hollow in the center. Another way is to model your mass of clay over a wad of wet newspaper which can be removed afterwards or, if left, will burn out in the firing. Some sculptors fill a small salt bag with sand and tie it over a stick; when finished modeling, pull out the stick and the sand will flow out leaving the head hollow. Solid figures can be fired up to about two or three inches in thickness but there is always danger of cracking.

The Chinese made beautiful little figures in clay, simple and delightful, which were usually placed in tombs. The Greeks have left us the Tanagra figures, the work of humble craftsmen, made for the people who could not afford marbles in their homes. But no marble has more of life, charm, and fragile beauty than these highly treasured terra cottas.

One of the best ways to model a small figure or sketch to be fired is to build up a hollow form of coils, pellets or sheets of clay. When such a hollow form has been built up, it can be modeled with the fingers or tools and finished in the same way as any other clay figure. With experience, human figures, animals and compositions can be made in this way, but it would be best to first try a comparatively simple form such as a head or a torso.

Only the best firing clay should be used; and one must watch the consistency of the clay to see that it is hard enough to stand up, yet pliable enough to be easily handled, and moist enough for the pieces to be stuck together by pressing or pinching, yet not stick to the fingers.

Imagine what would happen if you were to cut a loaf of bread in slices and then remove the soft part of the bread. If you put the slices back together, you would have the hollow form of a loaf built up in much the same way you build up a head with coils. It is very important to have your idea clearly in mind because, with this way of working, you shape the form as you go along and always from the bottom up.

To build a head in the coil method, either cut the clay in strips or divide it into rolls as shown in the illustration. Take one piece, roll it out into a long snake or coil and place it in a circle where the bottom of the neck will be. Pinch the two ends together and let it harden slightly, enough to support the second coil but not too dry to prevent the fresh clay from sticking to it. Clay adheres better to a roughened surface, so each coil should be scratched before another one is added.

Build up the form, coil upon coil, using a shorter coil where you want the wall to go in and a longer one where you want it to go out. As you add coils, one on top of the other, see that the joints of successive coils are not one above the other.

As you build up the hollow form with coils, you merely suggest the general shape of the head and features as shown in the illustration. Let the clay stand until it is hard enough to be modeled further, but still damp enough for fresh clay to be added. Then you can model the head as completely as you wish with the fingers or tools.

Hair and other ornamental details can be braided or modeled and stuck on while the clay is still wet.

If your clay becomes too dry, you can wet it with a cloth or spray it with an atomizer filled with water. In spraying, the finer the spray the

Diagrams showing coil method of building a head

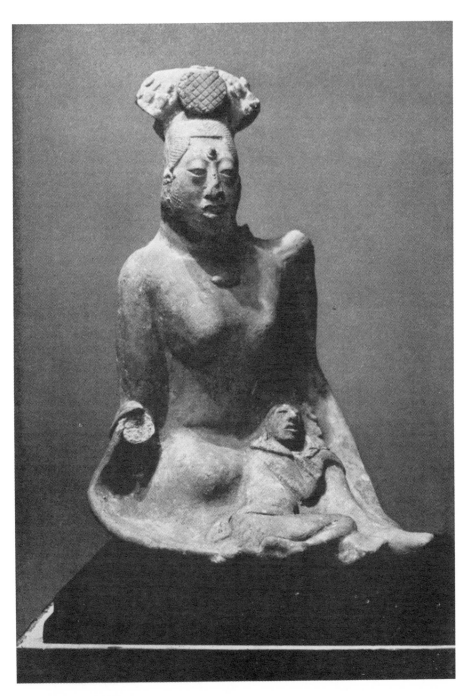

Mayan Goddess
Courtesy Peabody Museum; photograph Sunami

better. The cloth must not be too wet or it will destroy the surface.

When the head is finished it is hollow like a jug. It must be left to dry very slowly for a week or two before firing.

If you wish to make a head or figure by the pinch method, start with a coil at the bottom, but instead of continuing with coils, make round, flat cakes of clay about the size of quarters and build up the form with these much as you would lay bricks; only instead of placing the pellets one above the other, bend each little cake of clay and pinch it on top of the one below.

If you have modeled a head solid and then decide that you would like to preserve it as a terra cotta, you can cut it into two halves with a wire, hollow out each half with a tool and then stick them together again with moist clay. This, if done very carefully, is practical. A tiny hole should be made in the top with a nail or toothpick as an air vent.

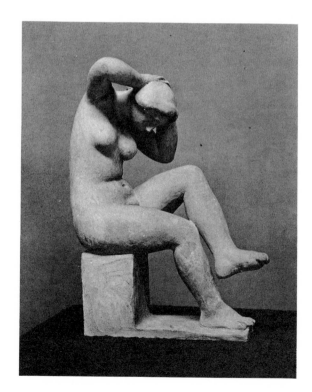

Seated Figure, terra cotta.
Aristide Maillol

*Collection Museum of
Modern Art, New York*

CHAPTER 9.

ON MODELING A HEAD

To the average person, a sculptured head is a realistic likeness of some-one—a recognizable portrait of a person he knows. To the artist, a sculp-tured head is registering in permanent form not only the likeness, which is a surface resemblance, but the spirit and sculptural character of the person. It is the quality of the person combined with the vision and sensi-tivity of the artist that goes to the making of a work of art. The first impact of vision gives the essential quality of a person—the quality that makes him himself, and different from all other people. Each person has a distinct character that goes back eons in its development, not only character of structure but of expression and of spiritual quality. The art quality that goes into a work of art is in retaining that first impact—the revelation.

The secret of the form and spirit is in the silhouette and in the design of the various profiles. To retain this revelation, it is valuable to make quick drawings of the profiles and the front view, as our first impressions are apt to become blurred and lost by constantly looking at the model. Also the model gets tired and bored, the muscles sag, the spirit goes and our work begins to reflect something without life or spirit.

The usual tendency in sculpture is to modify the variations of form in each individual and the result is a stereotyped sort of head. It is better to exaggerate variations. To the sculptor it is not exaggeration but rather amplifying and emphasizing these variations to create and intensify the expressiveness and power in his work so that his conception of the person carries over to the beholder.

Sculpture is a language like music or literature. In sculpture you select, emphasize and arrange. What you have to say has to be clear and direct and said in the language of sculpture. What you decide to leave out is also important, for everything that obscures and does not contribute to the conception must be left out. To use this language takes talent and years of

Sketches by the author
two preliminary drawings for the portrait head "Hilda" and a sketch for "Head of E.G."

training and work, just as a writer or musician works to master his medium. Of course there are exceptions to every rule—but then, they are exceptions.

When modeling anything the size of a head, an armature is necessary to support and hold the clay. Because I feel that every student should know how to make an armature and because an armature can either make or break your piece of sculpture—literally as well as figuratively—I am going into a very detailed description of an armature. You can buy one ready made. But someone has built it for you who knew nothing about what you intend to do, and too often knew nothing about sculpture. The armature you use is going to dictate your forms and proportions. If you make your own armature, you assume mastery of the situation and yourself dictate the forms and proportions you are going to use. This you can never do if you buy a ready made armature.

Before building the armature you must have your sculpture visualized—either from drawings or from a small model—for proportions and silhouette. As an architect plans his building, you must plan and build your armature, measuring everything; for this fundamental construction cannot be changed in any way later. If you think you can plan your head as you go along, you will find yourself in all sorts of trouble and will end up discouraged. In planning a head, I advise just concentrating on a head set on a neck; the neckline terminating where the neck joins the torso.

The usual armature is made of a threaded iron pipe screwed onto a wooden base, or of wood the desired length, about two by two inches thick, firmly nailed or screwed to a base. This base is made of boards—any kind of boards—and should be about twelve inches square. As clay is continually moistened, this base will tend to curl up. To avoid this, it should be made of two sets of boards screwed together with the grains running contrary. Onto this base is screwed a flange and into it is set the piece of iron pipe cut to the desired length. This pipe has a tee joint at the top into which you insert your lead tubing and secure it with a wooden wedge. This is your main support. The lead tubing is wound with copper wire and twisted into a form that will support the clay mass of the head.

To further hold and support the clay, "butterflies" are fastened and

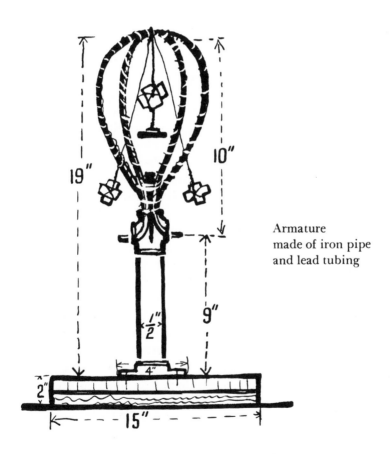

Armature
made of iron pipe
and lead tubing

How to make butterflies. (To avoid breaking wire pull hard with pliers while twisting; give wire a twist on under side to tighten)

hung on this frame. Butterflies are little wood crosses made by cutting wood into pieces about two inches in length by one half to three quarters in width. Two pieces are laid crossways and wired together with copper wire and then wired in different positions to the top of the armature. These butterflies are absolutely essential. Without them the clay will crack and drop away. The important thing is to have everything in the armature strong and, at the same time, have nothing stick out at the wrong places. Here butterflies are an advantage; suspended on wires, they can easily be pushed about and kept away from the surface.

Before applying the clay, the entire armature; base, wire, and butterflies, must be given two coats of shellac. When the shellac dries, start packing on the clay core. Build your approximate base of clay and pack the clay over the armature and around the butterflies, keeping the butterflies as near the outside surface as possible to support the clay. These, if they stick out, can easily be pushed or hammered back. Build up this core from your plan or drawings but keep it rough, poking holes into it with a finger or stick. This core should be allowed to harden somewhat and should not be too soft or it will sag. If it gets too hard, spray it with an atomizer or flit gun filled with water. Clay must always be harder inside than outside, otherwise it will fall apart.

After the core is prepared and has set over night, the mass of clay can be applied more carefully and the silhouette studied. Prepare a pile of clay sausage coils or strips about six inches long and keep them in a small covered garbage can or on a separate table covered with a wet cloth. See that the coils hold and do not break. If they break, the clay is too short or too dry. Keep your modeling stand clear of superfluous clay and tools.

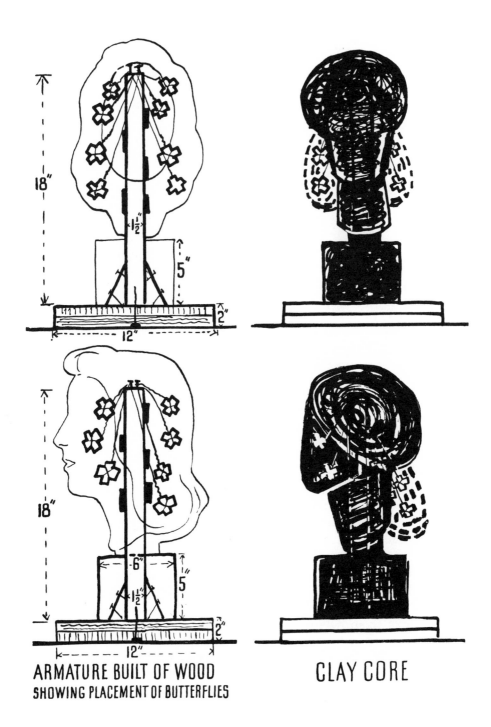

ARMATURE BUILT OF WOOD
SHOWING PLACEMENT OF BUTTERFLIES

CLAY CORE

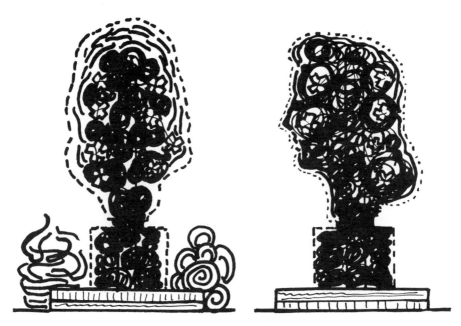

BUILDING PROFILES

It is advisable during the early stages, to work on your head from your idea and from your drawings without the model present; studying your clay model from the point of view of mass relationship, structure, balance and design.

Now study your living model. Pose your model in a proper light. An overhead light together with a side light is best. Build up a profile—study the model from both sides, checking the profile. Build up the front and study the model from the back. Now you have a sort of sectional framework to build on. Let it set a while to harden. Study your model from three quarters view and fill in. Look at your model from all angles; from above, looking down (top of head), from underneath, looking up.

Always keep in mind the big simple forms. Likeness will take care of itself if the basic form relationships are right and the planes well defined. Do not worry about details or finish. Keep the clay in a rough flexible state. Modeling is a matter of continually adding, cutting away, and adding again—continually adding. We can never add enough. Keep this in mind and always allow for expansion in all directions. That is why it is important to have a strong and flexible armature that will allow for growth. Even

as you cut away, the surfaces constantly expand.

As you approach the surface, the clay should be tamped and packed into a solid form. Forms should be worked upon by pounding, cutting and adding. Clay pellets are the accepted way of adding to surfaces as they build up to a desired solidity of structure.

I have discussed the tools used in modeling in a previous chapter, giving careful instructions as to the use of each, and also some important information as to the kind and quality of tools. Do not be misled or disturbed by the great number and variety of tools illustrated. It is well to know about them, what they are and how they are used. A student should have a few of these to begin with; but do not buy many. Begin simply and add tools as you need them. No student need ever be held back in sculpture by a

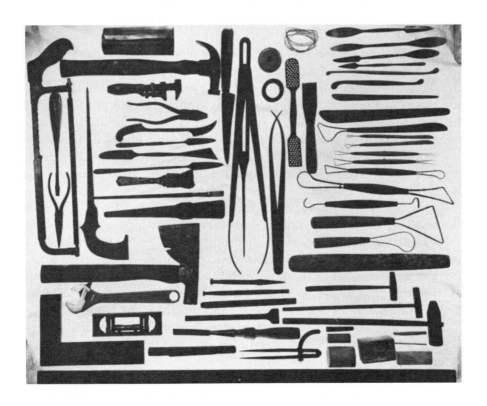

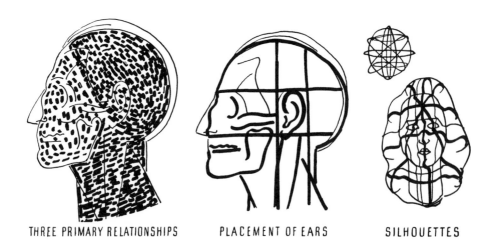

THREE PRIMARY RELATIONSHIPS PLACEMENT OF EARS SILHOUETTES

lack of tools. Let me repeat that the thumb is the first and best tool, with that and a paring knife, a block of wood and a few wire tools, he can always do his work.

Study the living model and study the clay model until you see what you want to carry farther. Study the three primary relationships; the ball of the skull, the column of the neck, and the pyramid of the face. Check the placement of the ears, eyes, nose, mouth, so that they are not too far off balance. No person is absolutely symmetrical. This should not be forced— neither should it be disregarded. Of course if your objective is abstract art, realistic proportions are not a consideration. Rhythm and design are always a consideration before realism but in abstract art the accent is on them without the realism.

The silhouette is important because it gives one a clue to the most important element: basic design. Rodin said that to him, sculpture was a study of thousands of silhouettes—their outlines giving the projections and recessions of form. These silhouettes must be considered from every angle, not just the vertical. The brain is much like a photographic plate; we look and register what we see. We must see intelligently and think about what we see as we let forms register on our subconscious mind.

Within the silhouette there are planes. Everything, a head, a nose, a leg, a hand, has a front, a back, a top, a bottom, and two sides. Each of these sides is a plane. Each plane meets another plane and makes an edge—either a ridge or a valley. It is important to keep each edge sharp and bold because the edge makes the design. The flow and rhythm and relationship to

STUDY OF
PLANES

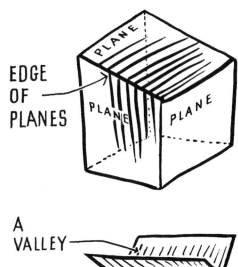

EDGE
OF
PLANES

PLANE

PLANE

PLANE

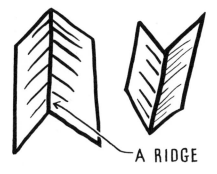

A RIDGE

A
VALLEY

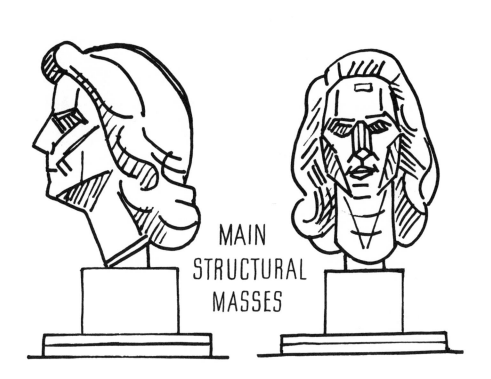

MAIN
STRUCTURAL
MASSES

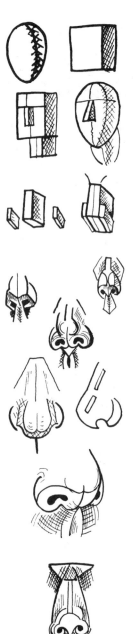

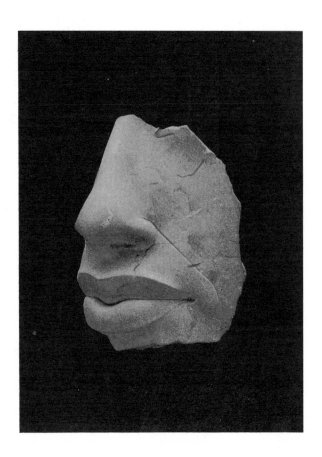

Fragment of the face of Nefertiti, limestone. Egypt
Courtesy Metropolitan Museum of Art

the big structural form is what makes a piece of sculpture convincing. The subject of planes is such an important one that I am including a chapter on planes alone.

After the main structural masses are related and the clay well packed, after the essential planes and essential bony projections are established, we begin to develop the features. Consider the nose as a block—an oblong or a pyramid projecting from the flat or rounded plane of the face. Study the structure of the nose—how it rises from between the brows, from the cheeks, from the upper lip. Notice the form where the bone rises at the bridge and where the muscles are attached. Observe the structure around the nostrils and tip. Note where the different planes meet. Every nose, every feature, is different but the basic construction is universal. This basic construction must receive your first attention. After that it is equally important to concentrate on the differences that make this particular nose individual and the proportions that give it individual expression.

When working on an eye, nose, cheek, ear or chin, never forget the relationship of each feature to the whole. Observe each feature. Note the basic structure of an eye which is a ball set within the folds of the eyelids and protected by the bony structure of the brow. Observe the relationship of the lids, their shape, the changes that come with movement. Note the planes of the lids as they meet the planes of the cheek and eyebrow. Note the construction at the corners where several planes come together forming a characteristic design.

Make drawings to record what you see under different lights and from

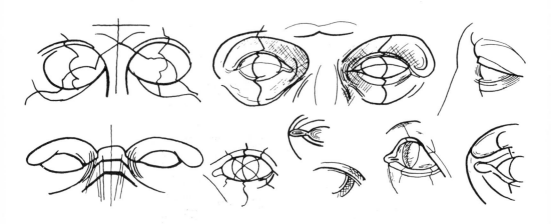

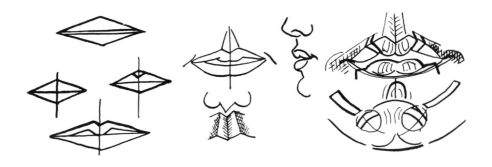

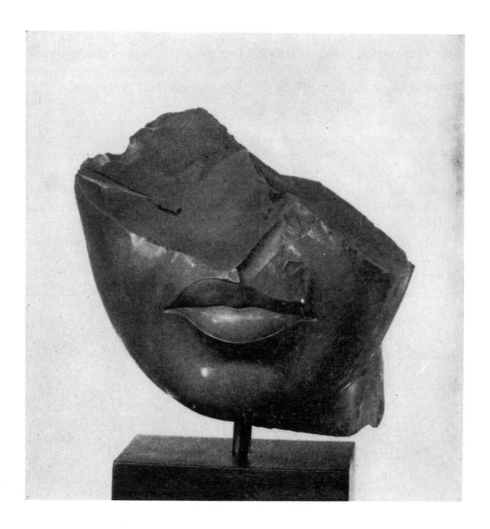

different angles so that you will understand the structure itself and not just the surface appearance. Remember you are not making a map of a face, you are developing a solid form.

The simplest analysis of the mouth is a horizontal line with a pyramid above and a reverse pyramid below. The line dividing this in the center reveals the secret of the welding of the whole human body from two parts. This shows distinctly in the mouth and chin; there the two parts are welded into an inseparable whole. After establishing the planes and the directions of the planes of the mouth, consider the round mounds of the upper lip, the variations of the rounded forms and how they divide in the center. Study the corners and the transition that takes place where they join the muscles of the cheek. The thing that is very important in the modeling of the mouth is to hold the edges and the tiny platform of the edges. It is important to accent the form and character of this most expressive feature.

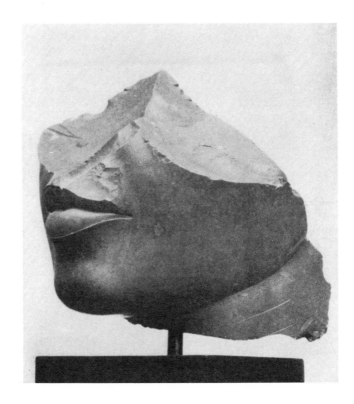

Fragment of a head
of Nefertiti. Egypt
Courtesy
Metropolitan Museum of Art

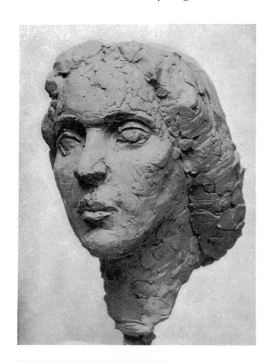

Modeled head, early stage

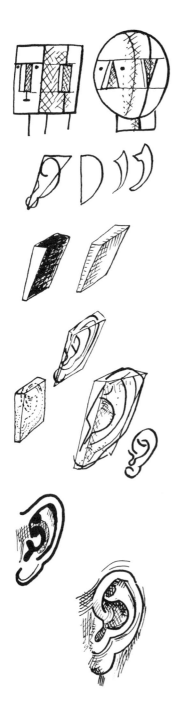

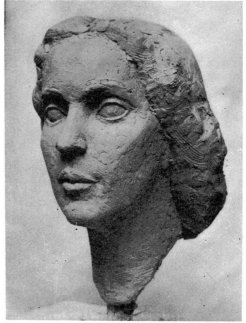

Modeled head, later stage

The two most difficult things for a student seem to be the placement of the ears and the construction of the jaws. Ears are variously placed in nature but usually the top of the ear comes on a line with the eyebrows and the bottom of the ear on a line with the bottom of the nose and continues the line of the jaw. Study the distances and spaces. There seems to be a natural tendency to crowd ears forward among the other features losing the three dimensional base of the head. Once this is established and the plane of the ear built up—it is simple to draw the design of the ear with a sharp tool and cut in the various planes. This cutting down process is much more satisfactory than building up the entire ear with pellets. The pellets are valuable for developing and giving volume to the form.

Sculpture usually finishes itself. The sculptor comes to a point where he can go no farther or where further work is just marking time. The best way to kill a surface is to continue to smooth out the form endlessly. The edges of the planes should always be held sharp until the very end when they can be blurred or softened here and there as desired.

The final surface, usually built up of pellets, can produce a lovely hammered quality. If these pellets have not been tamped down the surface has a lively, stippled effect. This can be left (as in Epstein) and give a molten effect in bronze. Or it can be tamped down into a smooth but still lively surface (as in Despiau) or it can be smoothed completely (as in Brancusi). Any of these surfaces become monotonous if the clay is too methodically applied. Many sculptors like to cast a rough clay model in plaster and then work on the plaster with rasps and sandpaper. Or they may file and buff and polish the bronze after it is cast. Or they may prefer not to touch the surface after they have finished with the clay.

It must always be remembered that there is no attempt on my part to impose a formula. The diagrams are made simply to pave the way for further study of each problem. I am not trying to direct genius but merely to aid the student who is anxious to acquire information, so that he will not have to struggle blindly but will know how to acquire knowledge.

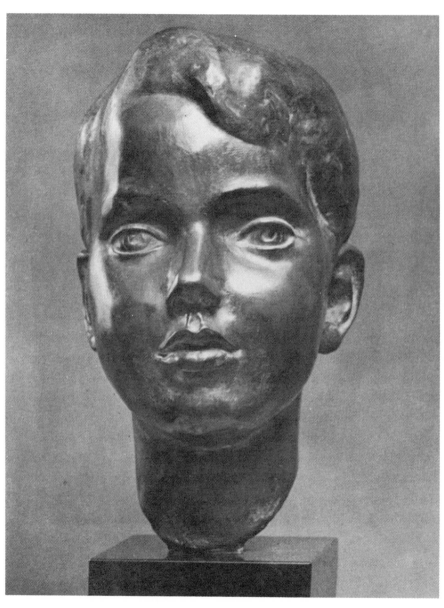

Basil, bronze. William Zorach

Photograph Walter Russell

CHAPTER 10.

THE STUDY OF PLANES

Everything has a top, front, back and sides. These surfaces or planes are what give shape and form to anything whether it is a box or a head, a figure or a foot; or any part or whole of a figure, animal or abstract design. The sculptor must learn to observe the direction and shape of these planes. He must see where they come together and how they meet—whether in a ridge or a valley. Many people do not see in terms of planes, but the fact remains that it is the formation and relationship of planes that give any object a feeling of solidity and volume.

Begin with simple objects. Look at a box placed in different positions as in Fig. 1, on the next page. Notice how each surface or plane has both a well defined shape and a definite direction. In the lower box the front plane is a rectangle and it has two directions, that is, it extends up and across. The end plane is also a rectangle, although it appears as a diamond shape in the diagram because of the angle at which it is drawn. This plane also has two directions, up and back. The top plane, again a rectangle seen in perspective, extends back and across.

Carefully observe the planes of the two upper boxes and note how a shift in position changes the direction of each surface and how the general directions of the planes give the forms themselves a definite direction in space, as indicated by the arrows.

In Fig. 1, wherever two planes come together they form a ridge—at right angles to the box. You will realize that the character of each edge is as important as the direction and shape of the plane itself. Bear this in mind always, because in sculpture you are not dealing with lines and tones, as you are in painting, but with ridges, planes and volumes. You cannot portray any form until you understand the character of each plane and the shape of the edge where it meets another plane. You cannot make a sculpture of a box without understanding the character of its edges and sides, or planes. You may not realize that you are thinking in these terms

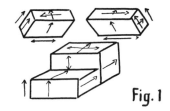

Fig. 1

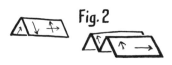

Fig. 2

Fig. 3

Fig. 4

Fig. 5

Fig. 6

because it is so obvious that any block of clay or wood or stone which portrays a box must have the same relationships that a box has. It must have flat sides that come together at right angles. I used this example simply because it is so obvious.

Planes do not always form ridges, as they do on the outside of a box. Often they meet in grooves or valleys, as in Fig. 2, which shows how two planes may rise to meet in a ridge and how a succession of planes can ascend and descend to form a valley between the two ridges.

Some planes are curved rather than straight. As shown in Fig. 3, a curved plane always has a definite direction in space. It may be in and out (as at right) or up and over (as at left). Such planes are active forces in any structure and the degree of curve and direction of movement are important factors for expressing form.

Compare the next two diagrams. In Fig. 4 there are three simple straight sided shapes which, because of the direction of the planes, draw the eye to the distant point where they converge. In Fig. 5 you will see how the arrangement of both curved and straight planes gives a feeling of forms going back into space. The small diagram of a man at the right indicates the angle of vision.

The plane structure of these simple forms is analyzed in Fig. 6. Each shift of position causes a change in the relationship of planes as seen from one angle. Four pillbox forms have been drawn in Fig. 7 to show the variations in direction of curved and flat planes when the same object is shifted and tilted at various angles. A curved plane carries the eye in the direction of the curve while a

Fig. 8

Fig. 7

flat plane usually suggests more than one direction because it can be interpreted as carrying the eye either across or back or at a diagonal. The force of direction is stronger in a curved plane than in a flat plane.

Look carefully at Fig. 8. Simple curved planes have been placed within converging forms to show the change of direction due to different positions in space.

You will learn to observe more complicated form and to both see and feel the planes that compose it and define it. Look at a human head; realize the multitude of planes. Each contributes to the total form by its placement, its shape and its direction. To analyze the basic forms of the head, observe the relationships of the sphere of the skull to the angular block of the jaw, and observe the proportions, shape and characteristics of each part. Try to find and see the planes which give a distinctive shape to each mass. The more you look, the more you will see and the more you will understand what it is that you see. In time you will find that you can use this knowledge to recreate in clay or stone the form you have observed.

Because the texture of the skin is soft and the contours appear rounded, you may at first have difficulty in seeing where planes meet to form ridges or valleys. Try to visualize each plane as a simple unit with edges or valleys where adjoining planes meet or intersect. These are just as important as the direction of the plane itself because they reveal the actual form of the planes. In one sense the ridges and valleys are the actual design structure of a piece of sculpture.

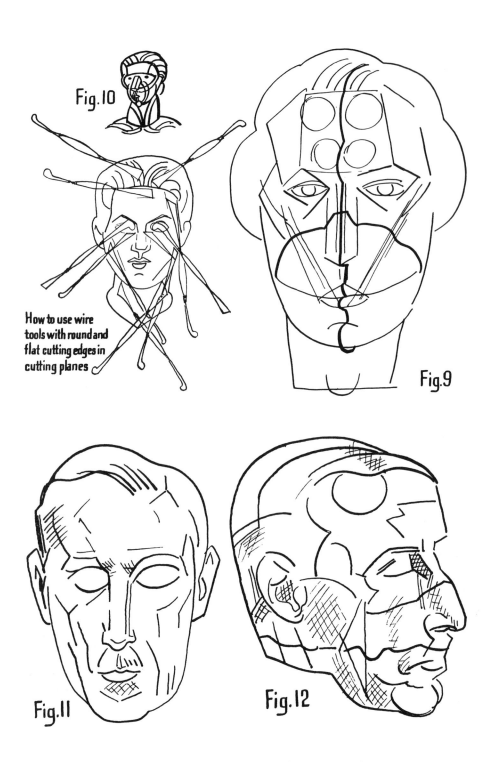

Fig. 10

How to use wire tools with round and flat cutting edges in cutting planes

Fig. 9

Fig. 11

Fig. 12

A study of silhouettes will give you a key to the plane structure. Draw imaginary cross sections as I have done in Fig. 9. Notice how the vertical silhouette down the middle of the face begins at the top and shows the curved plane of the hair, then the curve of the forehead between the two rounded planes of the upper forehead. (Feel these on your own head and observe on others how the light catches them to form highlights there.) Then it shows the valley intersection of that forehead plane with the curved plane of the frontal bone of the nose. The silhouette then follows along the plane of the nose, back at the tip, down the lip, around and in with the upper lip, out with the lower lip, back in with the curve leading to the chin, and out and around the curved line of the chin itself.

Then, in the same way, follow the forms indicated by the cross section line that cuts across the bridge of the nose, goes down at the side, across the cheek, around to the back in a shallow curve that pictures the plane of the neck at the base of the skull.

Look at Fig. 10 where I have indicated the direction of some of the major planes. Note how the planes of the hair are curved and extend up and back, while the main front plane of the forehead goes across to meet the plane of the temples. These in turn lead to the curved planes of the

cheek bone area which intersect the planes curving down at each side of the mouth. Observe the simple planes of the nose, lips and chin. Then notice how the forms of the neck are broken up by planes that define the underlying structure of it, just as do the intersecting planes of the shoulders around the collar bone.

This is, of course, only a suggestion of the multiplicity of planes that form the structure of the human head. But if you become aware of these general plane areas, you will begin to feel the form more clearly and be better able to construct in sculpture the relationships that you find in nature.

Always keep in mind that the important thing is to locate the big structural forms which the planes reveal before considering the minor planes or forms.

Figures 11 and 12 are studies for a head. These show how notes are made of what is seen in looking at a head as a whole and in observing details. On the side view sketch you will see in cross section, silhouettes drawn to help the sculptor remember the form he has observed.

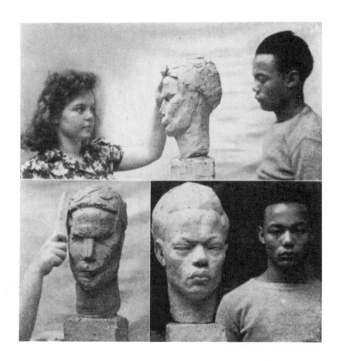

CHAPTER 11.

HEADS IN ART

A man working in a wilderness who had never seen a work of art might, from an innate genius and desire, produce a work that was beautiful and original. But as far as art influence is concerned, none of us today live in a vacuum. Our minds and eyes are continually assaulted by a conglomeration of commercial tripe that passes for art among many people. With modern means of communication and with the great variety of publications, we cannot exist without seeing the works of others, past and present. If we learn to know and to like good sculpture, our sculpture will be better. If our taste is poor and we admire the worst examples of sculpture, naturally our taste will be reflected in our art. It is important to study the finest examples of sculpture handed down through the ages and also to be aware of what is being done in art today in the world about us.

Many think that all work done in the past must be good, especially if it has survived the test of time and has been preserved in museums. All the work handed down to us has not been good and many works in museums are not masterpieces. Art appreciation develops and changes, many of yesterday's masterpieces drift down into museum basements, but certain things remain and are always an inspiration. In order to distinguish which are great and enduring works, we have to have intuitive taste and developed discrimination and understand the language of art.

The African Primitives have made extraordinary heads, using proportions and form as design to convey a great spiritual power. In these heads there is no sense of the flesh, almost nothing of the physical. It is the expression of the spirit in human existence with all its power, terror and mystical awe transcending the flesh. Study these heads for the purity and power of expression, for the amazing liberties they take with the human form to create this expression; for the unimaginable selection of form for emphasis and the amazing fertility of design and proportions.

In the Egyptian heads there is also a great simplicity and a marvelously

African Mask
Photograph Charles Sheeler

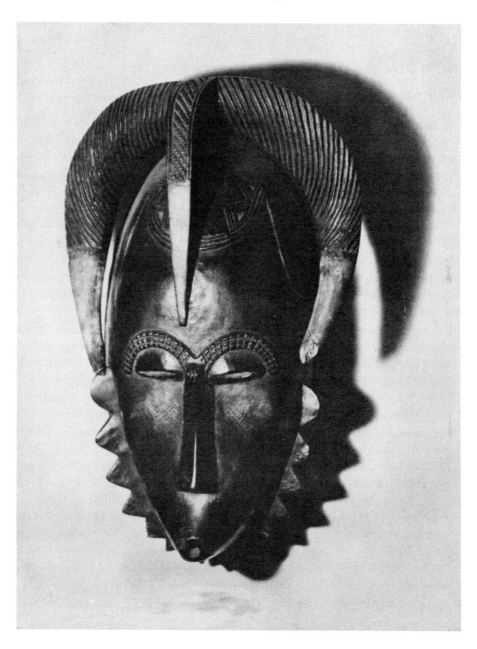

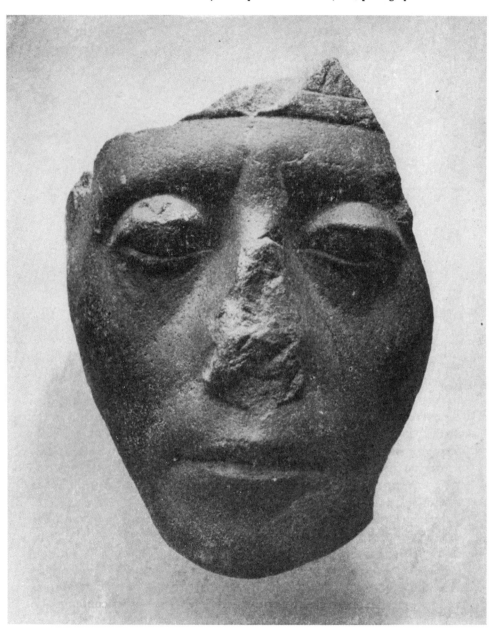

Se'n—Wosret III, quartzite. Egypt, 1887–1849 B.C.

Courtesy Metropolitan Museum of Art; photograph Charles Sheeler

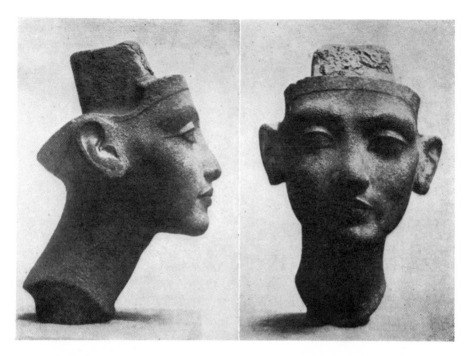

Queen Nofretete. Egypt, about 1370 B.C.

compact and unified conception of form. This too is a spiritual art. It is directed to the things beyond this world; eternal values and a belief in the continuation of life. Here is an uncompromising severity and purity of form; an intensity of purpose; life held to conventions but transcending them spiritually. There is sensitivity as well as power. The forms and relations of forms have a perfection that is not just craftsmanship but the highest art expression.

In the East Indian and Cambodian heads there is a great human quality as well as the spiritual withdrawing from the world. Here is a racial beauty of expression, a blending of flesh and spirit. To us the simplicity of these heads and the peculiar interest of their forms, is a never ending wonder. Here we have absolute simplicity without severity. This is an art of peace and acceptance; an art at ease with itself and secure in its contemplation of life.

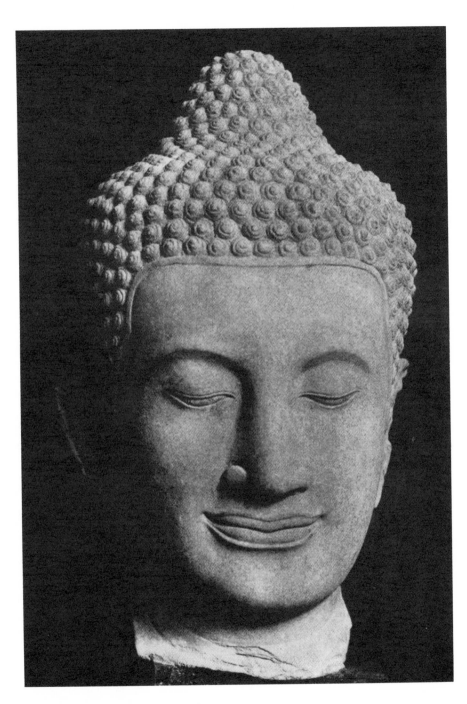

Head of Buddha, stone. Khmer

The Chinese have done heads, greatly human and greatly spiritual. There is warmth and sweetness in them as well as an impersonal quality.

Mesopotamian heads are heroic in the power of their expression. In them we feel a people's conception of divinity.

Archaic Greek heads have a design quality of loveliness and charm. The gods on Olympus are being forgotten in their pleasure in the human qualities and aspects of the God in man.

The later Greeks had a most highly developed sculpture but the spirit was forgotten and all concern was with the flesh, and even further with a perfection of surface beauty that is neither human nor spiritual. It is amazing how, in spite of its sculptural perfection, every Greek head of this period says the same thing to us in the same words. The surface remains, but life has been lost.

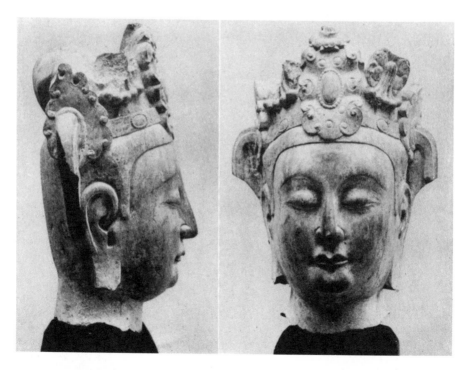

Head of Bodhisattva, black marble. Chinese, sixth century
Courtesy Metropolitan Museum of Art

Head of a Youth, marble. Greek, sixth century B.C.

Courtesy Metropolitan Museum of Art

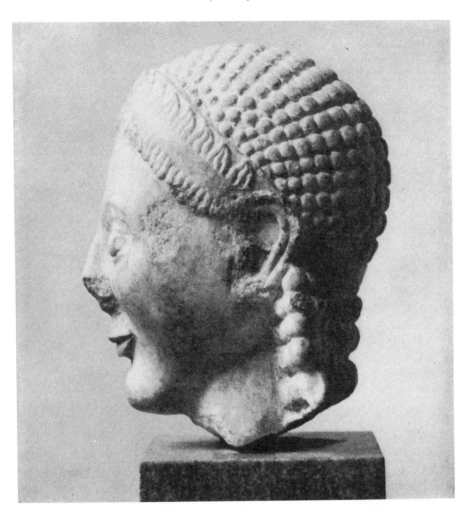

These ancient peoples before the Romans almost never made heads for themselves alone. The heads we treasure were once all attached to bodies. True portraiture began with the Romans. These people had no originality and little understanding of the Greek work they were content to copy. They produced just about the worst sculpture that has ever been done and their influence was responsible for the bad sculpture of the eighteenth and

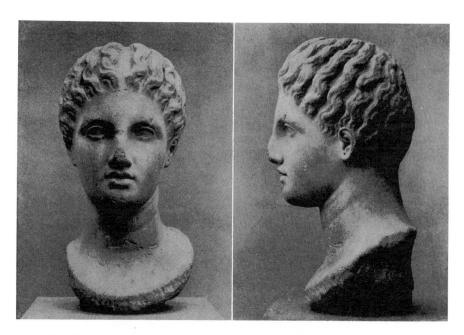

Head of a Goddess. Greek, early fourth century B.C.
Courtesy Metropolitan Museum of Art

nineteenth centuries. And yet the Romans produced the most marvelous portraits of men and women that have ever been done in sculpture. It may have been technique acquired from the Greeks combined with an appreciation of human beings as individuals, not as gods or ideals; a penetrating realistic interest in men and women. These portraits were done without any attempt to glorify the subject. The Romans were happy to make the man as he was. In this respect they are different from all other portraiture. Whether or not the people sculptured were happy to be sculptured as they were, we don't know. In spite of the occupation with realism there is no over-concern with detail. These portraits have great simplicity and extraordinary character and expressiveness. You look at a Roman head and you see not only a work of art but you see a man and you know him for just what he was, not what he wanted to be.

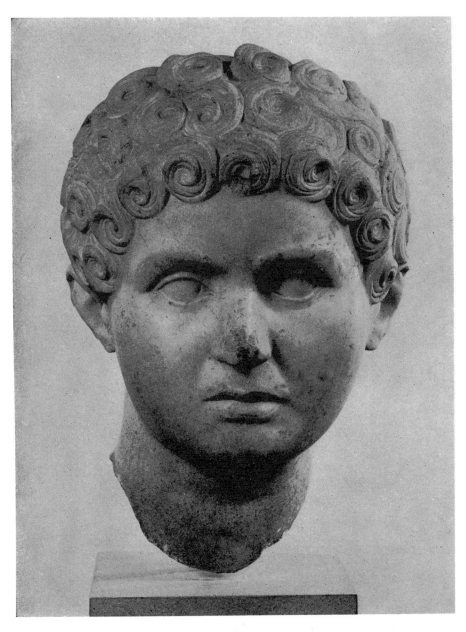

Portrait of a Woman, marble. Roman, first century A.D.
Courtesy Metropolitan Museum of Art

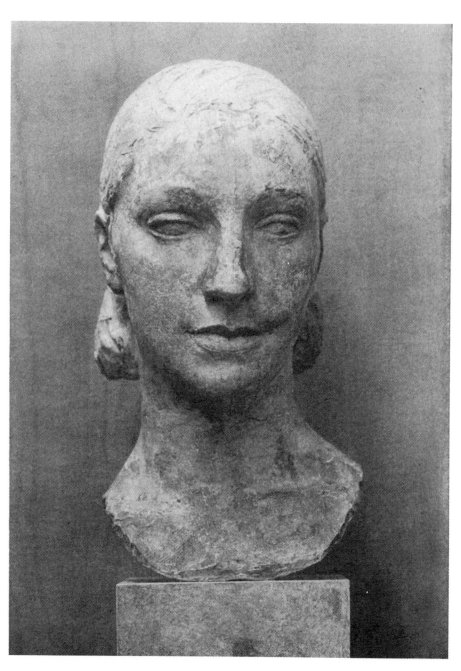

Mlle. Jeanes, plaster. Charles Despiau
Collection Museum of Modern Art

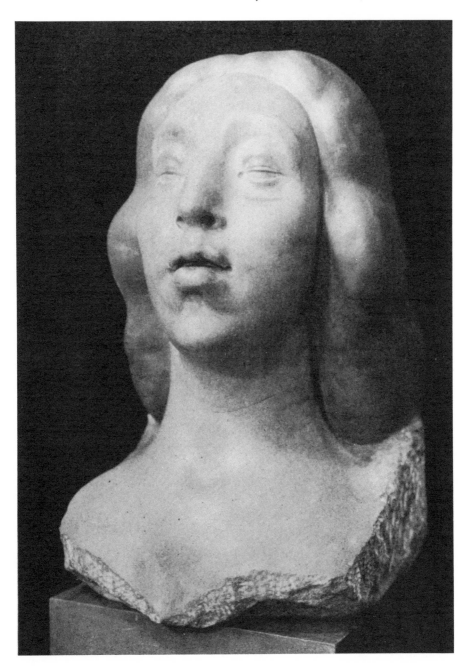

Head of Christ, black granite. William Zorach.
Collection Museum of Modern Art

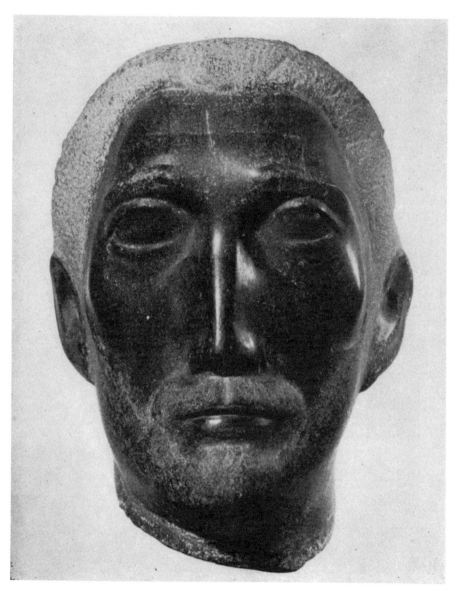

In contrast, Houdon, who retained all the over-concern with detail that burdened eighteenth century sculpture—the absorption in external textures, the concentration on surface disturbances—was a great sculptor. Basically his work is sensitive and sound. Underneath the superficial finish, the fundamental principles of form and design, rhythm and expression, are as firm and powerful as in any work of art.

Ideas in art change. Rodin, who was almost a god to his generation, is almost forgotten in our world today and his way of expression does not excite us. Yet he was a great sculptor. His portraits of people are fluid, alive; marvelously modeled heads.

In our time we have Epstein and Despiau. Epstein's bronzes have a great power and strength. He keeps his modeling in the rough, flexible, alive state which, interpreted in molten metal, retains the flow of the metal and the creative fervor of the artist. Epstein's sculpture is very personal in feeling and execution. The work of a real artist is usually fifty per cent himself and fifty per cent the sitter. With Epstein, I would say it is seventy-five per cent Epstein and twenty-five per cent the sitter. Although these are powerful portraits, one does not think of them as portraits but as works of art.

Despiau has perhaps done the most beautiful portrait heads of our time. Here we feel a real artist at work and at the same time we are absorbed in the personal quality of the person portrayed. Despiau himself, has written: "When I begin to analyze a head my aim above everything else is to discover the essential rhythm of it, to master the relations of the various parts, and to tie the one to the other by true transitions. I force myself not to describe such or such a picturesque detail, or such a state of mind, to realize the harmony among the sculptural elements." In this way Despiau translates into his work that inner energy from which this extraordinary life is derived, which endows each portrait with a vivid personality.

Discussing the head of Mme. la Comtesse Gilbert by Despiau in a lecture on contemporary sculpture, Professor Hudnut said: "By a searching concentration upon the structure of head and face—as if the head were a piece of architecture made up of vaults, walls, and openings—and by the forceful summation of this structure in clay—the planes accurately established, the important accents and transitions vigorously marked—the sculptor recaptures the underlying and formative order of his model. Accessories, costume, treatment of hair, may be simplified; the character remains."

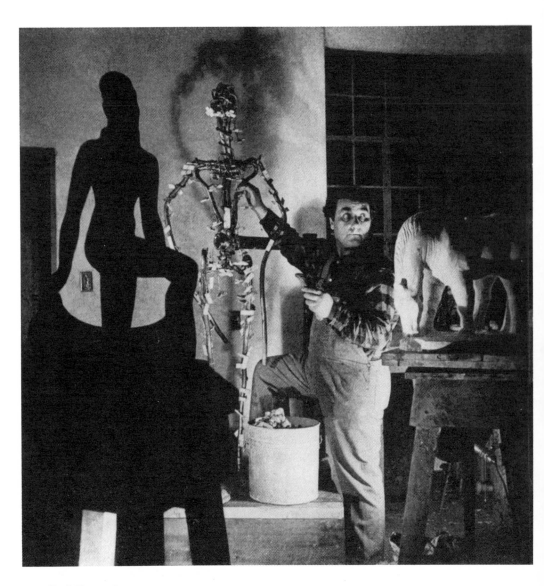

Building a figure on an armature
Photograph Walt Sanders, Black Star

CHAPTER 12.

BUILDING A FIGURE IN CLAY

The construction and building up of a figure in clay.

If we are considering modeling a figure as a work of art and not as a study we must start with the assumption that some human figure has impressed us so strongly with its beauty as to compel us to undertake to express in form our impression of that beauty. Or that some human figure has so moved us that we must express its meaning to us in the language of sculpture. Or we may be in the grip of an idea that we wish to express through the human figure, merely using the model as reference material.

But in this chapter we will only consider building up the figure as a study. If we have no pose in mind we try the model in different poses. If a model has a sense of rhythm, moves gracefully and easily, it is much simpler for us. A model who has studied the dance usually falls naturally into expressive and sculptural poses. I suggest choosing a simple standing pose, one that is not strained or affected or difficult to hold; one that looks well from all sides and is expressive of some simple gesture. It is important that the model stand on a turntable that can be turned so that the form can be studied in different lights. Begin by studying the model from various angles and lighting, turning the model and also walking around her.

As with a head make a number of drawings or designs expressive of the model from different sides. If you wish, make small sketches in clay for proportions and design. From them you can plan the architectural base of your armature, its directions, proportions, and relative measurements. A simple armature can come straight up between the legs. This is very valuable for over-life-sized figure or draped figures. But this kind of armature makes it very difficult to develop the movement and form in a nude figure. The most useful armatures for figures are supported by an iron pipe set in a flange on the base outside the figure with an elbow penetrating the figure at either the small of the back or the hip. In planning

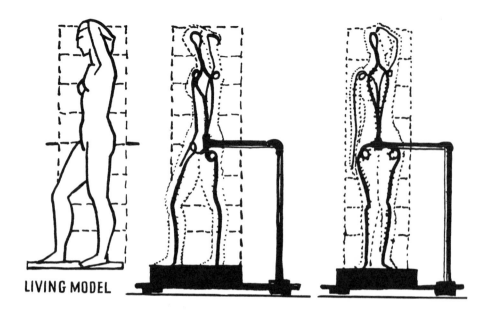

LIVING MODEL

this support, allowance must be made for a substantial clay base upon which the clay figure will stand. This is very important for it will give you some leeway if you have to lengthen the legs. You can always build upwards but you can never go below your wooden stand. Your armature dictates your proportions; that is why it is so important to plan the measurements carefully. One point to remember is that the iron pipe should project into the exact center of your figure above the clay base.

I suggest arranging to have the armature come out of the side of the figure as near the hip as possible. This avoids destroying the important juncture of the spine at the pit of the back and pelvis. Always allow for the extra height of your clay base in making measurements for your pipe. Make a base of wood—one set of boards over another running in opposite directions and screwed together and shellacked. Make a careful diagram with exact measurements of the required pipe and lead. Give this to a plumber. He will cut the pipe and supply you with a tee, elbow, joints, etc., and a flange to fasten the pipe to the wooden base. The strength and size of the material will vary according to the size of the figure you plan.

The usual school study is about twenty-eight inches high above the clay base. This gives about thirty-two inches from the board to the top of

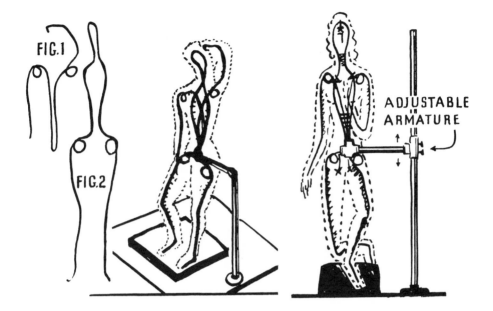

the figure. In addition to the iron pipe you need two pieces of lead tubing; one will be fifty-four inches long bent as in Fig. 1; this will support the arms and shoulders. The other will be six feet long and bent as in Fig. 2; this will be the support for legs, head and torso. Study the diagram Fig. 3, for placement and arrangement of lead to fit on the iron pipe. After the lead is set in place, wind it with copper wire and shellac everything.

For life-sized figures the lead tubing is reinforced with wooden slats where the form is thick, or with wads of burlap and plaster thoroughly shellacked. Butterflies are strung on copper wire and fastened to the lead wherever needed to support the clay. In building an armature always allow space for flexibility, especially of moving parts of the figure and for the joints. Remember your figure will fill out and continually grow thicker in every part.

After you have established your armature you will see how important it is that you have the proportions you want. Once these proportions are established it is impossible to change them without starting all over again. Your armature dictates your proportions and it is up to you whether you want these proportions to be realistic, decorative or fantastic.

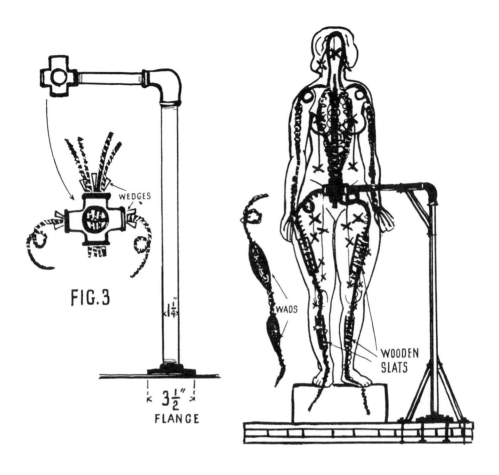

FIG. 3

WEDGES

WADS

WOODEN
SLATS

$3\frac{1}{2}''$
FLANGE

$1\frac{1}{4}''$

To go ahead with our figure we follow the same routine as in modeling a head. Our clay has been prepared in coils or rolls and we begin by winding these coils around the armature, always looking for the projection of forms and keeping in mind the silhouette. Pack the clay in; always let the inner layers harden before adding outer layers; otherwise the clay will fall off. Keep your surface rough.

Once your masses are established, your figure built up and your clay well packed, you begin to study essential construction. Establish the center of the figure, front and back; the correct slant of the pelvis and the projection of the hip bones. Be sure your figure is balanced and the weight supported by the legs and feet—not suspended in air or dangling from an armature. A plumb line may be of help in this.

Establish the center of collar bones.

Establish the basket of ribs.

Establish knee caps and ankle bones, elbows and wrists.

In the back, establish the spinal column, shoulder blades and neck.

Check bones and muscles of the legs, chest, thighs and neck; find where they join, where they go, what they do.

In studying the chest and back have your model lift up his arms, notice how the form of the basket of ribs connects with the back. This is important to unify the torso.

Remember that as a student you seek information. Art is something else. But information is a tool we need to be able to create sculpture.

Once the vital elements are established the important thing is to develop all the parts and relate them as solid form. Now it is a question of rhythm of planes. Form should flow in and around smoothly as does a macadamized road; not like a country road full of ruts and holes. The more perfectly a form conforms to its function the more beautiful it becomes. A sea gull is beautiful in its flight. A wave is a beautiful form. The

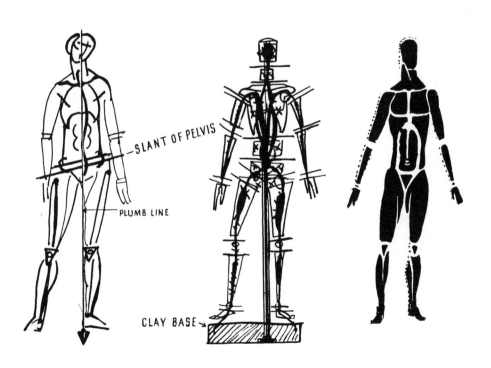

SLANT OF PELVIS

PLUMB LINE

CLAY BASE

taut muscles of a running horse, the movements of a man working are alive with beauty. A stick is round but has no essence of a beautiful form, but a tool made by a craftsman can be a marvel of form. In modeling a head or a body one must develop a beauty in the form. An arrangement of abstract form may be beautiful. Even the sordid and ugly in life may be beautifully expressed.

To return to the study of the figure in detail. Take the shoulder—you will notice the back, the shoulder blade, has a high point in the form of a pyramid. Establish this high point. Establish the valley where the muscles of the shoulders meet.

Find the highest point of the spinal column and trace the spinal column down to the pelvis where you will find an interesting design shaped like a heart or triangle.

Study the shape and form of the buttocks. You will find they are round but composed of both flat and round forms.

Remember always that the body has thickness, that every part has a front, a back and two sides.

Remember that muscles are built up in layers. Find out where muscles are fastened; where they flow in and around the back.

The collar bone is not a straight bone but is an S in shape which connects the front or chest with the shoulder blades and arm bones.

Stomach muscles have pattern and design.

Leg muscles have pattern and design.

It is important to learn the construction of the wrists and hands, feet and ankles. The foot should be treated as a cone and the toes as five cylinders with slight variations and divisions into joints. An anatomy book and a skeleton may make the construction of a foot and ankle easier to understand. In the ankle the outside bone is lower than the larger inside bone.

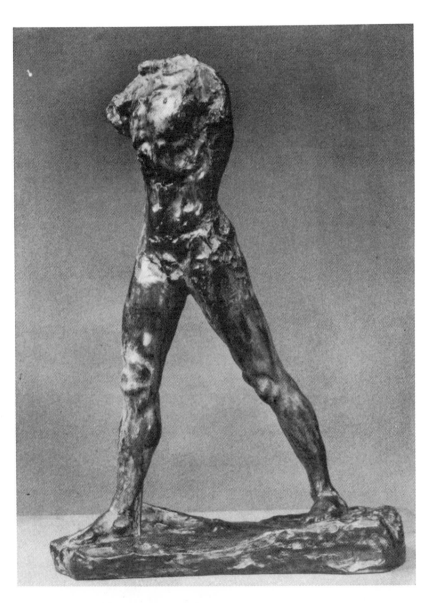

Man Walking, bronze. Auguste Rodin
Courtesy Metropolitan Museum of Art

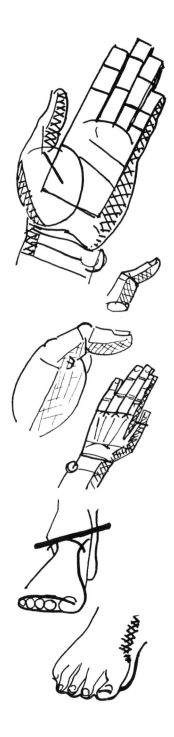

Feet, bronze. Roman

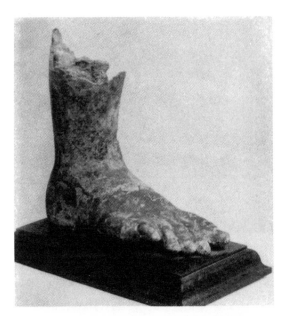

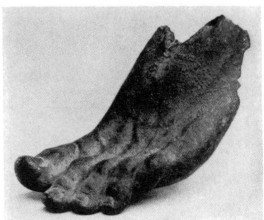

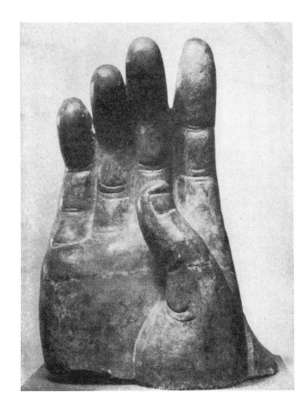

Hand, granite.
Chinese, T'ang, 618–906
Courtesy Metropolitan Museum of Art

The form and construction of the knee are very important and should be studied from the point of view of the design of the muscles, the movement of the knee cap and the sharp planes of the shin bone.

Remember always to allow space for the flexibility of the joints of the wrists.

Allow for the ball and socket movement of the hand where it joins the lower arm.

Treat the hand as a simple flat plane and the fingers and thumb as five cylinders or oblongs of different lengths divided by three joints. This will simplify the modeling of the hand and make it possible even for a beginner. A hand always seems such a problem for beginners. But no one part of the human body is more difficult than another if we grasp the fundamental structure.

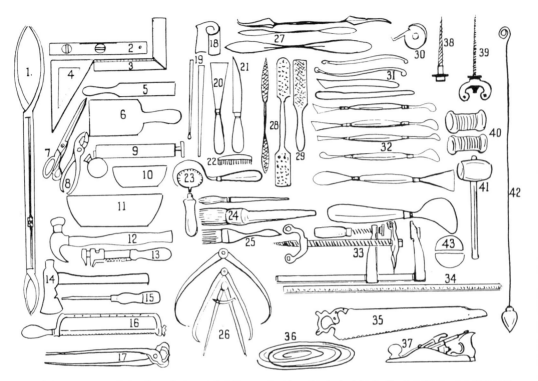

ESSENTIAL TOOLS FOR MODELING IN CLAY AND PLASTER CASTING

1. Proportional calipers
2. Spirit level
3. Square
4. Triangle
5. Clay paddle
6. Hardwood paddle
7. Scissors
8. Pliers
9. Flit gun
10. Flexible brass plaster bowl
11. Basin for mixing plaster
12. Claw hammer
13. Wrench
14. Hatchet
15. Screw driver
16. Hack saw
17. Pincers
18. Mould dividing brass
19. Mould chipping tools
20. Mould separating tool
21. Plaster knife
22. Small wire brush
23. Plaster tools
24. Plaster casting brushes
25. Shellac brush
26. Curved calipers and compass
27. Plaster spatulas
28. Plaster rasps

29. Large wire brush
30. 72 inch spring rule
31. Boxwood modeling tools
32. Steel and brass modeling tools
33. Wood carving clamps
34. 3 foot yardstick
35. Saw
36. Lead tubing
37. Plane

38. Lag screw
39. Bench screw
40. Rolls of copper wire
41. Wooden mallet for chipping moulds
42. Plumb line
43. Small rubber ball cut in two for mixing small batches of plaster

The care of the clay model.

It is important to keep a clay model moist while working. At the same time it is important not to keep it too moist. In the beginning the core should be left uncovered for a few hours or even over night until it sets. After that it is kept covered with a damp cloth when not working. Each day your clay will be a little harder. The rapidity of drying will depend upon the temperature of the room and the size of the mass of clay. You must learn by experience how moist to keep your clay and how often to spray it with an atomizer. A flit gun filled with water is good—anything that gives a very fine spray—the finer the better. A fine spray settles all over and penetrates. Water should never run off the model and the model should never be moistened enough to blur the surface. Never wrap your model in a soaking wet cloth.

When you have finished working for the day, spray the model lightly. Dip a cotton flannel cloth in water, wring it out so that it is just damp, and wrap it around the clay. Wrapping a wet cloth directly around clay will destroy the surface form. Poke nails or pins or strong toothpicks cut in half, into the model at all high points so that the wet cloth will not rest on the clay. Another good way is to bend a rather stiff wire and fold it over the model directly over the profile and sides before wrapping. After the damp rag is wound around the model, carefully wrap the whole in oiled silk, rubberized cloth, or oilcloth. Oiled silk is best as it is light as well as airtight. Or you can build a framework, cover it with oilcloth tacked in place, and set it over the model. This makes an airtight chamber, and the model need not be wrapped. Keep the model away from radiators and have the room as cool as possible when not working. On the other

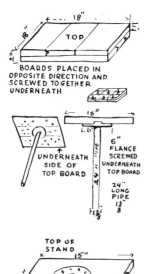

BOARDS PLACED IN
OPPOSITE DIRECTION AND
SCREWED TOGETHER
UNDERNEATH

18"
TOP

16"
6"
FLANGE
SCREWED
UNDERNEATH
TOP BOARD
UNDERNEATH
SIDE OF
TOP BOARD
24"
LONG
PIPE

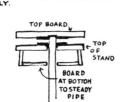

TOP OF
STAND
15"
6" FLANGE

6" FLANGE FILED FLAT
THE THREAD MUST BE FILED OUT
TO LET PIPE REVOLVE SMOOTH-
LY.

TOP BOARD
TOP
OF
STAND
BOARD
AT BOTTOM
TO STEADY
PIPE

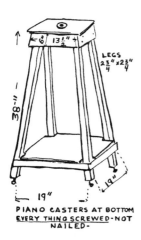

LEGS
2¾"x2¾"

13½"

38"

19"

PIANO CASTERS AT BOTTOM
EVERY THING SCREWED-NOT
NAILED-

Drawings for modeling stand

hand never allow your clay to freeze. You should be able to leave a model that is properly wrapped or in an airtight chamber for three or four days under normal conditions; after which it should be examined.

Each day you find your clay model a little harder, but it should not be too dry or too wet. If it is drying, spray it. If it dries too much while working, also spray it; and before wrapping it and putting it away, spray it again. If it is too wet, just leave it uncovered until the excess moisture disappears.

Care must be taken that the model will not be moved, touched or bumped. One false move by an inexperienced person may destroy your work.

The clay model should be kept damp until you are ready to cast it. The reason for keeping clay moist is that clay shrinks and cracks in drying. It should not be allowed to get too hard before it is cast because it has to be dug out of the mould after casting.

How to make a modeling stand or turntable.

You can work with clay on a simple work-table—any sturdy table will do, but it is better to have a modeling stand or a turntable. This you can either buy or make.

The simplest type of turntable can be made by putting a bolt through the center of two square boards that have been greased so that one will slide over the other when it is turned on the bolt axis. This can be used on top of a work table or it can be mounted on legs and made into an independent modeling stand.

The board used for the top of either a turntable or a modeling stand should be made by screwing together two sets of boards, the grain of one running at right angles to that of the other. This is to prevent warping from the moisture of the clay.

When making a modeling stand, the top board should have a metal flange fastened underneath at the center so that a length of pipe can be screwed in to serve as an axis. The top of the stand serves the same purpose as the bottom board of the simple turntable. A hole is bored through the center of it and another metal flange is fastened on top so that it will meet the bottom flange underneath the top board. This second flange should be filed flat and the threads in the opening should be filed down so that the pipe will turn easily when it is thrust through this opening. The top of stand is mounted on sturdy legs well reinforced with cross pieces. A third board should be placed below to steady the pipe.

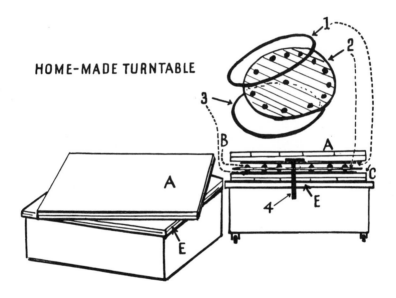

HOME-MADE TURNTABLE

Home-made turntable for life sized figure or stone.

1. Iron fifth wheel screwed to bottom of upper board A
2. Round $\frac{1}{4}$ inch three ply board with holes into which ball bearings fit B
3. Iron fifth wheel screwed to bottom board C
4. Iron flange and pipe screwed to bottom center of upper board A—penetrating hole in center of three ply board No. 2 through bottom board C and top of stand E

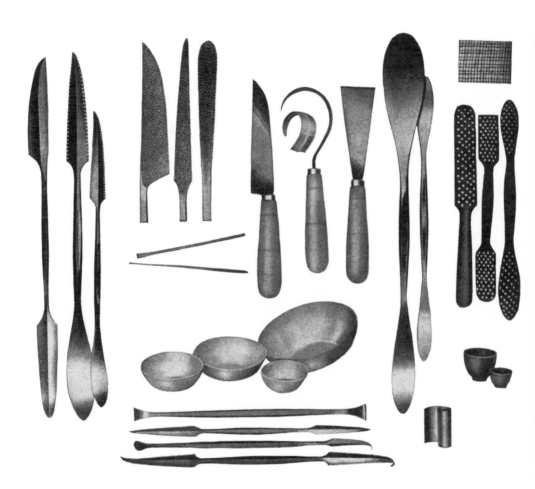

Ettl plaster tools and utensils

CHAPTER 13.

WASTE MOULD

Plaster casting.

A head or figure in clay cannot be preserved as such; a plaster cast must be made of it which in turn can, if desired, be cast in the beautiful and permanent metal called bronze.

First a mould must be made. There are three types of moulds, the waste mould, the piece mould, and the gelatine mould. The gelatine mould is used when a number of copies are needed at once or simply to avoid the work and complications of making a piece mold. However it is not as accurate as a piece mould nor will it keep very long without deteriorating. A piece mould is the most permanent and most complicated mould to make. It can be kept indefinitely and used a great many times.

The waste mould is the simplest and the most used. The sculptor, after finishing the clay, wants to put it into plaster to preserve it. He is not interested in saving the clay model; it has served its purpose, nor is he interested in making a number of plaster models. The waste mould is exactly what the name implies, in the process both the clay model and the mould are destroyed. What remains is the cast in plaster, a perfect replica of the clay model.

I will first describe how to make a waste mould and a cast from it.

Plaster casting takes a good deal of practical experience. To the beginner it will seem like a very messy job, but experience teaches us that it can be done neatly and efficiently. First wet a number of newspapers and place them around your modeling stand under your clay model. Wet newspaper stay put and do not interfere with the work. Cover the floor all around your working space with dry newspapers so that a minimum of damage will be done to your room. These papers can be rolled up afterwards, tied into bundles and thrown into a trash bin. Remember that plaster sticks to the shoes and tracks endlessly. You will be most unpopular if you neglect to guard against this. Try to stay on the job until you are

finished. If you must leave the casting room, wipe your feet thoroughly, or better still, step out of your shoes.

One of the first things to remember is never to throw liquid plaster in the sink. Plaster will harden in the drain and is likely to cause untold damage and ruin the drainage system. The safe method is to keep a separate pail or butter tub half full and when washing brushes and pans, do so in this tub. All brushes and tools must be washed clean in clear water as you go along. Plaster hardens quickly and once it has set your brush is ruined. The plaster will settle and harden in the bottom of your wash tub; then you can pour off the clear water on top; but be sure to have a strainer in your sink. The plaster can be scraped from the pail on to a newspaper and discarded in a trash bin.

In casting if, as often happens, you become nervous and confused, if you are afraid your plaster is setting too fast or that you have not mixed enough plaster—stop—think—relax. Scrape your hardening plaster from your pan and throw it away. Just start over again. No harm is done. You can do a little at a time. Fresh plaster can always be added to plaster that has just set. Be calm and collected; do each thing methodically. By doing and timing and experience you will learn. It is always wise to mix a small sample of your plaster to see how long it will take to set or harden. If it stays jelly-like and does not harden it is no good.

Working with and observing an experienced caster is the best way to learn. But if no caster is available any of us can learn by our own efforts and mistakes. An old Italian caster told me that when he was a boy his father started him in the trade by having him cast a brick and other simple objects. This is a suggestion worth considering.

Materials needed for plaster casting.

1. Red top moulding plaster . . . U. S. Gypsum Co., or Calvin Tomkins, 30 Church St., N. Y. C. Purchase in 100 lb. bags or barrels—the cheapest way to buy it. Plaster must be new and kept in a dry place. Old plaster or plaster exposed to dampness spoils and will not harden or set.
2. Two ordinary galvanized pails or enamel ware basins.
3. Liquid laundry bluing.
4. .003 gauge sheet of brass—about the thinness of a razor blade for shims. Tin can be used if brass is not available.
5. Blunt chisel. Burlap. Scissors. Wooden mallet. Soft brush, round and thick. One small floppy brush. Sponge. Modeling tools. Large spoon.

Strong knife with about a six inch blade. Small trowels can be useful.
6. Tincture of green soap. Lemon oil.
7. Iron bars, $\frac{1}{4}$ inch. Cut them the proper length with a hack saw. Bend them the proper shape in a vise. Large moulds require heavier irons.

Waste mould.

In casting a head it must be remembered that the mould must be so divided that all clay can be easily removed and every part of the mould filled with liquid plaster. This is usually done by separating the mould into two parts, the dividing line running around the head and in back of the ears. If the ears project, this dividing line must run along the outer edge of the ear so that it is cut in half front and back. This dividing line is built up of brass shims so that when separated, the clay can easily be removed and when the mould is put together for casting, it can be easily filled with plaster.

A thin sheet of brass the thickness of a thin razor blade is cut with scissors into pieces about an inch or an inch and a quarter square. These

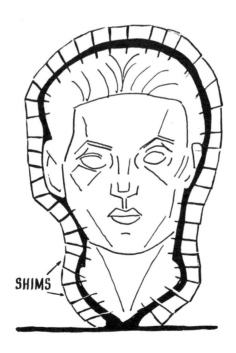

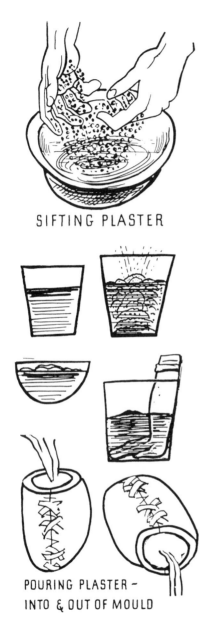

SIFTING PLASTER

POURING PLASTER –
INTO & OUT OF MOULD

are called shims. It is advisable to oil shims and then wipe off the oil. Tin can be used but brass is best. Determine carefully your dividing line for the mould, then insert shims along it, pushing each piece into the clay and allowing each piece to overlap, forming a solid wall separating the front and back of the model. The shims should project, according to the size of the model, about a half or three fourths of an inch above the clay and should form an even smooth edge. If the shims are placed unevenly and form jagged edges on top, you will get into difficulties after the plaster is applied. In order to follow the round forms of the model some shims must be cut in a wedge shape or in a curved shape and then inserted into the clay, following the form. Little plasticene balls can be squeezed to hold overlapping shims together on the top. These you will find a great help later on, when scraping the outside of the mould, to locate the brass shims and separate the mould.

If your clay model is pretty dry, spray it a little so that it will not absorb the water from the plaster. Brush lemon oil or any thin oil over the insides of pails or basins you are going to use for plaster. It makes them easier to clean. But do not leave any superfluous oil on the surfaces; wipe carefully with a cloth or sponge. Fill the basin about two thirds full of cool, clean water. Add a couple of tablespoons of liquid laundry bluing in this water until it becomes a deep blue. Sift plaster into the basin until a mound forms above the water. Then sift a little

more plaster on the surface. Let stand a few minutes, then stir rapidly for a few minutes with a spoon or trowel. Do not whip or bubbles will form. Do not stir too long. The longer you stir the quicker the plaster sets. Put your hand into the plaster and feel for lumps; if there are any, remove them. The plaster should be smooth, of the consistency of cream. It should cover and not run off completely when applied to the clay model. Apply plaster all over the front and back by throwing with the hand cupped and with an upward movement. Or apply with a soft, floppy, round brush, working swiftly from the top down. While doing this keep blowing the plaster into crevices and undercuts with the breath. Be very careful not to hit the clay model with the hand. Let excess plaster run into the basin and use until it becomes too thick to apply freely. Wash the brush and basin out immediately.

This is your first coat—the blue coat—and should be about a quarter of

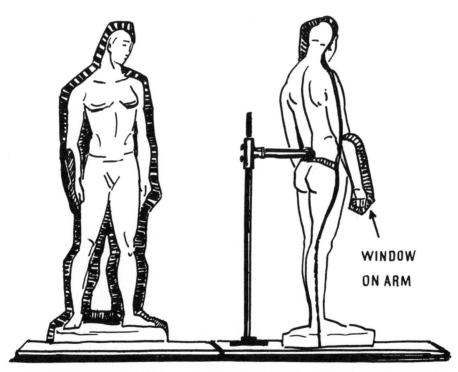

HOW SHIMS ARE SET ON A STANDING FIGURE - FRONT AND SIDE VIEWS

WINDOW
ON ARM

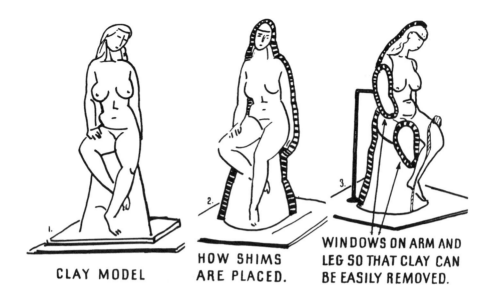

CLAY MODEL HOW SHIMS ARE PLACED. WINDOWS ON ARM AND LEG SO THAT CLAY CAN BE EASILY REMOVED.

an inch thick all over, and thicker than this around the shims. Scrape the plaster from the outside edges of the shims immediately. This coat of plaster should be allowed to harden, after which you are ready to apply your second and final coat of white plaster. The blue coat is a caution, a warning that you are approaching the surface of your cast when you are chipping away the mould.

While your blue coat is setting, mix your second basin of plaster. This is your white coat and you will need twice as much. Probably two or more batches will not be too much. Fill a pail or basin half full of clear, cool water, no bluing this time. Take handfuls of plaster from the bag and sift into the pail until the water absorbs all the plaster it can hold and little mounds of plaster begin to form above the water level. Sifting is important as you want to avoid lumps of plaster forming in the water— never pour plaster into a pail. Let stand a few minutes and then stir two or three minutes for large quantities of plaster. Place hand at bottom of pail, gradually stirring upward until the liquid becomes the consistency of thick cream. Remove any lumps. Apply by the handful, throwing plaster with an upward movement, working swiftly from the top down until this sets to a pasty consistency. Your plaster in the pail will be thickening fast to the consistency of sticky clay. Take handfuls of this; work

swiftly and cover the entire surface as quickly as possible to the thickness of the shims. Scrape shims again immediately. The protruding brass shims will guide you as to thickness. Try to have every part of your mould covered to the same thickness. If you have not mixed enough plaster mix a new batch and continue until you have the proper thickness. Now smooth out the surface with hand or trowel and scrape edges of shims until they show.

To reinforce your mould, add your iron supports which you have prepared beforehand. These you shape to fit the outside of your mould and fasten to it with strips of burlap dipped in plaster. The burlap strips are two or three inches wide by six or eight inches long. These pieces of burlap are wrapped around the iron and plastered to the cast; one iron, whole or in two pieces, entirely around the head near the shims and following their line; one across the face, and one across the neck, and the same in the back. If the head is small and simple these reinforcements may not be necessary.

If you put your hand on the plaster mould you will find it quite warm. When it has cooled it has set. Again with knife or trowel scrape away the plaster at the seams and expose the sharp edges of the shims. After the shims are exposed, cut lines across the separation of the mould here and

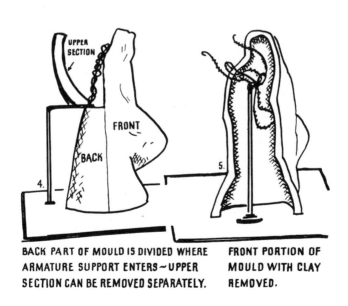

BACK PART OF MOULD IS DIVIDED WHERE ARMATURE SUPPORT ENTERS~UPPER SECTION CAN BE REMOVED SEPARATELY. FRONT PORTION OF MOULD WITH CLAY REMOVED.

there to give you key marks so you will know where the mould comes together. After the mould has set and hardened, you can drive a number of little wooden wedges carefully along the shims. Gradually separate the mould into two pieces. Use wooden wedges or a flat chisel or better still, a spatula. Insert carefully in the division of the mould, gently wiggling the chisel or spatula from side to side, first on one side and then the other. This operation must be done patiently and slowly. If the mould does not separate easily, pouring water along the seams will help to soften the clay inside. Be very careful not to push the chisel or wedges in too far as you will break the important edge inside the mould. If the mould does not separate be very patient; never force it. It will always come apart in time.

Now that the mould is separated, remove the back of it and dig out the clay carefully from the front. This should be done first with a firm modeling tool. Later when approaching the surface of the mould use a wooden tool. A lump of soft clay squeezed into the mould here and there will help pick up clay in the undercuts. The next step is to wash the mould. This can be done under running water in a sink or bath tub. Care must be taken not to injure the surface. A soft brush or sponge is best.

When the mould is thoroughly washed, let it stand until the water on the surface has evaporated and then brush in liquid tincture of green soap. Let mould absorb the soap. Lathering is not necessary when the green soap is applied full strength. Be careful to wipe out all the superfluous soap from the mould with a soft brush or moist sponge. Be sure the entire surface including the separating seams is well soaped all over. Run your finger over the mould and feel the surface; it should now have a soapy, greasy feeling. Let this stand about twenty minutes. Then paint the entire surface with lemon oil and allow this to set for another twenty minutes. Your mould is now ready for casting.

There are a number of methods used by professional casters. Perhaps the simplest method for beginners is to put both sections of the mould together. Watch that the mould fits perfectly according to the marks; then fasten it together with burlap dipped in plaster. See that all openings in the seams are sealed with plaster on the outside. Then pour plaster into the mould, turning the mould from right to left and upside down, letting the plaster run back into the basin. Let this coat of plaster set slightly; then repeat until you have a thickness of about an inch. Again, let set slightly. You can then line the inside of your cast with strips of burlap soaked in plaster to give it strength.

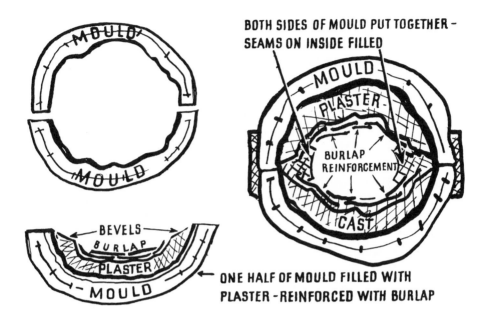

BOTH SIDES OF MOULD PUT TOGETHER –
SEAMS ON INSIDE FILLED

BURLAP
REINFORCEMENT

ONE HALF OF MOULD FILLED WITH
PLASTER – REINFORCED WITH BURLAP

Another method used by professionals is to fill each side of the mould with plaster after the soaping. To do this mix plaster as before; pour in the plaster when about the consistency of thick cream or paint it in with a brush. Blow into the mould as you pour the plaster in to be sure the plaster enters every crevice. In blowing into the mould you also get rid of any bubbles that might form. Pour off the excess plaster and repeat this until the inside plaster is about an inch thick. Let set slightly—then dip strips of burlap into plaster and lay into mould to strengthen it. Keep your plaster at a bevel away from the inside edges of the mould. Do not worry about plaster getting on your seams. When this happens just flake the superfluous plaster off after it has set. Do this with the sharp edge of your spatula being careful not to scratch the seam, but be sure all plaster is removed from the seam otherwise it will not fit properly.

Next put both sides together and fasten with burlap dipped in plaster filling all outside openings in the seams. After both sides are fastened together and set, mix plaster and pour into the mould to fill the seams on the inside. Pour in and pour out. If the opening is large enough for your hand to enter, fill all the seams and smooth out the inside of the mould, joining inside sections with burlap dipped in plaster. This will bind the joints

together. If the opening is too small these burlap strips can be lowered into the mould and pushed into place with a stick of wood or a tool. Let the whole thing set for an hour at least, or overnight. Then your mould is ready for chipping. Feel your mould with the palm of your hand to be sure it is cool.

If you are in a hurry you can begin chipping the cast away an hour or so after it has been poured. But do not be in too great a hurry. Tear off the outside burlap and the irons first. In chipping away the remaining mould, use a blunt chisel and wooden mallet. Tap gently; a sharp chisel will cut the plaster. What you want to do is to fracture each piece, not to cut it. Great care must be taken when the layer of blue plaster is reached. If the mould has been thoroughly soaped and oiled you should have no trouble with the mould sticking to the cast. It should break and fall away very easily, exposing your finished plaster cast.

In the process of chipping you are bound to cut into and injure your plaster model to some extent at first. This can easily be repaired. For repairing plaster fill a cup half full of water and sift plaster into the cup; have half as much plaster as water. Wait for the plaster to absorb the water—about five minutes—stir and let set until it thickens. Then moisten the place to be repaired thoroughly with a brush and with a spatula or wooden modeling tool apply plaster as you would clay to your model. You can work plaster almost the same as clay, using your finger or tool to get the proper texture. If you do not moisten plaster thoroughly it will show discoloration where repaired. You must never try to use plaster after it has set, as it will crumble away.

There are many variations to casting. You can get along without the reinforcing irons in many cases; a simple life-sized head can be cast without irons. If you have no brass for shims you can use a clay wall. This is done by rolling out sheets of clay or plasticene, cutting them into ribbons one fourth of an inch thick by an inch wide. Attach this upright wall around the head to divide the two parts of the cast and support it on one side with pieces of clay cut wedge shape. It has to be firm enough so that it will not slip. You can now throw your plaster as before but on one side of the clay wall only—first blue, then white, to the height of the clay wall. Let set and remove the clay wall. Cut a number of key holes along the plaster where you have removed the clay wall. Make these holes by revolving a knife in the palm of your hand, the point pressing into the plaster. Then soap and oil this edge of plaster and the key holes thoroughly with a small brush. Put small pieces of plasticene here and there along the outside

edge letting them extend a little way down. Now throw your plaster over the rest of the head. When this has set scrape the seam. The little plasticene balls will guide you as to where the seam is. Use wooden wedges, insert where the plasticene shows and tap gently until the mould is separated.

A clever way of casting is to use string. It is quick and easy if you become proficient at it. A waste mould such as we have been describing can be made in two pieces using one string, or four pieces using two strings. The four piece mould can often be removed without destroying your clay model. Of value if you want to restudy the latter. This method can also be used to make a model of a simple bronze, or a small wood or stone carving; these must be oiled or greased with stearine if used for casting. First give your model a thin coat of plaster all over, just a skim coat. Place a string over and down the sides, separating it into two halves. Use dental floss or strong linen thread. Wet the string first and let it dry slightly. Press the string into this thin coat of plaster and let it set slightly. Cover the entire surface of the model with plaster to a depth of three fourths of an inch or more by throwing plaster in cupped hand. Be careful not to touch or remove string. This must be done very quickly and cleverly or it does not work. Much practice is necessary—try something you do not mind spoiling. The plaster will begin to set fast so be sure to cover the string to the depth of an inch as quickly as possible. If the plaster is setting too fast, forget the rest of the head, take handfuls of thick plaster and plaster over the string. When this is set, take hold of both ends of the string and pull it swiftly through the plaster. You will have to learn by experience the exact timing and the exact consistency of the plaster. Feel the plaster with the finger before pulling the string, if it does not stick to the finger it is ready. Or try cutting the plaster with a knife, if it does not come together when cut, it is ready. If it is too hard you will not be able to pull the string, if it is too soft the plaster will fall back together again and will not separate. In an emergency you can always saw your mould in two and save it without too much damage. When you have pulled your string through successfully you can mix more plaster and build up parts you were forced to neglect, being very careful not to cover your line of separation. When the plaster is set the mould can be pried apart as before and you can go ahead with the casting.

A mould separated by string is built thicker than a mould separated by shims and you will not have your blue coat as a guide. Chipping is a matter of practice and intelligent application. Do not ever be in a hurry; you may seriously injure your cast. Some casters use a little clay water painted into

CONSTRUCTION OF THE ROMAN JOINT—
ROMAN JOINT FOR STATUETTE — MALE JOINT MADE FIRST

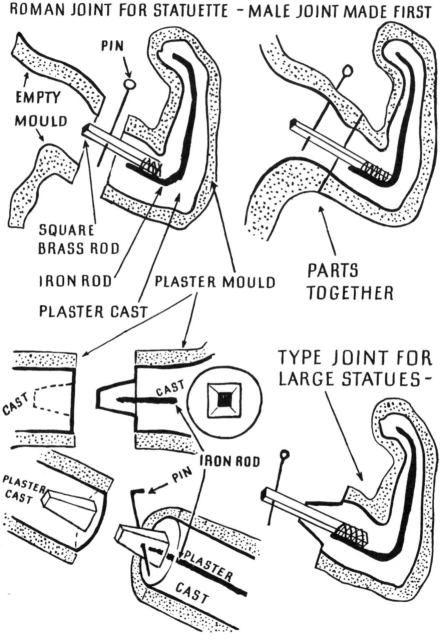

PIN

EMPTY
MOULD

SQUARE
BRASS ROD

IRON ROD PLASTER MOULD

PLASTER CAST

PARTS
TOGETHER

CAST

CAST

IRON ROD

PLASTER
CAST

PIN

PLASTER
CAST

TYPE JOINT FOR
LARGE STATUES—

the undercuts after the blue coat is applied and set, to facilitate chipping the mould from these difficult places.

A very simple little head or figure can be cast solid by filling each side of the mould and then adding plaster of a creamy consistency at just the right moment and squeezing both sides together. This method is also used in casting sections that you cannot pour, such as arms.

A mould which is not used at once can be put aside and cast at any future time. But before using it must be soaked in water until it absorbs all the water it will hold—or until all bubbling ceases. If dusty it can be washed with a soft sponge after soaking:

To facilitate casting in bronze where legs and arms or other sections of a cast figure are complicated or extended, a Roman joint is made. To make a Roman joint, the male end of the joint is first cast in the mould with an iron reinforcement. When this has set, it is trimmed as in the diagram so that it can be withdrawn. It is then covered with stearine, an iron pin is now greased and set into the joint, and the female section of the cast is poured. When the plaster is set hard, both ends of the Roman joint are complete. You pull out the pin, separate them to test them and replace them using the pin to hold them together.

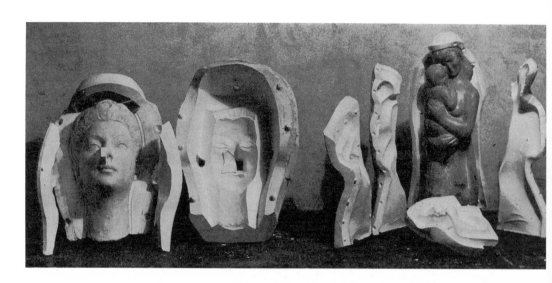

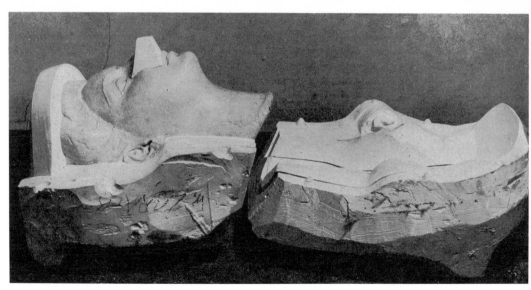

Piece moulds—showing moulds and outer shells

CHAPTER 14.

PIECE MOULD·GELATINE MOULD

Piece mould.

When duplicate casts are wanted of a piece of sculpture a piece mould or a gelatine mould is made. The piece mould is more accurate and can be kept indefinitely. The gelatine mould is easier to make and is much used commercially but it deteriorates in a short time. It is advisable to first make a waste mould of a large or important clay model before making a piece mould because plaster is a more substantial material than clay and can better withstand the necessary handling. The following directions can be applied to plaster models, clay models or sculpture in other materials.

A piece mould is a very complicated process and is just what the name implies, a mould made in small pieces so planned that each piece can be withdrawn from the model and from the surrounding pieces without disturbing them and so that all of them can be put together again to make a complete mould. These pieces in turn have to fit into a shell or mother mould which holds them firm and in place while the cast is made. Your selection of the order in which the pieces are made depends upon the problem at hand. Understanding the principle involved enables the caster to plan the number of pieces needed, the shapes and positions of these pieces. I assume that no one will attempt a piece mould until he has had considerable experience making waste moulds; or in other words, understands the principles of casting and the handling of plaster.

Study the model carefully. Plan your pieces with great care in order to use as few as possible and yet take care of all undercuts. The sections must be strong in themselves so there will be little danger of breaking. This is an engineering feat. Experienced casters can plan quickly and easily but a beginner will not find it easy even with a simple model. The pieces must be numbered in the order in which they are removed and they are assembled with the numbers in reverse.

If you are working from a clay model, it must be quite dry and hard.

Both a clay model and a plaster model must be carefully shellacked and the shellac dry before you start making the mould. But never shellac a piece of bronze, or stone; these are only oiled. To make your divisions, do not use shims, use a clay or plasticene wall. If you use a clay wall, care must be taken that the clay does not dry out and fall off before you finish with it. Plasticene will not stick to a greased surface; if you use it, grease the inside of each section after the walls have been built, in other words as you go along. Stearine is used for greasing the model and separating walls. Melt the stearine over hot water and stir in enough kerosene so that when cold it will paint on greasily and thin. Build your wall around your first piece or section. Grease with stearine the inside wall and surface of the model enclosed by it. Paint in the plaster with a floppy brush. Fill in carefully to the proper thickness. When you reach the outer edges of the walls smooth out the surface of the plaster with a spatula; let it set and scrape it smooth. Take off the clay wall. Wait until the plaster cools and then remove it carefully by tapping it on the edges. When loosened slightly, pull it away.

Each piece must be trimmed on a bevel and cleaned and the outside surface smoothed with a knife. Refit it to the model to be sure it is perfect. Observe carefully the direction in which it pulls away so that you can determine the bevel of the surrounding pieces. Cut V-shaped keys in the edge to facilitate keeping the piece in place. Set this piece in place and build your next wall; grease walls, section of model enclosed and soap and grease your piece of plaster where it will contact the new plaster. Proceed as before and continue the process until you have a complete mould.

After all the pieces are made and set in place, trim the entire outside surface with a knife to form a smooth loaf shape. Shellac and grease the entire surface. You are now ready to make your shell or mother mould, the outside form which holds the small pieces in place. This is usually made in just two pieces. If large and heavy, reinforce the mother mould with burlap and irons as much as is necessary.

If the piece mould is a very complicated one, as the pieces are being made, little wire loops can be inserted in the plaster while it is rather thick and before it has set. These loops are allowed to protrude from the outside surface (Fig. 2) to facilitate pulling out the piece and to hold it to the mother mould. Cover these wire loops with little blobs of plasticene when casting the outer shell. These hollows in the mother mould will indicate where to cut holes in the mother mould. In casting, a string can be

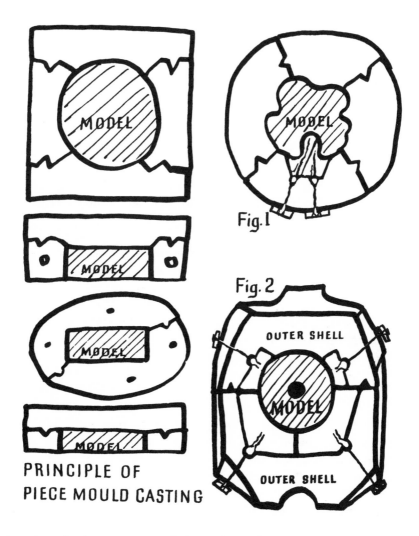

Fig.1

Fig. 2

OUTER SHELL

MODEL

OUTER SHELL

PRINCIPLE OF
PIECE MOULD CASTING

tied to the wire loop and passed through a hole in the mother mould, tied to a piece of wood and twisted to hold the inner piece firm.

Sometimes two or more small pieces must be sunk into a larger piece and the mother mould made to enclose one set within another (Fig. 1).

It is advisable to cover completed sections with tissue paper to avoid splashing plaster on them.

To make a cast from a piece mould everything is put in place and held secure in the mother mould. This is tied around with rope and wedges

placed under the rope to tighten it. Treatment of the inside of the mould depends upon whether it is to be used for a plaster cast or a clay squeeze for terra cotta. For a plaster cast the mould is soaped and oiled as for a waste mould casting. After the cast is poured and set, the outer shell is removed and all the pieces carefully removed and replaced in the shell. If the mould is to be kept indefinitely it should be shellacked and greased —not soaped and oiled.

For a clay squeeze the mould must never be oiled or greased or shellacked. Firing clay of a working consistency is pressed into the mould; for a rather small figure, one half inch thick—the thickness according to the size and character of the terra cotta. After the piece mould is removed, the clay is thoroughly dried and then fired.

For commercial purposes a thin clay is slushed into the mould—poured in and poured out several times until of sufficient thickness for strength. After it has set, it is removed, dried and fired. In terra cottas a tiny hole is made somewhere in the top to serve as an exhaust.

A mould into which clay is pressed should be made to separate into two parts and a small groove cut around each part near the separating line to allow for the escape of the excess clay when the two moist pieces are squeezed together. This excess clay is trimmed off before firing.

Gelatine mould.

To make a gelatine mould, the plaster model must be painted all over with shellac—if wood, stone or bronze, it must be thoroughly oiled. When the shellac is dry roll out sheets of clay to a thickness of a half inch or a little more and cover the entire model. This sheet of clay represents the gelatine and care must be taken that it is of an even thickness with no weak spots.

A gelatine mould is made in two pieces, front and back. It is a good idea to mark them on the outside with an "F" and "B." After the model has been covered with clay, a clay wall is laid edgewise on the line of separation between the front and back. Mix plaster and throw it on to make the front half of the plaster shell. The clay wall is then removed, the separating edge trimmed, key marks cut and the edge shellacked and oiled. This done, the back is covered with plaster. After this is set the front half is carefully loosened and removed, leaving the back in place. The clay coating is then removed from the front half of the model; cutting it carefully and evenly in a line with the back section of the plaster shell. Be careful that there are no cracks or openings along this seam into which gelatine could seep.

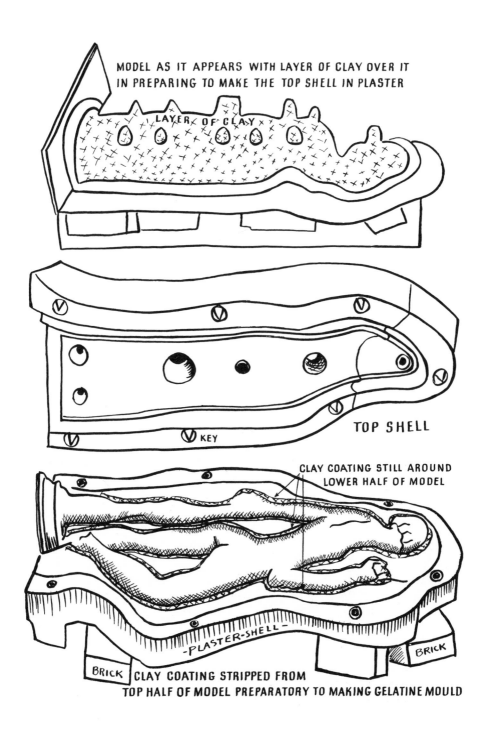

MODEL AS IT APPEARS WITH LAYER OF CLAY OVER IT
IN PREPARING TO MAKE THE TOP SHELL IN PLASTER

LAYER OF CLAY

TOP SHELL

KEY

CLAY COATING STILL AROUND
LOWER HALF OF MODEL

-PLASTER-SHELL-

BRICK

BRICK

CLAY COATING STRIPPED FROM
TOP HALF OF MODEL PREPARATORY TO MAKING GELATINE MOULD

Before putting back the front section of the plaster shell bore a couple of holes through it, one rather low and one about half way up. The front half of the plaster shell can now be painted with shellac and oiled, allowed to dry and replaced on the mould fitting it carefully against the back section which still has the clay coating over the model. Tie firmly in place. Caulk all seams with clay or plaster as gelatine will seep into the tiniest crack. Turn the whole thing upside down with great care so as not to move the front out of place; let it lean always towards the back and there will be less danger. (Instead of inverting the mould it can be left standing or lying and a third piece of plaster fitted over the base. Clamps can be used to hold it tight and prevent the gelatine forcing its way out. In this case, a funnel shaped hole is made in the top of the shell for pouring and the air vents planned according to character of the model.)

The gelatine is now prepared. Soak the gelatine in cold water until soft. Then melt it over a slow flame—always in a double boiler. When melted

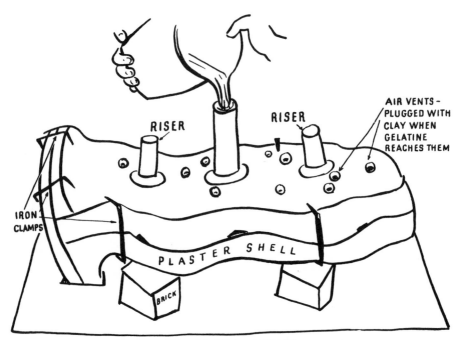

POURING GELATINE INTO CENTRAL FUNNEL -
RISERS SHOW HOW FAR GELATINE HAS FILLED MOULD

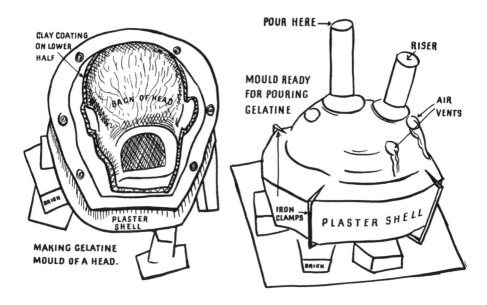

CLAY COATING ON LOWER HALF

BACK OF HEAD

PLASTER SHELL

BRICK

MAKING GELATINE MOULD OF A HEAD.

POUR HERE →

RISER

MOULD READY FOR POURING GELATINE

AIR VENTS

IRON CLAMPS

PLASTER SHELL

BRICK

remove from the stove and stir thoroughly but slowly. Let it stand until a skin forms on top. It is ready to pour when you can put your finger into it comfortably. If used too hot it will melt the shellac and stick to the plaster. Use a funnel and pour it gently into the space between the front shell and the model. When the gelatine rises to the level of the first hole, plug it up with clay, do the same when it reaches the second hole, and continue pouring until the mould is full. The holes or vents allow gases to escape and show you that the mould is filling properly. Allow the gelatine to harden over night and then remove the other section of the mould, in other words the back half of the shell. Remove the clay covering under this. This leaves the edge of the front gelatine mould exposed. Paint this edge with a solution of alum water. Coat the inside of the plaster shell removed from the back with shellac and oil it when shellac is dry. Cut the vents, tie the moulds together and proceed to make the back half of the gelatine mould exactly as you did the front half. If the gelatine is poured too hot it will melt the gelatine in the front half where it comes into contact and spoil the seam.

The mould should be left over night to set and become firm. Then the outer shell is separated and removed and each section of the gelatine

mould is very gently and carefully pulled away from the model. The elasticity of the gelatine allows it to pull away from the undercuts and spring back again to its original form. After all oil has been removed from the surface of the gelatine mould by brushing talc over it, the mould is brushed all over with warm alum water which hardens the surface of the gelatine. This must be dried off with a soft brush. Be careful to leave no little puddles of alum water anywhere as it will injure the gelatine. Now brush the mould all over with stearine—a few drops on a brush are enough. All this process must be gone through while the gelatine is in the plaster shell. Fit the two parts together and bind firmly. The mould is now ready for use and the plaster is poured exactly the same as in any other mould.

After using, the gelatine is dusted lightly with French chalk and put back into the shell until used again.

Another method of handling a gelatine mould for casting, is to fasten the model to a board with screws or burnt shellac as shown in diagram (Fig. 3). Run an indelible pencil line around the gelatine mould on the board so that you can replace the gelatine exactly.

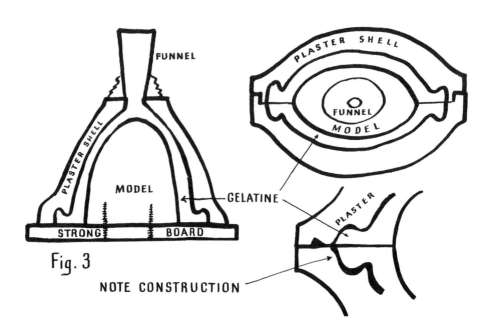

Fig. 3

Making moulds of fluid rubber.

Rubber in fluid form (latex) is the most recent development for reproducing sculpture. It is by far the simplest and most satisfactory method to use. It may be employed for a single cast or for great numbers.

The material is available in several types under various trade names. The easiest type to use is known as PLIATEX Fluid Rubber. It has the exclusive advantage of combining with a new accelerator which enables you to make a mould of your model with two brushed on applications all of which can be done in about 30 minutes. Other types produce similar moulds but require numerous applications requiring several days to complete.

Most Pliatex moulds are of the glove type. The fluid rubber is brushed directly on the model; the finished mould is seamless and is peeled off like a glove.

The coat type mould is used on complicated models where peeling off the mould is not practical. The best course to follow: before applying the rubber, a fin made of strips of mould-dividing brass should be inserted the full length of the model at a point where a seam may be advantageously placed. The mould is removed in the manner of a coat.

Plaster casings or mother moulds are generally used to support rubber moulds; these are usually made in two halves, directly over the rubber before it has been removed from the model, as explained in sections on casting piece moulds and gelatine moulds.

Fluid rubber is now readily available. The manufacturers supply complete detailed instructions, easily understood by the beginner and simple to follow.

Liquid plastic for casting sculpture.

Many beautiful results are now being obtained by casting liquid plastic into rubber moulds. Sculptors have produced novel and interesting pieces for exhibition which are transparent, opaque and translucent in many colors.

One of the products of this type is Castelite which is simply poured from the container into the rubber mould then set in an oven at low temperature, 175° F. until hard. An improvised oven made from a corrugated box with an electric light bulb will provide sufficient heat.

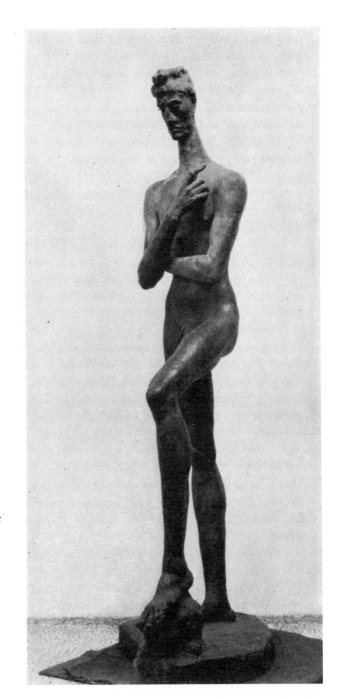

Standing Youth, cast stone.
Wilhelm Lehmbruck

Courtesy Museum of Modern Art;
photograph Sunami

CHAPTER 15.

STONE CASTING

In recent years cast stone has been much used as a medium for casting. It has this great advantage, the sculptor himself can, by this method, cast his work in a permanent and satisfactory medium with very little expense. If he sends his work out to be cast in cast stone, it again becomes expensive but still not as expensive as bronze.

This medium, if treated with taste, is very satisfactory and durable if kept indoors. Out of doors it has not proven very durable for any great length of time. The name "cast stone" implies that stone has been ground up and mixed with the proper proportions of sand and Portland cement. The ground stone comes in various natural colors. For white and cream colored casts, marble powder is also used.

There are two ways of doing stone casting. One is the tamping method. The mixture is made quite dry and then tamped into the mould with little tamping bags filled with sand. In this case the mould has to be made in sections so that every part of the inside can be reached. The wall of cement has to be built up piece by piece. Leave it in the mould for three days. Keep the mould wet with wet cloths and soak with water every twelve hours. Some continue to keep the cast wet for some time after it has been removed from the mould.

The second method is to have your mixture thin enough to pour. Pour this mixture into the mould, filling it completely. Each method has its advantages and disadvantages. The tamping method is apt to show the lines where each mass of mixed stone has been tamped on the one before. These lines sometimes develop into serious separations with time. With the pouring method, the undercuts are apt to fall away because a liquid mixture has a tendency to settle. This can be avoided by putting stones or weights on the top of the mixture after it is in the mould, to squeeze the mixture into the undercuts. As I said, cast stone can be permanent

indoors but out of doors it has a tendency to crack and disintegrate.

For cast stone, a piece mould is always necessary. It must be carefully made, keeping in mind that it is to be used for this purpose; the shell or mother mould must be very strong and well reinforced because it will have to withstand great pressure.

The inside surface of the mould must be soaped and greased with stearine dissolved in kerosene. Let the surface set before pouring.

Cast stone formulas.

The following are a number of formulas for the mixtures used in casting in stone and cement.

2 parts cement (Portland cement).
1 part marble dust—Mix color with water.
Soap mould and grease mould with stearine dissolved in kerosene.
Let surface set.
Pour mixture in mould—let stay 3 days—keep wet cloths on mould and wet or soak every 12 hours.

Artificial limestone
1 part natural limestone (size: coarse sugar to dust)
1 part fine Ottawa sand
1 part white marble aggregate (size: powdered sugar)
1 part white Portland cement
Add dry color to this mixture if desired.

Artificial marble
2 parts colored marble aggregate (size: sugar or finer)
1 part fine Ottawa sand
1 part white Portland cement (add dry color if desired)

Artificial marble
1 part colored marble aggregate
1 part fine Ottawa sand
1 part white marble aggregate
1 part white Portland cement

As long as you keep the proportions 3 to 1 or richer, you can mix the aggregates up any way you wish.

When poured the mixture should be of the consistency of thick cream.

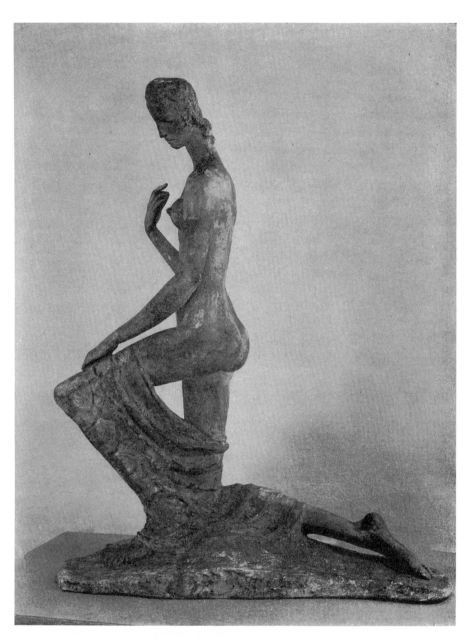

Kneeling Woman, cast stone. Wilhelm Lehmbruck

Courtesy Museum of Modern Art; photograph Sunami

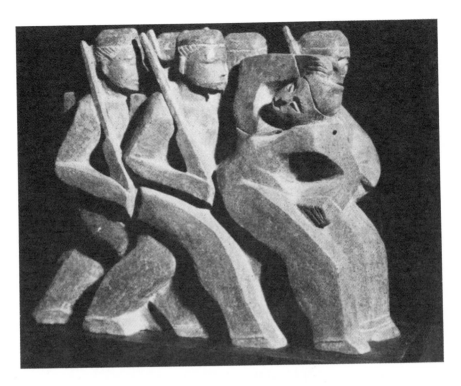

Martial Music No. 5, Drafted, artificial stone. Anita Wechsler
Photograph Bogart Studio

Remove the sculpture from the mould after 24 hours but it must be kept wrapped in wet cloths for 2 or 3 days more. If it dries out too quickly, the sculpture will crumble.

The following is a method of casting artificial stone worked out and used very successfully by Anita Wechsler:

Materials

Water, dry color (earth colors are best, as umber, sienna, Indian red), marble dust (fine and medium, white or any color or grade desired), white artificial stone (purchased at dental supply houses), wood fiber, mixing bowls of earthenware or rubber, spatulas, cold chisel, mallet, etc.

Preparation

For quantity of color needed to obtain any desired effect, mix test samples in advance.

1 part or less raw umber to every 4 parts water gives a good neutral beige tone.

1. Mix color and water, enough for entire casting.

 a.—Stir thoroughly.

 b.—Pour a pint or more into covered jar to keep for final touch-up.

2. Mix (dry) marble dust, fine 25%, medium 25%, white artificial stone 50%.

3. Have plaster mould ready.

 a.—Waste or piece mould.

 b.—Use wet mould, prepared with stearine as separator.

 c.—Use open, i.e. in two halves. Do not close mould until directed.

 d.—Fluff fiber, ready for use.

Mixing

4. Stone may be mixed in one or more batches, as convenient.

 a.—Take (always stir first) 1 part color water, No. 1 above.

 b.—Add, slowly, 2 to 4 parts dry mix, No. 2 above.

 c.—Spatulate thoroughly while adding dry mix, and continue after desired thickness (about thick as heavy cream to sour cream) is obtained.

 d.—Joggle hard to get out bubbles.

Packing

5. Pack wet stone mix, No. 4, into open mould, No. 3. Pack the more undercut half of mould first.

 a.—Firmly pack small quantities at a time. Commence in lowest parts of mould, as nose, building gradually to higher parts. Mix should be thick enough to adhere to mould, not sinking into center, and thin enough to press into all detail readily. Practice in packing is essential for best results.

 b.—Make first coat about ⅜″ thick. First half of mould should be complete in both coats before starting second half.

 c.—When packed, go over entire first coat, pressing *very firmly* into mould.

 d.—Second coat: Impregnate fiber with stone mix. Pack this, starting in low parts, as before—⅜″ to ¾″ thick, depending on size of sculpture. Overlap fiber edges for strength.

e.—Bevel stone pack to knife-edge at joint.

f.—Clean edges of mould.

Closing

6. In four hours or less mixture will have set enough to close mould. Be sure it is firm before proceeding!

 a.—Use half of mould packed first. DO NOT JOGGLE.

 b.—Raise.

 c.—Invert gradually, making certain stone pack adheres to mould.

 d.—Set in place.

 e.—If necessary, seal mould seams with strip of burlap dipped in plaster.

 f.—Fill seams from inside with hand or tool. Use same mixture as for packing. Press firmly into all joints.

Setting

7. Allow to set overnight.

Finishing

8. Chip away waste mould (or open piece mould in usual way).

9. Chisel away projecting seams.

10. Make small quantity of fresh stone mix using color water from jar, 1.-b.

 a.—Fill any gaps in seams, chisel dents, etc. Allow to set.

11. Surface. Use files, sandpaper (No. 1/0 if wet, No. 1 if dry), electric grinder or chisels, as desired.

Advantages

a.—This material will take iron reinforcements, if needed.

b.—Because it is hollow, it is light.

c.—The surface may be worked on at any time once it has set.

CHAPTER 16.

CASTING IN BRONZE

Lost wax process.

Here and there a plaster cast by a master sculptor has been cherished and preserved, but the plaster cast is primarily just a step towards putting the sculptor's work into a permanent medium. And that medium usually is bronze. Terra cotta is also used but a true terra cotta is planned as such from the beginning. Casting in artificial stone is also much used. Both of these mediums an artist can handle himself and they are relatively inexpensive but they lack the permanency and versatility of bronze.

Sculpture carved direct in stone is creation within the limitations of the rock—an architectural relating and balancing of form expressed in power and solidity and grandeur. Bronze is fluid and in it the mobile and intricate side of sculpture finds its permanent form. When a sculptor finishes his modeling in clay the art content of the work is complete. It is then cast in plaster and the final casting in bronze brings this expression to its permanent form. Just as truly as plaster takes life from the clay, bronze brings the work to its fullest beauty.

Bronze casting, whether sand or the lost wax process, is a highly developed and complicated craft. It requires great skill and constant practice. Sculptors today practically never do their own bronze casting. Most bronze casting is done in large or small foundries by men who have worked in foundries all their lives. To the student who has the inclination and wants to know every angle of the art of sculpture, a short apprenticeship in a bronze foundry would not only give a world of experience in moulding and casting but would instil very valuable working habits.

In order to give the student as accurate an explanation of bronze casting as possible, I have gone into the foundries and made drawings of various stages of the work in progress, questioning experienced foundry men and following the process from beginning to end.

There are various opinions as to the merits of the lost wax process as

opposed to the sand process of casting. Monumental as well as small work is done in each, and both simple and complicated pieces. But it is generally conceded that wax is more practical for the more elaborate and complicated models and sand is better for simple models and those not complicated with too many undercuts. In the last analysis, the quality of the casting, whether in sand or wax, depends upon the workmanship, the material, and the experience and integrity of the founder.

Reproductions in bronze can be made from almost any hard material, such as models carved in wood or stone, but usually the sculptor delivers a finished plaster model to the foundry. If this is to be cast by the lost wax process the plaster model is first given two or three coats of shellac diluted in denatured alcohol. The shellac is applied very thin, otherwise it may peel off and bring the surface of the plaster with it. A gelatine mould is then made of the plaster model. The gelatine used is the regular gelatine used in making plaster casts; or a gelatine called Agar-Agar, made of seaweed, can be used. This is very good for fine detail. This mould is made in two or more pieces and after it has set is separated from the model. The inside surface is oiled with cotton-seed oil and painted with a mixture of ⅔ pure yellow beeswax and ⅓ rosin. The brush used is a fine quality camel's hair and the beeswax and rosin are melted in an iron or copper pot. As wax is transparent, dry color is added so that the surface can be seen. Usually English vermilion is preferred; being a mercury color it burns out clean in the kiln.

After the sections of the mould are brushed in carefully with wax, the mould is closed and the inside slushed with a melted hard wax made of thirty parts cerecine, sixty-nine parts rosin and one part carnauba wax. This strengthens the wax model which otherwise would be dangerously fragile. This liquid hard wax is poured in and out until a thickness forms which corresponds to the desired thickness of the bronze cast. The thickness is determined by the size of the work, from about an eighth of an inch to a quarter or more. The wax is now allowed to cool, after which the gelatine mould is removed and the wax is now a replica of the plaster model. If the piece is small it is left hollow temporarily and supported with pieces of wood to keep it from sagging. If the piece is large, a mixture of equal parts of plaster of paris and silica is poured in to make a core; after which the seams are retouched with a spatula heated over a flame. All imperfections are now retouched and the surface gone over and slight changes made if necessary.

The bronze cast will be hollow and of the thickness of the wax. Conse-

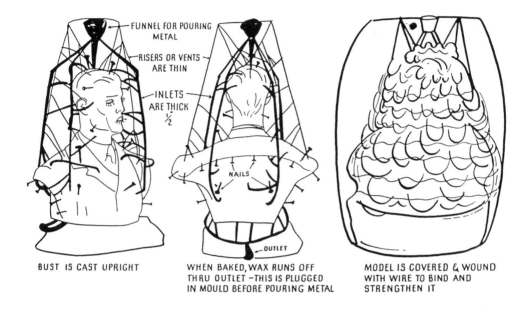

FUNNEL FOR POURING
METAL

RISERS OR VENTS
ARE THIN

INLETS
ARE THICK
$\frac{1}{2}$

NAILS

OUTLET

BUST IS CAST UPRIGHT

WHEN BAKED, WAX RUNS OFF
THRU OUTLET –THIS IS PLUGGED
IN MOULD BEFORE POURING METAL

MODEL IS COVERED & WOUND
WITH WIRE TO BIND AND
STRENGTHEN IT

quently a core will have to be poured into the model and must be held in place after the wax is removed and the metal poured in. Supports have to be prepared for this core and nails of various sizes and lengths are heated slightly and pushed into the wax model so that half will penetrate the core and hold it while the outside half will be imbedded in the outer shell when that is made. For small work ordinary finishing nails are used, for large works, spikes of various lengths. A considerable number are used; they are put in wherever it seems advisable. After the nails are placed, inlets and vents or risers are applied. These are solid wax rods; the ends are slightly melted with a spatula to attach them to the model as in the diagram. They form a circulatory system for the metal to travel and the gases to escape as the molten metal when poured, travels downward and then upward. The inlets serve as lead-ins for the metal. The risers serve as exhausts to remove air pockets and gases.

The wax model, bristling with nails and wax rods, is now covered with a liquid mixture of plaster of paris and silica, very much as when casting in plaster, and the entire mould is built up into a barrel-like form. The outside is covered with reclaimed burnt out material mixed with liquid

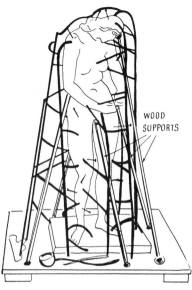

WOOD SUPPORTS

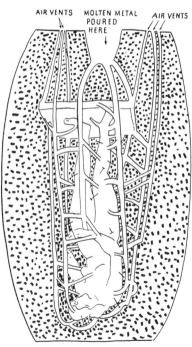

AIR VENTS MOLTEN METAL POURED HERE AIR VENTS

plaster. This reclaimed material is used because it is stronger than an entirely new mixture. All this hardens in about ten minutes. If it is a large piece the core was poured in beforehand. If it is a small piece, the mould with its casing is turned upside down, the inlets completed with a funnel, and the core of the plaster and silica mixture is poured.

The completed mould—now a barrel-shaped form—is placed in a kiln. This kiln is made especially for each firing. It is built up of fire bricks with a mortar made of loam, ashes and water. The mould is fired from twenty-four hours to seven days according to its size. During the firing the wax partly runs out from the outlet at the bottom of the mould and is partly burned out. After the mould is thoroughly baked and annealed, it is allowed to cool until you can feel no heat on the outside of the kiln. The mould is then removed from the kiln and placed in a form of wood or metal; sand is packed and rammed in around it. Or it is packed in a pit in the ground so that it will withstand the pressure of the in-rushing metal. Great care must be taken to keep the vents and inlets clear of dust and sand, to prevent this they are covered with paper.

Bronze is an alloy of copper with a small percent of tin, zinc and lead. There are various mixtures:

85 copper—5 tin—5 zinc—5 lead
88 copper—8 tin—3 zinc—1 lead
90 copper—6 tin—3 zinc—1 lead
82 copper—3 tin—13 zinc—2 lead

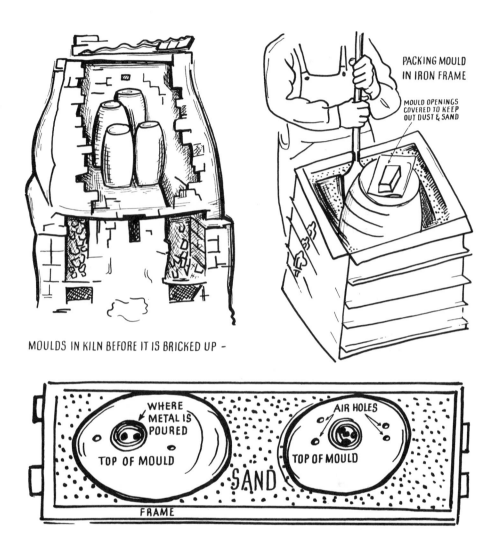

MOULDS IN KILN BEFORE IT IS BRICKED UP –

PACKING MOULD IN IRON FRAME

MOULD OPENINGS COVERED TO KEEP OUT DUST & SAND

WHERE METAL IS POURED

TOP OF MOULD

AIR HOLES

TOP OF MOULD

SAND

FRAME

For casting, it is heated to nineteen hundred or twenty three hundred degrees in a graphite crucible in an iron drum. These drums are heated in a forced draft furnace built in a pit in the ground. The crucible of molten metal is lifted by tongs into a shank with handles. Two or more men carry this to the mould and pour the metal into the inlet funnel. After the metal is poured, it is allowed to cool for a few hours. Then the outside

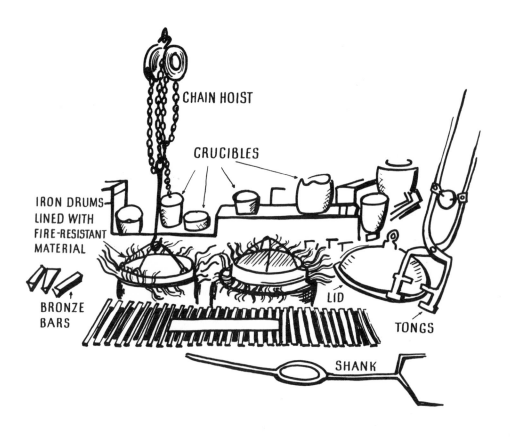

CHAIN HOIST

CRUCIBLES

IRON DRUMS
LINED WITH
FIRE-RESISTANT
MATERIAL

BRONZE
BARS

LID

TONGS

SHANK

reinforcements are removed, the plaster of paris and silica broken away from the bronze casting and the inside scraped out.

The bronze now looks like a fantastic figure imprisoned in a labyrinth of vines and creepers. Now the inlets and risers and nails are all cut off, and the figure brushed off as clean as possible with a wire brush. It is then placed in a bath of weak solution of sulphuric acid, one part of acid to twenty-five of water. The bronze is left in the bath for ten to twelve hours —overnight is the usual time. In the morning it is removed, given a thorough washing and brushing in clear water, and left to dry. The bronze is now ready for chasing and finishing.

The holes left by the nails, inlets and risers are plugged by threading round pins of bronze and screwing them into all holes and then sawing them off. The surface seams are chiseled, imperfections filed and welded,

the surface detail of the plaster model studied. The craftsman imitates as nearly as he can, all surface detail that has been lost in the casting. Bronze chasers or finishers use a great variety of small steel tools, some shaped like chisels, some like little bushing hammers and files. Imperfections are pounded and ironed out so expertly that often the sculptor himself has difficulty finding the variation from his original model.

Modern sculptors often like to do their own chasing and finishing. Some, like Brancusi, like to file, scrape, sandpaper and then buff their bronze until they have a glistening mirror-like surface. Sometimes this surface is lacquered to keep the bronze from oxidizing and darkening. If allowed, bronze will take on a natural patina of a silky golden color which in time becomes quite dark.

The average person thinks of a bronze as a shiny almost blackish color. But if one were to file or sandpaper an antique bronze, one would find it the color of brass or copper underneath. A bronze cast, cleaned, chased, and finished with wire brushes and emery cloth, or buffed with cloth wheels, is a light golden color. Left alone it would gradually tarnish and get quite dark and beautiful. But this does not happen quickly and sculptors seldom wait for this natural patina but use various methods of coloring casts.

Antique bronzes buried in the earth for centuries acquire a lovely variegated greenish patina. Some sculptors patine their bronzes to get this effect. This is done by heating the bronze cast with a blow torch until it is quite hot; but not too hot, for then the color will not take. The cast is then brushed with a solution of acid, ten drops to a cup of water. For an antique green effect, a very light copper nitrate is used; for a brown patina, ferric acid; for black, ammonium sulphate; for blue, collie crystal with ferric nitrate. Various interesting patinas are arrived at by combinations of these various acids, daubing a little of this and a little of that on with a brush and at the same time playing the flame on the bronze. Experience alone will show you how to get the desired effect. For a green patina the bronze needs to be hotter than for the others. I have arranged the acids in the order of the heat necessary for the best effect.

Bronze can be silver, nickel, or goldplated. Patterns can be painted out on it with hot wax and the bronze nickel plated to give the effect of an inlaid pattern.

After patining the bronze is left to cool. Then it is waxed with ordinary floor wax in paste form and if desired, can be rubbed to a polish.

In conclusion I would say that models can be cast satisfactorily in various

metals; iron, gold, silver, lead, and aluminum. Iron must be cast in sand, not wax. It is a beautiful material but impractical out of doors. Lead with four percent antimony is freest from corrosion and is the most permanent under all outdoor conditions. Aluminum is a very beautiful material and takes a lovely polish resembling old pewter. It has great advantages in handling and shipping because of its lightness. It is one third the weight of bronze. Outdoors it will last indefinitely but the surface is subject to a superficial corrosion that dulls it and destroys much of its surface beauty; it becomes a lifeless grey.

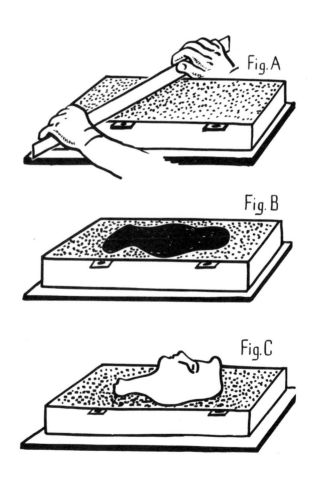

Fig. A

Fig. B

Fig. C

CHAPTER 17.

SAND CASTING

Before glue and gelatine moulding were developed, all plaster replicas from any hard material such as plaster, wood or stone, were done by the piece mould process. This method is still used in sand casting of bronze and is preferred by some to the lost wax process. It is used a great deal for casting of the less complicated pieces of sculpture, monumental as well as small. Sand casting is similar to piece mould casting in plaster, as the mould has to be made in sections of sand, each piece drawing away from the model and fitting together into an outer shell or mother mould.

It is easy to understand that when the model is complicated with under-cuts this process of casting with sand becomes very involved and requires a great deal of experience and skill. As metal is cast in a molten state, the mould must be made of a material that will withstand terrific heat and pressure, and at the same time be fine and plastic enough to make a perfect impression of every minute detail of the model. The sand used in casting is not regular sand which would just fall apart, but is a composition of fine French sand and loam, or substitute French sand, which packs and is adhesive almost like clay. This sand is packed moist and when the mould is completed, it is baked and becomes quite hard, somewhat of the consistency of brick but still retaining its granular quality so that it can be resifted and used over and over again with the addition of fresh sand.

The first step in making a sand mould is to shellac the model or plaster cast so that it will resist the moisture of the sand. An iron flask or frame, large enough to hold the model with sufficient space around it to allow for the sand mould, is placed on a strong board base which must also project slightly around the frame. This flask is then packed with sand. This is done by filling the flask with more sand than it will hold and by placing a board over it and pounding it down with a mallet. Afterwards level it off with a straight edge (Fig. A). The general shape of the model is scooped out to half its depth (Fig. B). The model is powdered with a separating

powder and is pressed into the flask, back downward, to half its depth and the outer surface of the sand smoothed and pressed out level with the spatula (Fig. C). This forms the division of the two halves of the mould. This division is dusted with a parting of soapstone and then bonedust, dusted on with little bags.

A second flask or frame exactly the same size as the first one is fitted onto the lower frame. The piece mould is now made very much as a piece mould would be made in plaster. Each piece is made about two inches in thickness and must draw away from the model and from all adjacent pieces. Each is trimmed and dusted with parting powder (Fig. D—no. 1).

When all the pieces are finished and put together, the outside is dusted again and an outer shell or mother mould is made (Fig. D—no. 2). This is done by packing the space above the pieces with sand. Iron rods are bent and fitted over this layer of sand following the general contour of the mould; running up and down and across and fastened to the sides of the flask with wire. (Fig. D—no. 3) These rods are covered with paste to make them adhere to the mother mould. The iron rods strengthen the outer shell so that it can be lifted without breaking up. Sand is now rammed and packed in this outer mould to the level of the edge of the flask. A strong board (Fig. D—no. 4) is placed over this and the two flasks, upper and lower, are clamped together with powerful wooden clamps (Fig. D—no. 5) and the whole thing turned over.

The back, which was only a temporary bed, is now lifted off (Fig. D—no. 6) and the sand removed. The separating space is smoothed and grooves cut as keys so that the two sections can be easily fitted together (Fig. E—no. 1). The empty frame is replaced and a piece mould is now built of the back exactly as it was of the front; except that in most cases the back is more simple and requires few if any pieces. The model is now embedded in a piece mould, front and back (Fig. E), from which it must be removed. Each section, top and bottom has to be taken apart; the model removed; all pieces replaced again; and a core made. The back section which is on top, is lifted off and turned over. With it comes the outer shell which was fastened to the flask with wires. The pieces are now exposed; each piece is lifted with a tool made of sharpened steel wires (Fig. F). These pieces are fastened to the mother mould by driving long thin wire pins into each piece as it is put in place, the pins penetrating into the outer shell. This is done because the whole back must be held firm so that it can be lifted and placed over the other half as many times as is necessary during the process of making the core.

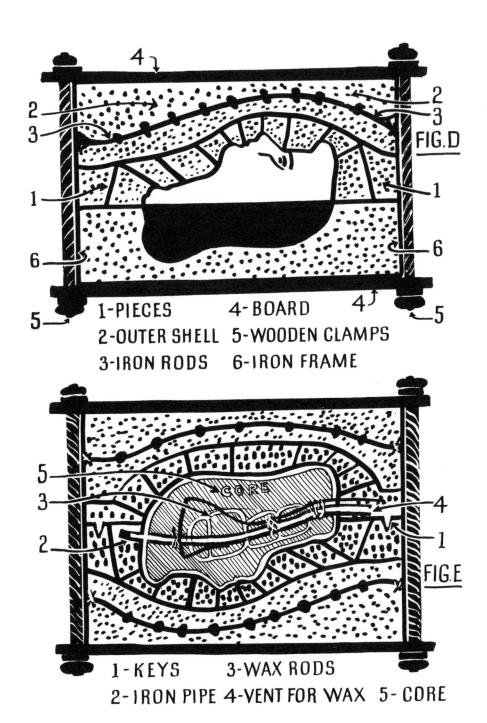

FIG.D

1-PIECES 4- BOARD
2-OUTER SHELL 5-WOODEN CLAMPS
3-IRON RODS 6-IRON FRAME

FIG.E

1-KEYS 3-WAX RODS
2-IRON PIPE 4-VENT FOR WAX 5- CORE

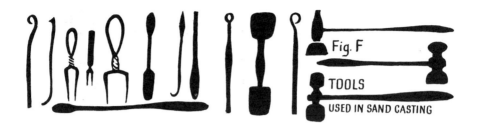

Fig. F

TOOLS

USED IN SAND CASTING

We now have a flask containing the piece mould of the back, everything in place and the pieces pinned securely to the mother mould. This is set to one side. We also have the model, its back free and exposed and its front embedded in the flask containing the piece mould of the front. It is necessary to now free the model from this side of the mould and remove it. A third flask is now placed over this front flask and filled with sand, packed tightly around the model and to the top of the flask so that there can be no movement of the model in handling. A board is placed over this and the two flasks clamped together and turned over so that the front is now on top. The clamps are removed; the uppermost flask lifted off, the outer shell coming with it. This flask is placed to one side ready to receive the pieces of the mould as they are removed. Each section is carefully removed from the model and put in place in the outer shell but this time the pieces are not pinned to the mother mould.

The plaster model is now free and is removed. If metal were poured into the mould as it is now the cast would be solid bronze, heavy and impractical. Nothing much heavier than a paperweight should be cast in solid bronze. Since bronze must be hollow it is necessary to make a core. A core has to be made with a space between it and the mould that is the exact thickness of the metal, usually about $1/8$ to $1/4$ inch according to the size of the model. Parting powder is again dusted into the front half of the mould and sand is sifted in all around the inside and pressed in lightly, to about the depth of one and a half inches. The core will have to be supported by iron pipes running through from end to end and bent to hold the core firm so that it will not shift in the mould. The main pipe acts as an axis, the others hold it from shifting. Grooves are cut in the sand at either end of the mould and the iron pipes are laid into these. Great care must be taken not to injure the surface of the mould. These iron pipes are wired together and painted with paste so that the sand which is packed

around them will stick. The axis pipe is hollow with numerous holes in it. At this point several wax rods are fitted into the holes in the pipe. These project into the core (Fig. E—no. 2) and will be melted out when the core is fired and the channels left by them will serve as vents or exhausts for gases to escape (Fig. E—no. 4).

The mould is now packed with sand; and a duplicate built up approximating as nearly as possible the back of the model. The back of the mould is placed on over this to see that the sand is a perfect duplicate. It is removed and sand added and removed where needed. This is repeated until the sand is a perfect replica of the back of the model. It was because of the necessity of all this moving on and off, that the pieces of the back of the mould were pinned securely to the outer shell in the flask. Great delicacy must be exercised at all times in handling the flasks.

When the sand replica of the model is perfect, the upper or back flask is set aside and the exposed surface of the core is pared or shaved off for the thickness of the metal. This is done with a specially made curved spatula. To be sure that the core does not lie too close to the mould, a test is made by placing small pellets of sand every few inches apart on the core. The

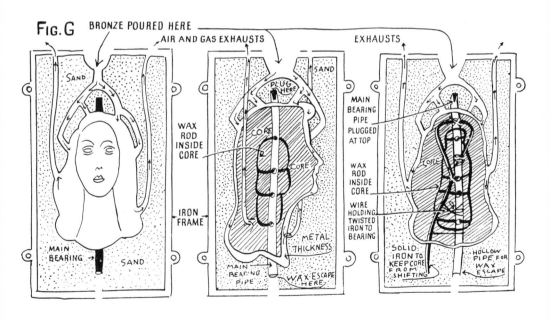

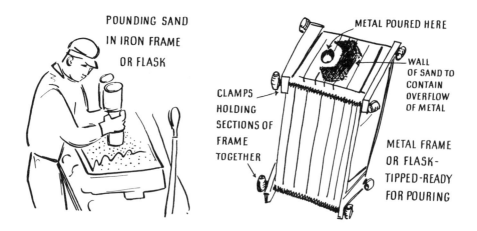

POUNDING SAND
IN IRON FRAME
OR FLASK

METAL POURED HERE

CLAMPS
HOLDING
SECTIONS OF
FRAME
TOGETHER

WALL
OF SAND TO
CONTAIN
OVERFLOW
OF METAL

METAL FRAME
OR FLASK-
TIPPED-READY
FOR POURING

mould is replaced and if any of the pellets are crushed, the core is farther shaved down so that the metal filling the space between the mould and core will be of an even thickness when poured.

The exposed half is now painted with graphite and dried lightly with a torch. Pellets are again put on the core, this time to keep it from sagging. The flask is again replaced, the two flasks clamped together and the whole thing turned over. Again the top flask is removed and each piece removed and placed in the mother mould. The core is shaved down the proper depth under each piece as it is removed. This side of the core is then painted with graphite and dried lightly with a torch. The core is then removed, the pellets brushed off and the core laid in place on the front half. While the mould is separated, grooves are arranged and cut into the flat surface of the mould for the pouring of the metal, also gates and vents for the gases to escape (Fig. G). The gates or smaller channels are arranged so that they enter the mould at various projecting points and lead into the main channel. After all vents and channels have been arranged in both sides of the mould, both frames are fitted together around the core and baked until hard, about twelve hours.

The bronze is now heated and melted in a forced draft furnace to about nineteen hundred to two thousand degrees Fahrenheit. While this is being done, a kerosene blow torch is played over the inside surface of the mould, covering the surface with a fine soot that prevents the metal from burning the sand. The core is replaced in the mould and both flasks are clamped together. Any possible openings or cracks are rammed hard with sand so that no metal can escape. The flasks are tipped end up with the funnel open-

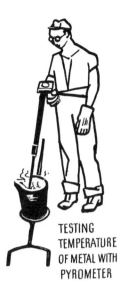

TESTING
TEMPERATURE
OF METAL WITH
PYROMETER

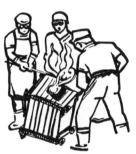

POURING BRONZE

ing on top. A wall of sand is built around the opening so the founder pouring the metal will know when the mould is full and overflowing.

The founders put on asbestos gloves, apron, puttees, goggles and hood, lift the crucible of hot metal from the cauldron with iron tongs, place it in an iron carrier or shank and set it on an iron plate. They remove any refuse which collects on the top of the boiling metal. Some test it for heat with a pyrometer; others judge by experience and the practiced eye. Two men lift the crucible with the iron bars of the carrier and tip the molten metal into the mould. In a few moments it is all done. The mould is opened, the sand broken away, and a gruesome image is exposed; covered with baked sand and extending rods and bars. The core which is inside the bronze is scraped out, the cast is brushed and cleaned with nitric acid, gates and vents are sawed off and the surface chased and finished, an expert craftsman's job. The bronze is complete; every minute detail of the surface of the plaster cast is there.

This process has to be repeated for each casting as the mould is completely destroyed in the process. Very large models are cast in sections with Roman joints and welded together.

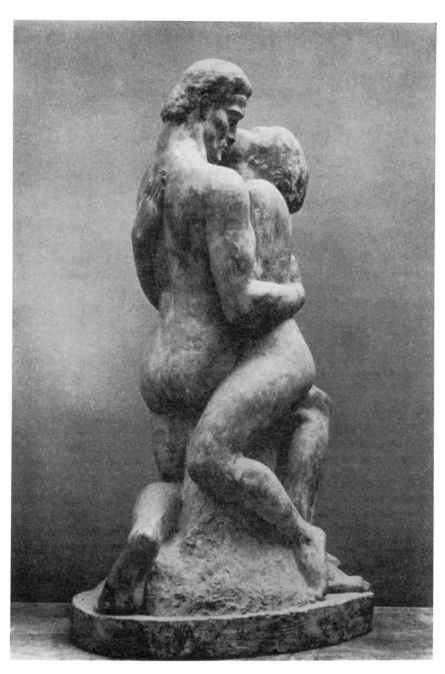

The Embrace, plaster patined to resemble bronze. William Zorach

CHAPTER 18.

PATINES FOR PLASTER CASTS

The clay model is alive, it has a human quality of warmth, it even gives a pleasant illusion of being better than it is. The plaster cast is dead and the end of illusion; you will never see your sculpture again until it is cast in a permanent medium or unless you patine the plaster cast thus recreating the illusion. A student usually cannot and in any case, should not, cast his studies in bronze. He should wait until he has done a good deal of work of his own and has arrived at a personal style. Although a plaster cast is fragile, if handled with care, it will last forever. We have handed down to us today, plaster models made by the ancient Egyptians.

White plaster is an unpleasant medium, it absorbs the light, it gets terribly dirty and never shows the sculpture to advantage. So sculptors color or patine their plaster casts to resemble terra cotta, or bronze or stone. This is very useful for exhibition purposes and if the patine is good, it is often mistaken for the real thing.

Patining is a very tricky business, here and in stone casting we enter the realm of secret formulas. To me there is only one secret formula—Art itself—and that remains a secret. You can tell a student everything about Art, what it is, how to do it, but unless he possesses that quality in his soul he may produce a good piece of work but he can never produce a work of art. I will give a few formulas for the various materials that the student wishes his work to resemble. By experimenting himself, trying this and that, doing things over and over again, he will get the best and most interesting results. Interesting results are gotten too by trying one thing over another. Personally I have no one way of patining, I am always changing my way of doing things in an effort to get a certain result I want. If you want to keep your plaster white, you can lose the absorbent dead white look by giving your plaster cast a coat of milk.

For Terra Cotta: There are a number of ways to get a terra cotta effect. While the plaster is still somewhat moist or at least not thoroughly dry,

give the entire cast a thin coat of orange shellac (shellac thinned with denatured alcohol) and let it dry. This will cause the cast to turn an interesting pinkish color. Another effect is to give your cast a thin coat of red clay water and let it dry thoroughly, then thin shellac and let it dry. When dry rub with a soft cloth or if you like a wax surface, rub all over with floor wax. Use a paste wax, not a liquid, and polish as much or as little as you wish.

Another effect is to mix a little dry color of whatever shade you desire in thin shellac (cut with denatured alcohol) and paint entire surface of cast. Let dry; then give another coat of shellac. Mix guilders whiting with dry earth colors of various close shades. Keep each shade mixture in a separate little pan. When the shellac on the cast is drying, moisten it with denatured alcohol with just a touch of shellac in it and daub this powdered color on a small area at a time varying the tones lighter and darker to your taste. This will lend variety and life to your surface. When finished, this can be left a mat surface or if highlights are desired, it can be waxed with floor wax in paste form and rubbed to a high polish. This gives a very beautiful effect. The surface can be powdered here and there again after waxing if too shiny.

For Bronze: In patining for bronze, the effect depends upon your undertone. There are two basic methods. In one you paint your cast with an undertone of bronzing liquid, let this dry and then glaze oil colors over this. Or you can use diluted shellac mixed with powdered tints of black, brown, grey or green. In the second method you dye the cast with color and dust the bronze powder over it. Personally I prefer this method. The undertone can be Indian red, black, burnt umber, or green, or a combination of all to give the effect of old bronze. This undertone is obtained by dyeing the plaster with aniline dye. The plaster must be absolutely dry through and through and after painting on the dye, it must be thoroughly dried again. Instead of dyeing the cast powdered color can be mixed with thin shellac and painted on. I repeat, have your plaster absolutely dry otherwise any surface you put on will crack and peel off, and if the shellac is not very thin the same thing will happen. In using dry colors stir the pigment into the shellac and give the cast two coats, drying thoroughly each time. Then give a coat of Japan size thinned with turpentine. When tacky, pat on bronzing powder. When dry, wax with wax paste and while wax is still moist, take a large brush and powder on a mixture of whiting and dry pigment. Rub with a soft cloth to a polish and you will have the effect of a lovely old bronze.

By varying this endless effects can be obtained; dark, light, gold, aluminum (with aluminum powder), black, etc. If you have no Japan gold size, give your cast a coat of shellac instead and when tacky, rub in your gold or bronzing powder. You can also brush and pat in powdered color immediately afterwards. Wax, if you like, and rub to a polish. If you find you do not like the polish and prefer a mat surface, powder it again with your dry color mixture.

For Granite or Marble: Study a sample of the polished marble or granite desired. Give your cast three thin coats of shellac, paint in your general tone with oil paint thinned with turpentine, and mottle with a brush or rag. Brush in the larger blotches (if any), let dry somewhat and then splatter on black oil paint with a whisk broom or stiff brush. Spatter any other colors in your sample; green, red, white, pink, grey. Patterns of flat color can be either painted or stenciled on before spattering. You can spray on thin color with a flit gun or atomizer. Work with it until you get the desired effect. Be sure to clean out the flit gun or atomizer immediately after using; if shellac, with alcohol—if oil paint, with turpentine.

When dry, varnish your cast if you wish to exhibit it out of doors. Plaster is not an out of door medium but if it is painted with hot linseed oil or with a good spar varnish, it will stand up out of doors for some time. After the varnish is dry you can give it a coat of paint if you wish. This gives added protection. This applies only to a patine where oil paint is used for protection outside. If you varnish the cast for protection out of doors you have to shellac it first. But if you paint the cast with hot linseed oil you must not shellac it. Apply the oil to thoroughly dried plaster and let it soak in; then paint with oil paint. When dry, varnish, and if you wish mottle with oil color.

If you wish to use Dutch metal leaf or gold leaf, paint the cast with Japan gold size. Gold leaf or Dutch metal leaf gives a much richer patine. After the color is applied to the plaster, paint the cast with Japan size and when tacky, lay on leaf. After this is dry the cast can be toned or patined the same as above.

To give plaster a pure white stone-like finish, give it a coat of thin glue filler, applied warm. When dry apply guilders whiting as in guilding frames. Dissolve rabbitskin glue overnight in enough water to cover it. It becomes a jelly and is then melted over a flame in a double boiler. Sift whiting into it as you would plaster, stir, and when it is of a creamy consistency, apply to the cast with a brush. Let it dry overnight. When dry sandpaper it with the finest grade of sandpaper until polished. It will have the look of white marble.

The last method used in the patination of Greek and Roman casts at the Metropolitan Museum was as follows:

1. Apply a solution of Zinc Sulphate (½ lb. of Zinc Sulphate to 1 gal. of water.

2. A second application of Zinc Sulphate (3 lbs. of Zinc Sulphate to 1 gal. of water). Allow to dry for 1 week.

3. Dust off cast and apply a thin coat of White Shellac.

4. Paint cast with thin coats of commercial flat white paint thinned with turpentine and tinted with permanent pigments according to the color of the original marble simulated. Remove brush marks by stippling with brush or fine cheesecloth. The number of coats required varies from two to four depending on degree of detail in the sculpture and original condition of cast. The last coat should have a small amount of varnish added, ½ pt. to a gal. or less, depending on the degree of sheen desired.

5. A final coat is applied for the purpose of "Toning." This is generally flat white thinned with turpentine and tinted a lighter tone of the same color as that used for the basic coats. Before drying, this coat is manipulated by wiping with cloths to procure a subtle accentuation of the modeling and effects typical of ancient marble sculpture. When dry the cast is rubbed to the degree of sheen desired.

CHAPTER 19.

BRONZES IN ART

Bronze casting is a highly developed and complicated art, yet it was one of the earliest discoveries of man. Before 2000 B.C., man found out how to use metals and how to combine them to make the alloy known as bronze. In Egypt, he discovered a way of tempering bronze to the hardness of steel; a process which has mystified men down to the present day when scientists have again discovered the formula. In this far off age before history, man had discovered how to cast in bronze, both by sand moulds and by the lost wax process. The works of art he cast range from the crudest animal forms to the most highly developed art forms. His casting technique equaled ours today. Every bronze was an original; there was no need for replicas. These bronzes are our history, our insight into early civilizations, our contact with the human race. These and the stone carvings which have survived, are the two permanent means of recording the earliest civilizations. Even bronze has its hazards in surviving the centuries. It has always been a material of war; large bronzes were always being melted down for weapons and, sometimes, even recast into money.

Asia Minor is called the birthplace of the human race; it certainly was the birthplace of art. Before 2000 B.C., they had there a highly developed art and we have beautiful things in bronze preserved from that far time. The Babylonian figure of a king, about 2300 B.C., is a beautiful, simple and complete expression—monumental in its compactness and solidity in spite of its small size; fine in its interpretation of a human body and the character of a human head.

The bronze Ibex from Iran is a highly stylized and finely designed animal with a long tradition of sculpture behind it. The dignity of this proud animal is expressed with strength and power. The Crouching Lion also from Iran is a figure of grace in movement, fine in line, the form beautifully understood and realized.

We think that we have progressed today in developing an abstract

Ur-Nammu, King of Ur. Babylonian, about 2300 B.C.
Courtesy Pierpont Morgan Library

Ibex. Persia, fifth century B.C.
Ackerman-Pope collection

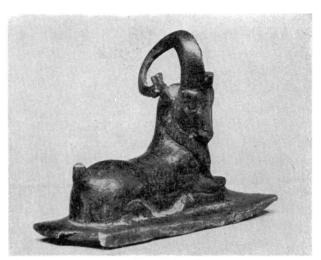

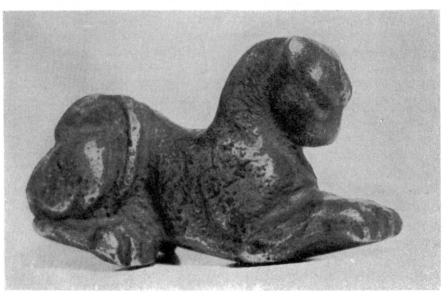

Crouching Lion. Persia, 248 B.C.–226 A.D.
Ackerman-Pope collection

quality in our art. It has always been in man's nature from the earliest times to express his relation with life through abstract form and design. Art forms have always fluctuated between the tendency to pure abstraction and the tendency to realism. Abstraction and formal design existed in Iran in 2000 B.C. The very earliest Greek sculpture was definitely abstract and there was an abstract quality in Archaic Greek sculpture. The late Greeks became fascinated by the beauty of the human body and forgot the human spirit. Western sculpture had turned definitely towards the realistic. The Renaissance became fascinated by the interplay of muscles and by the effect of suffering and strain as expressed in muscular form and they forgot the meaning of strain and suffering to the human soul.

This led logically to the elaborate, superficial and unsculptural bronzes of the 18th and 19th centuries when even the interest in the human form was lost in the wonder of perfectly executed details of costumes and ornament.

In one sense civilization has been an effort to free man's soul from fear and suffering. This has been reflected in the art development of the human race. It has a tendency to lead to the pleasant, the superficial and the innocuous. Art is an emotional as well as an intellectual expression. It has to reach the depths of the human soul, not just play across the surface of life.

In Egypt, China and India we find a highly developed art expressed in bronze and dating back to this earliest period of history.

Egypt developed her art through formal and rigid religious laws. Every art form was prescribed and inflexible but the power and force of artistic talent transcended these limitations and rose to great heights. The Egyptians were a people with a passion for permanence and with a sense of the indestructibility of the soul and intellect of man. These qualities were attained in their art. Egyptian art was essentially an art of stone carving. Bronze was not so completely a thing of convention and for the glory of dynasties. Their small bronzes were often free expressions of the artist's interest in life and the living things around him.

The bronze cat reproduced is a formalized deification of a cat in accordance with Egyptian tradition but to anyone who knows cats, it is a most marvelous cat. Realism has been added to stylization. This cat is as alive as any living thing could be alive. There is dignity and respect, an appreciative understanding of the animal and an expert craftsmanship that has never been excelled.

Look how beautifully they understood and valued the eyes. And how marvelously the ears sit on the head and relate to the forms of the head.

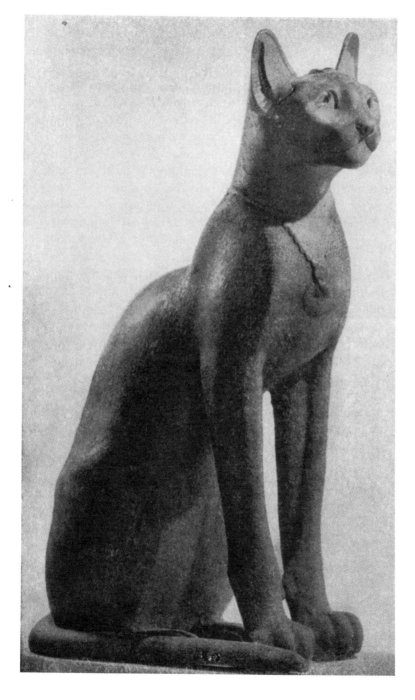

Cat, bronze.
Egyptian,
Saite period

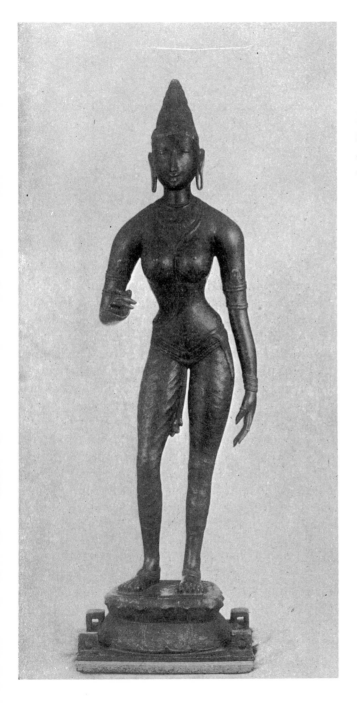

Bronze Figure.
South India, late eleventh
century
Courtesy Freer Gallery,
Washington, D.C.

Look at the beautiful feet, how big and soft they are. How the muscles ripple under the skin. Every part of the animal is beautifully expressed and understood. All form is handled with the greatest simplicity. It is monumental even though the cat is no larger than life.

Like the Gothic, East Indian art was anonymous; an art created by masses of people in the fervor of religious enthusiasm. These people were mastercraftsmen and some of them were great artists. Most of the work is in stone but they also produced great numbers of small bronzes.

When visiting the Freer Gallery in Washington, I came upon this East Indian figure. Its abstract relationship of form and beauty of movement and line made a tremendous impression on me. Flowing freely and rhythmically with a lovely and voluptuous charm, it embodied an appreciation of all that is fruitful and delicious in flesh and spirit.

Different races have different standards of beauty which they express in their art. That is what makes art so diverse and fascinating. These standards represent an ageless development of dimensions and forms. The whole appreciation of beauty and character of a race can be found in a people's art. That is what we find in this Indian figure. We are looking at a bronze with a great background of craftsmanship, a rare perfection of a craft and at the same time a great appreciation of the human spirit. This is not a conventionalized figure but is the creation of an individual personality. It may be a symbol but it is more than a symbol, it is human and alive. There is a human sweetness in the face. The drapery clings to the body and enhances it with its change in texture without in any way destroying the clear lines of the figure. There is a beautiful basic line down the center of the figure—accentuating the voluptuous breasts and pivoting figure in a gesture of the dance. The roundness of the breasts and buttocks, the clean, round thinness of the legs, so different from our Western figures, belongs completely to India. This is perfect unity of form and expression.

In a section of Africa now known as Nigeria but once known as the kingdoms of Ifé and Benin, a highly developed art found its expression in bronze. To the Greeks and Chinese and Egyptians, bronzes were only part of their art; but in Benin, bronzes were the whole art expression of the people.

Among the African tribes we found an art that was purely an expression of the spirit and with no concern with the flesh; an art that dealt with the awe and fear of natural phenomena and with man's effort to fortify himself before the overwhelming forces about him. Instead of developing towards what we know as realism, this art developed an architectonic sense of proportions, a balance and unity of design.

Head of a King, bronze. Kingdom of Benin

Heads of a King and Princess, bronze. Kingdom of Ifé

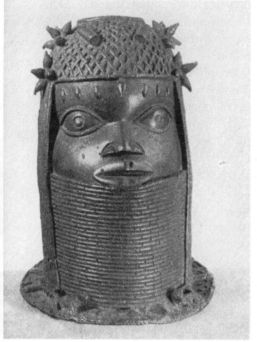 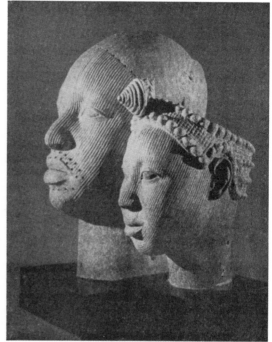

The one exception was Benin. Here art developed more along the lines of realism in our sense. It became an art of recording history and portraits of human beings, of pleasure in the modeling of animals and implements. It is a highly sophisticated art; direct power of expression has been softened by human qualities and by the pleasure of treating pattern and design as an ornamental enhancement. They made the most beautiful and playful little animal, bird and insect forms in bronze, used as weights for scales and in other everyday activities. They made portraits of their kings and princesses. They covered the wooden pillars of their palaces with bronze reliefs of their history.

The Benin heads, animals and figures were cast by the lost wax process. They were the equal of any craftsmen in the handling of this process and in the development of bronze sculpture. These sculptors loved all the surface

ornament and complicated detail; but their understanding and modeling of heads show an appreciation of form as we understand it today. The construction of the mouth and nostrils, the relation of the planes in the head, the treatment of eyes are something we can understand and appreciate. These heads seem fantastic and decorative at first, but it is because the personal style of adornment of these people was so fantastic from our point of view. The heads apart from the ornamentation are remarkable portraiture, as in the two heads from Ifé. The head of a human being was all important to them. When a body goes with the head, it is quite primitive and undeveloped. This is something we might sympathize with because we have the same tendency to concentrate on the head; in contrast to the Greeks to whom the head became a convention and concentration was on the body.

In the neighboring kingdom of Dahomey, beautiful brass casting was done and is still being done today. This is only a small part of the art of Dahomey. They are supposed to have been the first people to discover and work in iron. Naturally most of their iron casting has been destroyed by rust. They, themselves, gave it up for casting in brass when brass was brought in from the outside world. They were delighted with this handsome new material and did all manner of fine work in it; both figures and animals. These are mostly small and delicate pieces, cast in separate sections and put together. Many of them are extraordinarily fine; many of them are corrupted by the white man's realism and taste in souvenirs.

In the Greek horse reproduced, silhouette and line were the basis of consideration. The artist by tradition and by instinct and training knew that through the silhouette, the spirit of the form is revealed. Here the beauty of line, the subtlety and grace and aliveness are beautifully carried through the whole figure. There are knowledge and understanding of the construction of the animal, not from anatomical analysis of a horse, but arrived at through constant observation of the spirited animal in movement. Consider the beautiful construction of the neck and shoulders, so simple and proud, the long line from the hip bone, the quiet but powerful movement in the legs. It is not a portrait of a horse but the essence of all horses in spirit and power.

The early bronze Herakles shown here, is a sturdy figure, powerful and well developed; a well understood anatomical study of a man in action, but still retaining an art quality. The expression conveyed is that of a youthful playful fellow. The proportions are rather dwarf-like, not the idealized proportions of later Greek figures. Although still Archaic in expression,

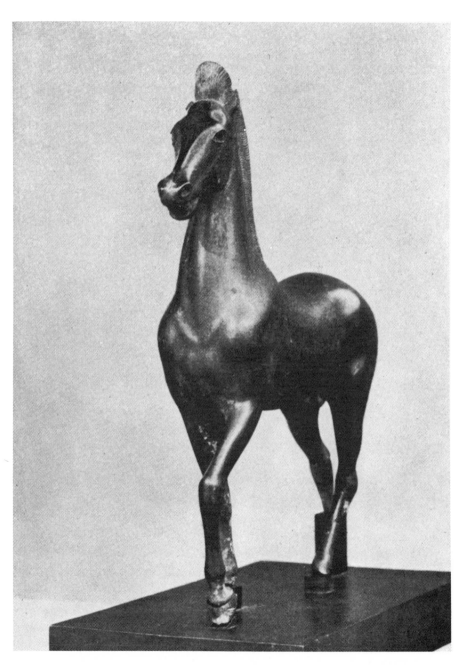

Horse, bronze. Greek
Courtesy Metropolitan Museum of Art

Herakles, bronze.
Greek, about 500 B.C.
*Courtesy Metropolitan
Museum of Art*

there is already the tendency to be absorbed with the realistic aspect of man at the expense of the art content. Perhaps the more flexible medium of clay lent itself to the easier possibilities of realism. In the Archaic Greek stone carvings, realistic form was suppressed for a more static godlike interpretation of the figure.

Herakles is a powerful and entertaining little figure, compact and of one piece; completely realized, lively in its interplay of form.

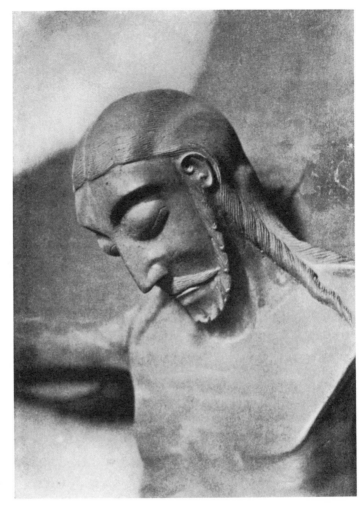

Crucifix,
bronze. Gothic

There were many beautiful and well executed bronzes made all over Europe during mediaeval and Renaissance times. But although the craft of bronze casting was highly developed, the art content of most of the sculpture was not of a very high level. There was a greater and greater preoccupation with anatomy, realistic drapery, the purely decorative and ornate. Much of it was not even sculpture but just blown up and glorified jewelry design, full of beautifully executed but totally unrelated detail. In all the

Bird in Space, bronze. Constantin Brancusi
Courtesy Museum of Modern Art; photograph Ansel Adams

confusion of effort and art activity there emerged a few fine bronzes. During the 18th and 19th centuries, the worst qualities of these bronzes were admired and exaggerated, culminating in Carpeaux and Rude.

Usually an epoch fades out. This time it ended with a great sculptor, Auguste Rodin. Rodin, at least, admired the finer qualities of Michael Angelo and developed a great and powerful romantic sculpture, the best of his period. "The Thinker" and "Burghers of Calais" express all the power and vitality lacking in the rest of this age.

After writing about the really magnificent things in sculpture throughout the ages, I cannot bring myself to write about the inferior sculpture of Europe and America before the present day. I see little in it beyond the dully realistic, the glorified model posing, and the grandiose monuments. My standard of sculptural expression and accomplishment does not include these bronzes. The things I include are those which I feel can give the student standards of accomplishment and understanding of what is fine and worth-while in art.

During this period sculptors occasionally produced works in bronze of beauty and interest; but they are isolated, solitary bits of life in a morass of competent but unsculptural effort. These are some of the names standing out through these years as strong in bronze sculpture: Verrocchio, Donatello, Houdon, Barye, Rodin, Saint Gaudens.

To me there is a revival of true sculptural values in the work being done today. Only time can give this art its ultimate value, but at least it is of our time and life and is of intense interest to any sculptor working today. I will write of a few sculptors of today who have expressed themselves in bronze and contributed to the richness of this art.

Madonna and Child, bronze. Jacob Epstein
Courtesy Sally Ryan; photograph Paul Laib

Woman, bronze.
Gaston Lachaise
Courtesy Whitney Museum
of American Art

Brancusi.

Brancusi's work has had a great influence on the art world of today, not only on sculpture but on architecture and industrial design. He was only part of a wide movement but his "Bird in Flight" was perhaps the first streamline idea in bronze. I don't know that one can say it is expressive of a bird but it is derived from the idea of the speed of a bird in flight—the swift closing of the wings as the column shoots through space. The name alone is provocative and holds much of its fascination for people. It is a glistening, highly polished form. Its beauty is in the extremely simplified and highly developed treatment of this form. It attains the very difficult combination of utter simplicity without emptiness. It has an emotional and intellectual content that is not lost but intensified by its simplicity.

Epstein.

Jacob Epstein is perhaps the one artist who utilizes the medium of bronze in the most complete and perfect sense. He models clay as if it were molten bronze. He does not model clay to be interpreted in bronze. The metal is always in his mind, he does not feel that he is using clay. It is the most perfect use of the molten quality of metal. You never feel in his fluidity the painting and modeling quality that you feel in Rodin. You never sense his modeling with his fingers or tools. This is an art in which a brutal, crude strength combines with tenderness and emotion. Nothing is sweetened or softened. The surface is never developed for itself but remains as it happens, letting the inner expression come through in all its intensity. This is not an art arrived at by trial and error or slow development and seeking of essentials, it is sure and swift and forceful in conception and execution.

Lachaise.

Gaston Lachaise was a sculptor who found his expression primarily in bronze. His approach was to model spontaneously a figure or head in clay, retaining the fluidity and life of the clay. Sometimes he would cast the model in bronze at this point and leave it as in his head of John Marin. More often he would cast the clay in its rough state in plaster and then rasp and work up his plaster to a high finish, cast it in bronze; and again chase, file and finish the bronze with emery cloth; sometimes sending it out to be buffed to a mirrorlike surface. I selected this particular bronze because it brings out beautifully the lightness and elevation, the sensitive

balance which is one of the possibilities of bronze. In this figure is all of Lachaise's appreciation and adoration of the sensuous quality of the female form. But it is more than that, it is a complete appreciation of woman. He was a master in the handling of expanding surfaces until the inner content overflowed the outer form. He was a mastercraftsman in keeping the absolute simplicity of the whole while fully developing the form in every detail. He had a code of perfection and the ability to carry it through.

This woman is elegant and highly sophisticated; she is not of the earth like Maillol's women, but is suspended above it, a creature to be adored.

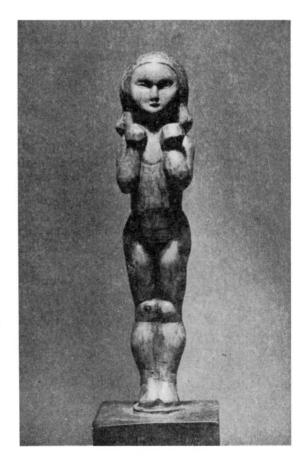

Figure of Child,
wood-carving.
William Zorach

CHAPTER 20.

WOOD CARVING

Carving in wood is one of the simplest and most delightful forms of sculpture. Wood carving is perhaps the oldest art. Although excavators have found carvings in stone done during the stone age and bronzes from the bronze age, wood was probably the first material used by man for carving. It is the simplest and most natural material for a man to pick up and use to carve an image or just decorate. But wood, like iron, dissolves with time and leaves no trace. If wood is cared for it will last indefinitely indoors, but it will survive only a short time out of doors if neglected at all. We have examples of wood carvings done by the ancient Egyptians still preserved, but the dry climate of Egypt is such that even wood can survive the centuries. In our northern climate, stone out of doors suffers great corrosion from the elements and wood has very little chance of survival unless very well cared for and kept painted or oiled.

The natural beauty of wood is a delight to a sculptor. It is a medium particularly free from complications. It is not heavy or expensive to handle like stone, nor is it complicated like clay—it does not have to be put into expensive metal to be permanent and reach its completion. The sculptor can leave it at any time and there are no complications; he can work on it whenever he wants to and he can even take it with him. The tools are easily procured and easily cared for, a penknife will do for small things. The physical effort is not too great. And for a young sculptor without money—after all most young sculptors are without money—beautiful works of art can be produced without any monetary expenditure. Wood can be picked up in wood piles, sections of trees and limbs can be used, even in the city one can find beautiful chunks of wood for no cost or at most, a few dollars.

Almost all woods are beautiful. The variety is endless; in color, grain, size, texture. Every material should be treated in such a way as to bring out its intrinsic beauty. The grain of wood will follow the contours of your

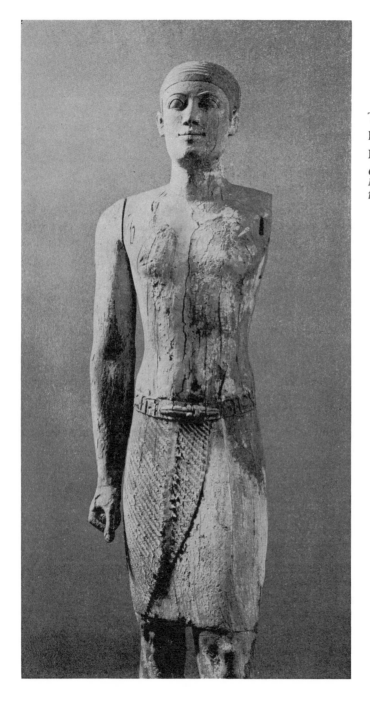

The Royal Architect,
Ka-Pu-Nesu, wood.
Egypt, 2750–2475 B.C.
Courtesy Metropolitan
Museum of Art;
photograph Charles Sheeler

sculpture and add beauty to it, but the work wherever possible should be done with the grain. Arms at right angles cannot satisfactorily be carved in wood; you cannot cut across the grain to that extent, the cross surface would be entirely different from the up and down surface, the grain of the wood will not support the arms and they will snap off. Where such projections are required, the arms or projections should be carved separately in pieces running with the grain and joined to the body with Roman joints.

There is great freedom in carving wood and much field for fantasy. The work is neither slow nor laborious; you do not need a too rigid plan beforehand, you can always see what you are doing and plan as you go along. Tiny things can be carved with a penknife in little pieces of fine grained wood, animals and figures and heads can be carved in round sections or chunks, and even huge figures and compositions can be hewn out of tree trunks.

Pine is soft, uneven in grain and very splintery. It is just an aggravation to try to carve a little thing in pine. But if used on a large scale and carved with a crude strength, it can be magnificent. Basswood is soft, fine and almost without grain. Small things can be carved in it with very little effort. Boxwood is finer and harder and even better to work with. Teak is very easy to carve, in spite of its rough, porous texture, the grain does not interfere at all and the color is very beautiful. The fruit woods, apple, cherry, pear wood, are most beautiful; very hard and lovely in color and grain. They check and crack easily; their only fault. Mahoganies of all kinds, and walnuts of all kinds are beautiful woods for carving, easily procured and in almost any size desired. Fibrous woods like mahogany are less likely to check and crack. The domestic birches and maples are good, the oaks less so, the grain is very hard to handle and the splinters a nuisance. Roots and burls are very special.

Tropical woods like snakewood, cocobolo, ebony, lignum vitae are very hard and very beautiful. Lignum vitae is interesting for the possibilities of its black and white coloring and its hard, beautiful surface. But all woods carve easily and are pleasant to work with if your tools are sharp and if you cut with the grain. In some woods, like the black center of lignum vitae, cutting across the grain is like cutting glass.

You must continually watch the grain in cutting wood. This grain not only runs up and down, it wavers in and out, travels around knots, and sometimes winds round and round the tree. The minute your tool runs into a contrary grain, stop, and work with the grain from the opposite

direction, otherwise you tear and splinter the surface. Never drive a tool directly into the wood and then try to twist it out by working it back and forth, you will just break tools. Always cut at an angle. If your tool sticks, pull it straight out the way it went in or cut the wood away around it carefully with another chisel.

It is advisable to collect pieces of wood, picking them up wherever you find them and keeping them around for years—picking one out for use as you need it. In this way the wood becomes seasoned. If you cut a tree to use in carving, do it in the winter when the sap is out; remove the bark, paint the ends, and if possible, drill a small hole through the center core so that it will dry from the inside as well as the outside. In this way it is less liable to check.

Wood is best if it dries slowly. The checking and cracking of wood are the only drawbacks of this beautiful medium. There are endless theories as to how to prevent this—the one given above is the best. The Indians selected wood found in streams where it had been under water for many years. Small pieces of wood can be soaked or boiled in oil. But there are pieces of wood that defy all theories. I have worked on a well seasoned piece with a hole drilled through the core and had it check and crack outrageously. And one time I picked up a large piece of mahogany, green, wet, and unseasoned, and carved a mother and child in it. In twenty-five years there has never been a sign of a crack or check.

Checks and cracks expand and contract with dampness and changes of temperature or humidity. Steam heated apartments play havoc with wood. This can be controlled to a large extent by oiling, waxing, and caring for wood. If these cracks remain permanently they can be filled in with pieces of wood fitted and glued in, and the surface refinished.

It is best to approach wood carving simply and directly. Put your enthusiasm and inspiration into the carving, not into a preliminary model. If you use the latter, make a free sketch just for plan and directions of volumes, but feel free to depart from this in any way you wish. Do not let a preliminary model crystallize your idea or work. Fit your conception into the piece of wood, don't try to force a piece of wood to fit your plan. Drawings are always useful for holding the spirit and for a record of knowledge, but the creation of the sculpture takes place in the carving itself. If wood sculpture does not mean this to you, I would say, don't work in wood, choose another medium.

The surface of finished wood is beautiful. A rough surface is often attractive at first but dust and dirt seep into it and it begins to look mouldy

Newborn Calf,
chestnut wood.
Most of carving
done with an axe.
Heinz Warneke

Harmonica Player,
kelobra wood.
Nat Werner

*Collection of Larry
Adler; photograph
Bogart Studio*

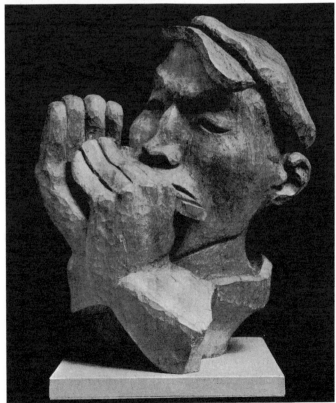

and moth-eaten. But a finished surface can be waxed or oiled and grows more beautiful with age. This surface can be uneven with the tool marks showing or it can be smoothed completely with sandpapers. Until you are sure that you are not going to do any more cutting on your wood with tools, use sharkskin for any smoothing or rubbing, never sandpaper. The grit from sandpaper becomes imbedded in the wood and dulls the metal tools; there is no such danger with sharkskin. A piece of no. oo sandpaper is wrapped around a piece of wood and used to clean up the rough edges and crevices. After this an agate burnisher is used to give brilliance and durability to the surface. This presses down the fibers of the wood and polishes it at the same time, preserving the warmth of tone of the natural wood much better than any other finish. This polishing with a burnisher should be done whether the surface is smooth or chiseled. If more of a finish is desired, the wood may be waxed and oiled. Wood darkens with time and oil darkens it still further. Linseed oil or floor wax can be used on wood. A very good oil for wood is made by mixing a tablespoon of vinegar and a tablespoon of olive oil in a quart of warm water; shake well, brush on and rub well. This gives a beautiful finish.

Wood is a beautiful medium for reliefs that are to be used inside. The wood must be kiln dried and the sections glued. The back should be reinforced by strong wooden bars set into a groove; not screwed or glued but held in place by the groove so that there is allowance for expansion and contraction. Wooden bars in back of the panel can be screwed to the panel but washers must be placed under the heads of the screws and there must be a slot in the bar to allow for expansion and contraction. This is to prevent warping. The panel must be thick enough so that there is still room for the carving.

I prefer to make a complete drawing or cartoon for a relief and trace it on the wood. In this way I retain my original sketch and I can carve freely and directly into the wood, feeling my way as the form develops. After the desired depth of the relief has been determined the first roughing out is done with a half round gouge. Later a chisel with a shallow curve is needed, and one or two small ones for detail work. It is not necessary to invest in a whole shopful of tools. One can manage with very few.

After the depth of the background has been established, the relief is crudely roughed out and the modeling suggested; this is where the shallow gouge becomes necessary. There should be no attempt to work on the details until the principal planes have been worked out since it is the surface undulation of the pattern that gives the finished relief meaning.

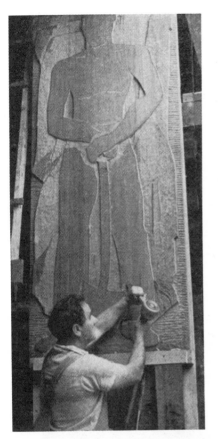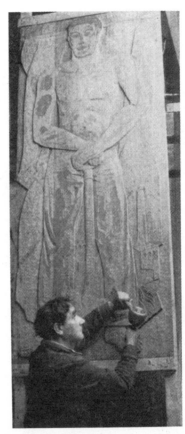

First stages of
work on relief

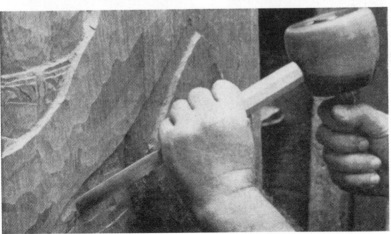

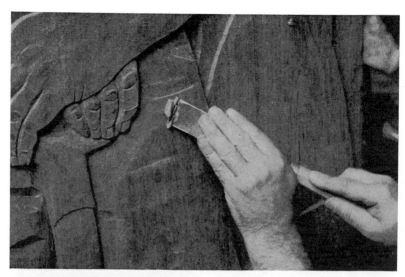

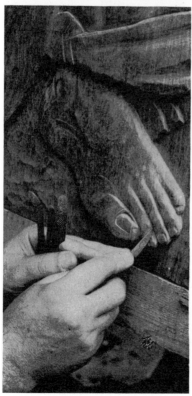

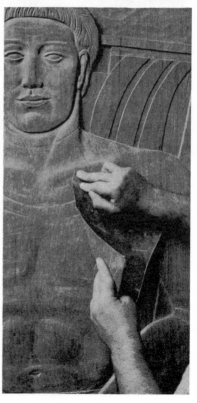

Later stages of work on relief:
developing surface modeling,
using rasps and sharkskin

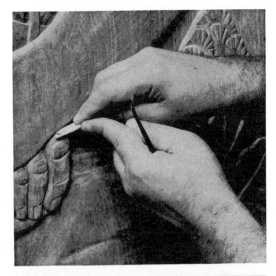

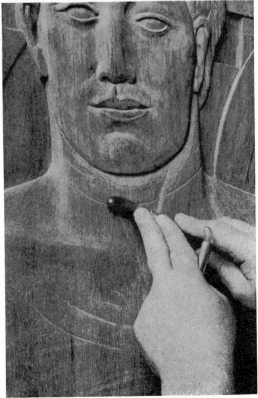

Final stages of work:
sandpapering and burnishing

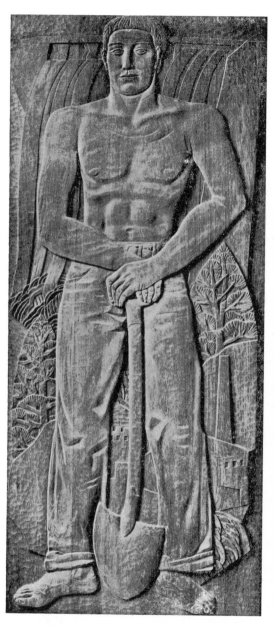
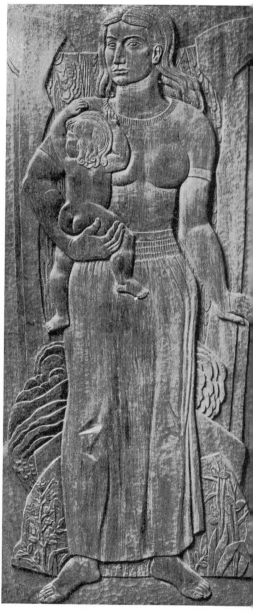

Man-made Power Natural Power

Teakwood panels; Courthouse, Greeneville, Tennessee. William Zorach

Courtesy Section of Fine Arts, Washington, D.C.

Only experience can teach how to guide one's instrument and how much pressure to apply or how heavy a blow to strike with the mallet in order to get the best results. The chisel is used with a mallet to cut into the wood but the chisel is also used without a mallet to shave or plane the surface. A V-shaped tool is used to incise outlines. The modeling is done with shallow curved gouges. Rasps are used to refine and smooth rough edges. Various forms of this tool may be needed in dealing with different shaped surfaces. Rasps bevel off the ridges left by the chisel and prepare the surfaces for finishing. As I described above, the finishing is done first with sharkskin, then very fine sandpaper and after that, burnished or waxed if desired.

Tools for wood carving.

For simple figure carving the student will need only a few tools, but for intricate decorative carving, he can use a great variety. Excellent tools are made by J. B. Addis, Sheffield, England, and Buck Brothers, Millbury, Mass. Tools used for wood carving are not carpenters' chisels but regular wood carving chisels with tapering blades and sharpened like a razor.

The student will need a mallet made of hickory or lignum vitae, one or two flat chisels and two or three shallow curved chisels or gouges of various sizes—one half to one inch wide. When roughing out large figures an adze may come in handy for chopping away large masses. These are difficult to purchase and may have to be ordered from a blacksmith or tool maker.

Good sturdy handles are important. These should be capped with

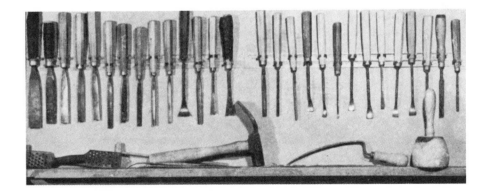

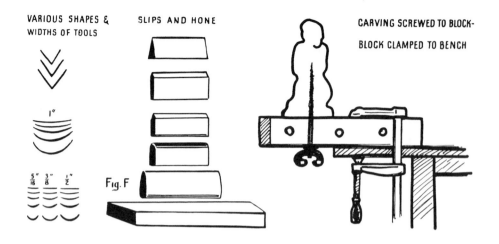

VARIOUS SHAPES &
WIDTHS OF TOOLS

SLIPS AND HONE

CARVING SCREWED TO BLOCK-

BLOCK CLAMPED TO BENCH

Fig. F

leather or brass tubing cut about one half inch wide and fitted onto the end of the handle; or the handle can be wrapped with tape to prevent splitting.

It is important to have a sturdy carpenter's bench with a strong vise attached. If your work is large it will stand of its own weight while carving, but small pieces should be held in the vise or screwed to the bench from underneath. A hole should be bored in the bottom of your carving and a bench screw, which goes up through a hole in the bench, screwed into your block of wood to hold it firm. If this is not obtainable an ordinary large lag screw with a washer will do. Wood must be held firm while working; ingenuity will be required to figure out ways of fastening wood and holding it firm with a vise or clamps.

Tools for wood carving must be razor sharp. It is very important to keep your hands off the wood and out of the way of the chisel; carelessness can cause a serious accident. Never hold the chisel with one hand and the wood with the other. If you are not using a mallet you need both hands, one to push and one to guide.

For sharpening tools, an oil stone about six inches long and a number of slips of hard Arkansas stones of various shapes (Fig. F) to fit inside of gouges are best for honing. Add a few drops of "3 in 1" oil now and then. It is important to oil the stones and keep them brushed and wiped clean with kerosene or gasoline.

In sharpening a flat edged tool, hold it at an angle of about fifteen

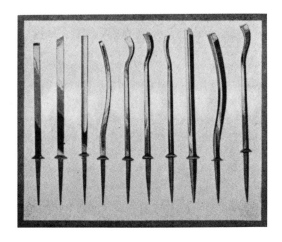

Ettl tools

degrees with finger of left hand pressing on blade. Push it back and forth being careful to keep the chisel flat on the stone. After sharpening one side to a cutting edge turn over and slightly sharpen the other side. Then hone and strop, and run your tool through a soft piece of wood to remove feathery edge or burrs. By running the edge of the tool over the edge of your finger nail very lightly and carefully you can feel if there are any rough edges which need going over again.

A leather strop can be made by attaching an old razor strop or piece of leather belting to a block of wood; smear it with Crocus Powder, or a very fine emery powder mixed with grease.

If a tool gets chipped or broken it must first be ground down on a grindstone, preferably one with water running over it. This prevents the tool from getting too hot and losing its temper. If a carborundum wheel is used the tool must be constantly dipped in water while sharpening. A carborundum wheel is apt to overheat the tool and spoil its temper.

To sharpen a gouge or curved tool, hold the handle in the right hand with left hand pressing down on steel part of tool. Push tool forward from bottom left side of stone to top right at the same time making a rocking motion to right as you push forward and a rocking motion to left as you pull backward. Then reverse motion and repeat movement from bottom right of stone to upper left, repeating until edge is good and sharp. Rub the inside of the gouge with the proper shaped slip, holding the tool in the left hand against the bench and with the right hand make a series of movements downwards.

Experience alone will teach you how to sharpen and use tools. I cannot stress enough the importance of keeping your tools sharp and of knowing how to sharpen your own tools.

Most of the work in wood carving is done with chisels but here and there you will find a wood rasp valuable in cleaning up crevices and such places. Wood rasps all seem to be imported and are very difficult to find. You can buy a shoemaker's rasp which is very useful.

I have already described the general practice of finishing wood. I would like to add that I have found broken glass one of the best tools to use when a smooth surface is desired. Window glass or any thin glass is good. You can continually break fresh pieces as the old ones wear dull. You can break pieces of any size or shape; the best way to break glass is to file two opposite points and snap it.

Torso, wood.
John Hovannes

CHAPTER 21.

WOOD SCULPTURE

Wood carving has been done by all people at all times but usually it has been just part of the art development of races and the one that is usually lost to us because of the perishable character of wood. In a few periods and for a few peoples, wood carving was a primary sculptural art. The Chinese carved wood just as they carved stone, in the same tradition and just as beautifully and comprehensively. Their choice of material seems to have been dictated by whatever was conveniently at hand. To the African tribes, wood carving became their greatest expression and overwhelmed all their other forms of art activity.

In medieval Europe wood carving became a major form of expression. During the Romanesque and Gothic periods, endless Madonnas, Saints and Christs were carved for their churches and shrines. Figures were carved for public buildings. Wood carving became a pastime for people and a decoration for their homes. The highest development was reached in the French Gothic but not confined there. We find it in all the neighboring countries—as far as Spain and in England—colder and more meticulous in the Flemish; rapidly degenerating into lifeless masses of drapery in the German states—workmanship without feeling or inspiration or art content.

In America the Indians and Eskimos expressed themselves in wood—usually in rather primitive carving, decorative but without depth, such as their Totem poles. But they also have left us a few extraordinary ceremonial masks and carved figures of people, animals, birds and sea life. The Natural History Museum of New York and the Museum of the American Indian have some very fine and interesting pieces. A student of sculpture could very profitably spend time studying them.

In the early development of our country the carvers of figure heads and cigarstore Indians and even merry-go-round animals developed a beautiful folk art—something entirely apart from the accredited sculpture of their day. They were craftsmen with work to do. They never thought of themselves as artists. But art expression and design personal quality is in

their work, such as is not found in the work of the professional sculptors of that period. The work of the latter is mostly lost in the storage rooms of museums—and justly so.

These wood carvers did not use the professional sculptors' technique of studying and seeking out form. These men knew their form and how to achieve it—a certain tool scooped out hair in the accepted fashion, another rounded out the folds of drapery. They knew their craft and accepted its conventions. They had a job to do and a given time to do it in. The tool swiftly and surely was guided through the wood. But many of these men loved the work and loved the sea. And a man working is often a man dreaming. The spirit of the dreams of these men often went into these figure heads. There was pride and individuality in these men and in their work. It is not only the professional sculptor who produces sculpture. These craftsmen produced art just as the craftsmen of the medieval world produced art.

There are a number of private collections of this work; the Drexel, the Sewall, the Peabody Museum and the New York Historical Society. Historical interest or the connection with the sea rather than art appreciation, inspired most of these collections in the beginning, but for artists they have been an inspiration. Today both people and museums are beginning to realize their art value and importance.

Study these early American carvings. There is an amazing directness of approach and an amazing simplicity of effort and intention.

Today almost all sculptors interested in direct sculpture do more or less carving in wood. A few make wood their complete expression. A great deal of beautiful and interesting wood carving can be seen in the studios of the artists, in collections and galleries and in homes.

African sculpture.

Primitive art is to the modern artist like a fresh wind blowing into a warm, stifling room. Man retains his skill and his power of expressing life through art, but he has gradually contented himself with following the forms of realism, with expressing himself through things as they are in a limited vision. The power of the spirit and the greatness of the imagination are too often not in him. Until our present age, adventure and boldness, advance into the unknown, had departed from art. We were involved in our rapidly narrowing world of art. The sudden realization of the wealth of art existing in other peoples and other times was a revelation that has transformed and expanded the whole art of today.

Figurehead of ship "Edmonton" (Canadian) 1882
Courtesy The Mariners' Museum, Newport News, Virginia

The carving of primitive races is of special value to students because the approach of these races was very direct and simple and it is by a simple and direct approach that a student evolves a personal expression. There is power and strength in primitive carvings that is lacking in a more sophisticated art, especially when that so-called civilized art has run its course and reached a decline.

The strength and power of a primitive are revealed in his approach. He is not concerned with naturalistic form as we see it. He takes a piece of wood; divides the column into basic forms familiar to him; a head, a neck, a body, arms and legs. These he carves sensing the limitations of his area in the wood, and by his innate sense of design and skill, arrives at an architectural arrangement of elements which generate great power and at times a mystic and savage intensity.

Primitive African sculpture was one of the great discoveries of this age. Western artists suddenly woke up out of their ever contracting dream world and realized the outside world was full of wonderful art and art developments and not bounded by their little efforts. I do not want the word "primitive" to be misleading. These Africans were primitive according to our civilization, but they were not without a civilization of their own; a highly developed one of customs and codes. Their art had a past as well as a present.

The wood sculpture of the various African tribes is one of the great accomplishments of man and its influence on the art of this age has been tremendous. For we suddenly realized that there could be power and expression in art form such as we had forgotten and that the fertility of the imagination could produce wonders of form relationship; that the forms of the human body and the features of the human face were not sacred as we had come to see them but could be arranged in orchestral symphonies and rearranged to hold and trap the imagination into architectural relations of form and the most intense expressions of human emotions.

This is a strange and spiritual art in that it deals with the things of the spirit and not the flesh. It is intellectual as well as spiritual but it is not warm or kindly or sensuous. There is sex in it but not love. It is fierce and proud and unyielding. It is man's spirit holding its integrity before the forces of nature, transcending his fears and terror of the known and unknown that surrounds him.

It is the forms that the African used to express himself that are so extraordinary to us. The different relationships between head and neck

African Wood-carving
Photograph Charles Sheeler

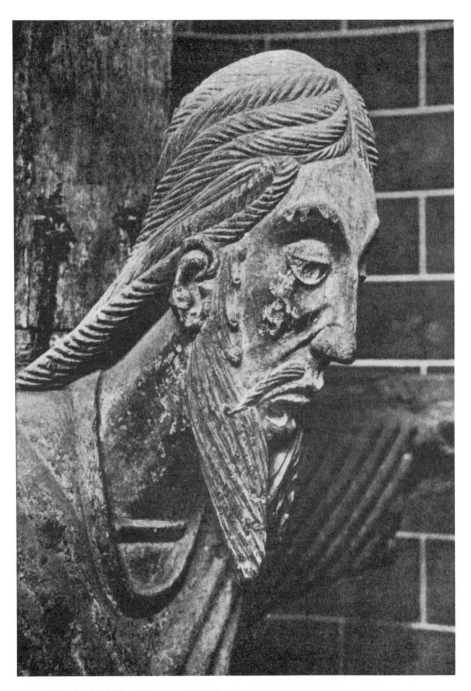

Head of Christ. German Gothic

and torso and legs are used by his unhampered imagination to build architectonic and emotional relationships with complete freedom.

What an African can do with a human head, the liberties he can take, are beyond belief. Take the eyes, they can be sharp and tiny and crowded into the sharp bridge of the nose; they can be enormously enlarged and strangely placed—in one head realistic, in another, wholly abstract—reduced to an expressive line, a hollow below the brow, or a ridge across the face. Look at the nose, in one head heavy, dominant; in another thin, straight, and long above the exquisite nostrils. Look especially at the nostrils in African carvings, they are most beautifully and sensitively designed.

The use of lips, the balance of a bulging dome of a forehead against a protruding lower jaw and lips, not coarse as we are too apt to think of negro features but delicate and fine. And again there are faces dominated by an enormous mouth. The decorations that they inflict upon their persons, they incorporate to adorn their sculpture.

A student would do well to study African carvings. It is a lesson in possible freedom from the conventions that hem us in and which we unconsciously come to accept. It is a vision of an enlarged horizon of possibilities in art.

Romanesque and Gothic.

Perhaps because of the beautiful forests that originally covered Europe, wood carving became an art of the people. This happened during the period when men were using their forests to the fullest extent; clearing them for fields and cities, using wood in every way possible in the civilization they were building. The permanence of stone also went into his constructive efforts but wood with its warmth and richness was equally his material. The stone sculpture that he used to adorn his stone buildings was incorporated into them and all its forms subservient to their position and use. This was true of much of the wood sculpture used in the interiors of buildings, but here the rigidity of stone and architecture no longer dictated form. The individual was still working in a cooperative mass effort but when they turned to work in wood, individuals began to emerge from the mass of workmen.

Men began making their figures of Christ to express their inner spiritual need, to carve their Holy Virgins with the Christ Child in the image of God, as they felt him and in the image of woman as they knew her, absorbed in and devoted to her child. Man began to make Saints in his own image with the human qualities of the men and women he knew; but his

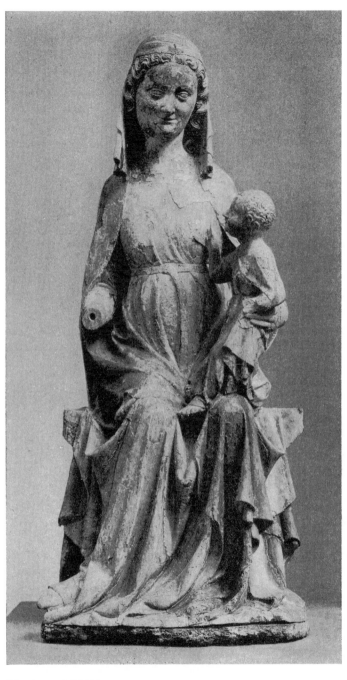

Virgin and Child.

French, early fourteenth century

Courtesy
Metropolitan Museum of Art

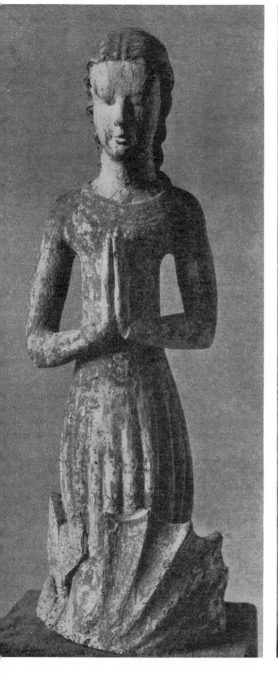
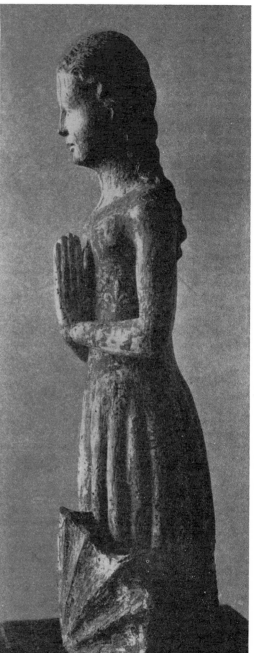

Saints were still man's triumph over life and death. It was a period of deep religious feeling. Man lived close to his God and built his life on religion as he knew it. The suffering of Christ on the cross was not just a motive for sculpture. It was the culmination of all his own suffering. The mortification of the flesh was a reality as well as a symbol of preparation for life hereafter.

A great many sculptors today carve in wood along with the work they do in other materials. I will try to reproduce as many of these works as possible throughout the book. Some few sculptors have made wood their most important means of expression. There is Barlach, one of the best and most serious of German sculptors. In Barlach, we have a very religious type of expression; not only religious in accepted meaning, but also in

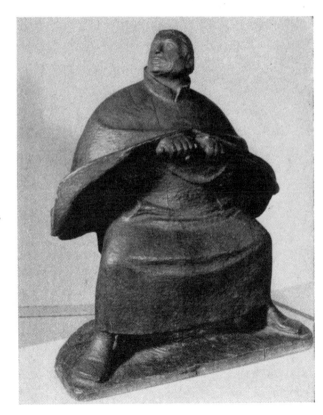

Man Drawing a Sword, wood. Ernst Barlach

Courtesy
Cranbrook Academy of Art

the respect and interpretation of the medium. Here is wood carving with superb skill, masterfully executed; at times mysterious and brooding, and again militant in feeling. The forms are handled in broad sweeping planes, highly simplified—in the true wood carver's tradition.

Robert Laurent has more or less abandoned the medium of wood carving for the wider fields of bronze and stone; but all his early work as a sculptor was in wood. He has a natural feeling for this medium, a sense of the fantastic and charming, in the best meaning of the word. He is inventive and imaginative and a fine craftsman.

Chaim Gross is, I think, the one man who remains a sculptor of wood even though he uses other mediums as well.

To Chaim Gross wood is a beautiful medium to be lovingly interpreted

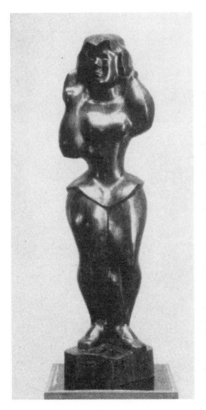

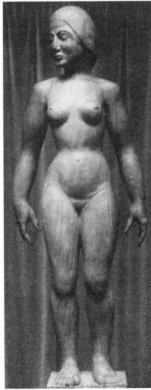

Young Girl, teakwood. Robert Laurent

Lillian Leitzel. Chaim Gross
Courtesy Metropolitan Museum of Art

and in which he can find complete expression. He is very conscious of the limitations of the tree trunk. He never oversteps its bounds or forces it into forms contrary to the nature of the wood. His form is held contained in the block, sensitive and dynamic. There is strength and great simplicity of spirit. He uses the qualities of the abstract but deals with realistic forms, that of the life around him. His subject matter is particularly his own and always entertaining and different. He builds compositions of acrobats, bicycle riders, dancers; with gaiety, good humor, and youthful vitality. All this is very important and a contribution to art.

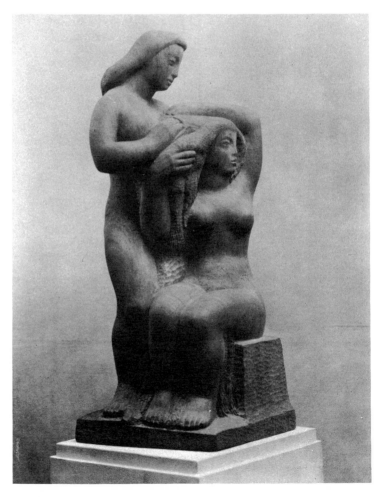

Two Women, mahogany. Concetta Scaravaglione
Courtesy Whitney Museum of American Art; Photograph Sunami

Young Pegasus, walnut. William Zorach
Courtesy Whitney Museum of American Art

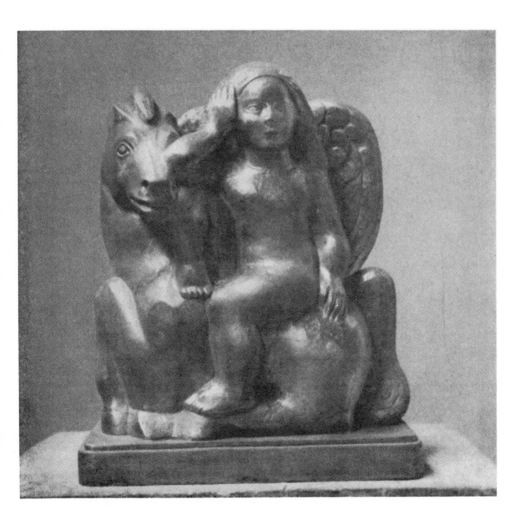

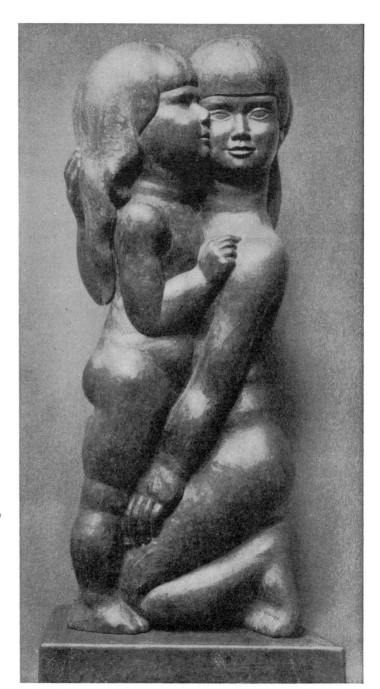

Two Children,
mahogany.

William Zorach
*Courtesy Ralph Jonas;
photograph Peter Juley*

CHAPTER 22.

STONE CARVING

The principle of the use of tools for cutting stone is very simple and is the same today as it was before history. Thousands of years ago man chose a rock and with an implement pounded this rock until he got a semblance of form, and then with stones and abrasives, and much muscle and patience, ground the rock down to a smooth and polished surface. We do the same today. We have a greater variety of tools and our knowledge of metallurgy is greater than it has ever been in history; but the ancient Egyptians were also great metallurgists, and primitive people developed various methods of drilling and polishing not so different from our methods today. They had bow drills, hand drills, stone hammers and points, adzes of stone and metal and various crystal pastes and abrasives. There are primitive wheels, run by foot pedals, used today in China by jade cutters, the same as those used centuries ago.

It is simple to acquire a knowledge of tools. The important thing for the student to realize is that it is not the complicated tool or the variety of tools that counts. The most beautiful and finest work can be done by the simplest method and with the simplest tools; in the case of stone carving, a chisel, properly tempered, and a hammer. But he must have a tremendous desire and a terrific perseverance to carry him through years of application. The student can work in a class where stone carving is taught or with a sculptor who does direct carving. If this is impossible he can get a good working knowledge by training himself. Most local blacksmiths have a knowledge of tempering tools and will usually help a student and demonstrate and explain the tempering of tools.

The most important thing is intelligent application, experimentation and development of skill. Of course there is always a right way and a wrong way of using tools. Someone can tell the student exactly what to do but often when he tries to do it himself he will do everything wrong; I have done it myself; but I have persisted until I could do it correctly.

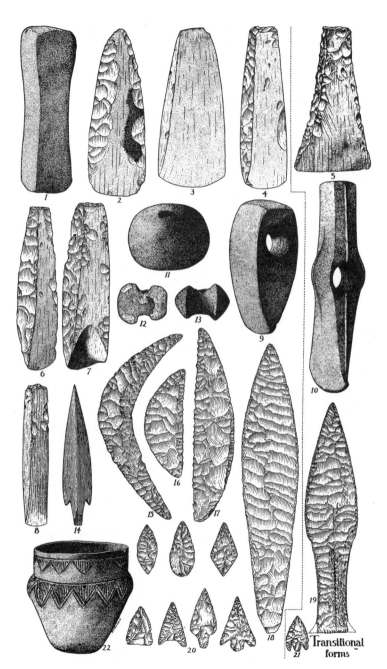

Neolithic implements. Denmark

Courtesy American Museum of Natural History

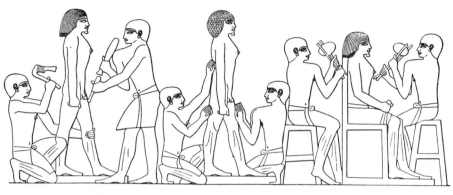

SCULPTORS CARVING A WOODEN STATUE, ONE WITH
AN ADZE, THE OTHER WITH MALLET AND CHISEL.

FINISHING A STATUE BY POLISHING
WITH RUBBING STONES

SCULPTORS AT WORK ON A STONE STATUE, SHAPING
IT BY POUNDING THE SURFACE WITH STONE HAMMERS

FROM A WALL RELIEF IN THE TOMB OF TI AT SAKKĀREH DYN V(2560-2420 B C)

SCULPTORS AT WORK

Tools required. (See figure and list on following pages)

The tools that are necessary in cutting stone are points, pointed chisels, plain flat chisels, tooth chisels, and bush hammers, both 4 point and 9 point.

These tools should be of various shapes and sizes, according to the work. To hit the chisel a striking hammer is used, as heavy as you can handle for roughing out, and a light one for delicate work (No. 17). The heavy hammer should have a long handle and the light one a short handle. A square hammer, made of soft iron or brass, or a wooden mallet is often used for delicate work or finishing, but a regular stone cutters hammer is most practical for heavy work. For drilling holes or splitting stones, drills (No. 14), shims and wedges are necessary (Nos. 4–5). One of the most important things a student must realize is that his tools must be kept sharp. For this an old-fashioned grindstone with water running over it is best. A regular carborundum wheel takes the temper out of tools very quickly; but if you have to use a carborundum wheel, dip your tool constantly in water as you are sharpening it so that it will not get too hot. I always keep a piece of an old grindstone on my bench—to rub the tools on while working.

Two most important things in a sculptor's equipment are glasses to

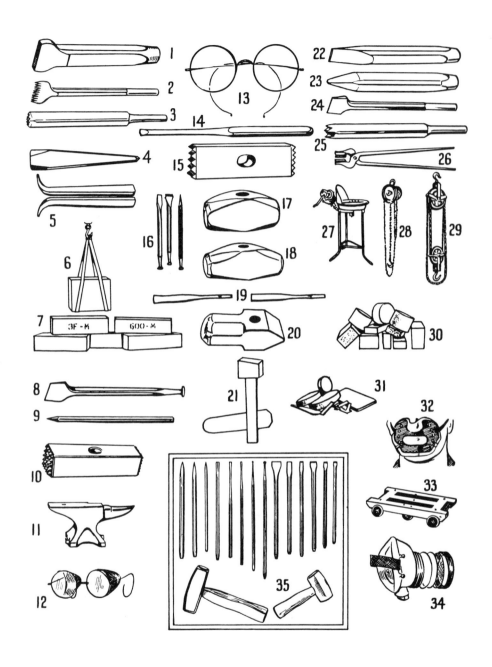

Tools and Equipment for Stone Carving

The following tools from
Trow & Holden Co., Barre, Vermont
Catalog No. 9

1. Hand-set or pitching tool
2. Marble tooth chisel
3. Nine point tooth chisel
4. Stone splitting wedge
5. Stone splitting shim
13. Stone cutters glasses
14. Hand drill
15. Bush hammer
16. Mallet head marble tools
17. Cutters striking hammer—made in
 1¼ lb. to 4 lb. sizes
18. Cutters hammer for heavy cutting
19. Hammer handles
20. Beveledface-sharpeners—hammer
21. Flat face stake for forging tools
22. Granite chisel
23. Granite point
24. Marble chisel
25. Four point tooth chisel
26. Tongs for forging chisels
28. Chain hoist

35. Marble cutting tools
Supplied by the Ettl Studios,
6 East 46th St., New York City

The following tools from
Granite City Tool Co., Barre, Vermont
Catalog No. 9

7. Rubbing bricks for polishing gran-
 ite—marble
8. Marble chisel
9. Marble point
10. Bush hammer
11. Anvil
12. Glasses with sideshields
27. Forge
34. Respirator no. 94

The following tools from
Dawson, Macdonald Co.
141 Pearl St., Boston 10, Mass.

6. Canvas hoisting slips
29. Chain hoist
30. Hand rubbing bricks
31. Felt buffers and sheetfelt
33. Dolly

The following supplied by the
Martindale Electric Co., Box 617,
Edgewater Branch, Cleveland 7, Ohio

32. Respirator

protect the eyes from flying stone and dust, and a respirator to protect the lungs (Nos. 32–34). The latter should always be worn for working indoors. The human system can absorb a certain amount of marble dust without harm but granite dust, even in small quantities, is dangerous.

The same tools cannot be used on marble and granite. A granite tool

has a blunt point (No. 23); a marble tool, a sharp one (No. 9); also the tempers are different. You can break and waste all kinds of tools if you do not use them properly; but you can also break endless tools if they are not tempered properly. The tools most perfectly tempered are those bought from large manufacturers of tools where everything is done scientifically, where heat is controlled by instruments which remove all the guesswork of heat treatment guided by colors.

For the carving of marble or limestone, a personal knowledge of tempering is not really necessary. A few good tools will last a long time. But in doing carving on a large scale in marble or in carving granite, you will have to learn how to temper your own tools or have a blacksmith temper them for you. In an appendix I will list a number of manufacturers where you can buy tools and places where you can have your tools retempered. If you are located where these are not available, go to your local tombstone cutter for advice and he will tell you of a local supply house or a blacksmith who will make tools for you and explain the process to you and perhaps let you practice in his shop. The process is simple, but to do it right is another thing and requires not only knowledge but skill and experience. Every blacksmith has his own theories and methods. So much depends upon the kind and composition of your steel and the stone you are going to cut. And again no matter how experienced the blacksmith is, some of the tools he makes will invariably be imperfect for he has to rely upon the human eye and human judgment.

Tempering tools.

In roughing out granite or marble the sculptor usually uses a chisel which is shaped from steel 5⁄8″, 3⁄4″, or 7⁄8″ thick. A pointed end is used for marble and a blunt end for granite. Other chisels forged from similar steel have a blade or regular chisel edge. In the first step in reforging the chisel, it is heated to a bright but not extremely brilliant red—never white hot. At this point the metal is annealed to a flowing condition so that it can be hammered or forged to its proper shape. You have only your eye to tell you when the chisel has been brought up to the proper heat and at this point the chisel has to be hammered on the anvil as rapidly as possible while it is at the maximum heat so that the metal will flow under the blows of the hammer and can be pounded into the shape desired.

It is very impractical to forge a chisel under a very dull red heat or to forge a chisel after the original bright red heat has died down as the metal does not flow properly under dull red heats. Hammering the tool at this

point will result in crystallization and breakage. It is also dangerous to overheat your chisel as this will burn and destroy your steel.

Now that your chisel is forged and shaped it should be allowed to cool gradually, either by placing it at the side of the forge away from the fire or by throwing the chisel on the ground where it is allowed to cool entirely. This leaves the chisel in a somewhat annealed state relieving some of the forging strains. At this point the chisel can be filed and sharpened, but an expert blacksmith usually hammers the chisel to a perfect edge at the time of the forging operation.

In the next operation of hardening or tempering, the chisel is brought up to a heat slowly, to what the blacksmiths call a cherry red, not too far up, and the tip dipped in a pail of water containing a handful of salt to the depth of ¾ of an inch—blacksmiths call it finger nail depth—just about the length of one's thumb nail. When dipping the blade end of the tool in the water, you hold it in a vertical position and gradually turn and work it up and down. It is then brought out with the tongs and rubbed in sand sprinkled on a board or emery cloth tacked on to a piece of wood. The scale is rubbed off by rubbing it in sand. The color can then be seen traveling towards the point. For granite, dip into water again when the color is turning from silver to light straw at tip; for marble, when it is bluish purple with a tinge of golden copper to bronze at the tip. For limestone the color is allowed to become purple at the tip. The tool is dipped into the salt water to the depth of a half inch. Enter the chisel into the bath very slowly touching the tip of it, gradually submerging the entire chisel, moving the chisel around in a circular movement. This practice prevents the too abrupt checking of the chisel. Plunging it too suddenly into the water and holding it in a fixed position invariably result in a definite line through the body of the chisel known as a water crack. In other words, this makes the steel too brittle at this point to withstand the heavy blows of a hammer.

There is more to tempering than this. The question of whether to heat your chisel in charcoal or coal, or a combination of both—the question of composition and kind of steel; whether to use rain water, clear water, brine, or oil for tempering; all this is part of the science of metals. The foregoing will give the student an adequate idea of tempering tools. The description may seem complicated and drawn out. The actual operation takes only a few minutes. An expert blacksmith seems to do the whole thing in a few quick operations. The element of heat is very important. If the steel gets too hot it becomes too brittle and will develop a water

The Faith of this Nation is Eternal. William Zorach

Collection Wright Ludington; photograph Wallace Russell

crack; if too cold the steel will remain soft. The temper should always be a little harder than the stone to be cut.

About materials.

I would advise the student to begin with Caen stone or limestone, both of which cut very easily. Granite is very hard and difficult to work. Alabaster is the easiest stone to cut; it requires no more effort than wood. White marble is quite simple to cut. Veined or colored marbles are more difficult. Great care must be taken in selecting these, in fact in selecting any stone, so as not to get a piece with seams and cracks. You can test a stone by sounding it with a hammer. If it rings like a bell it is sound. If it sounds dull there is probably a crack somewhere in the stone. Pouring water over stone will also show up cracks.

Stone can be bought from various marble companies but it is quite expensive, especially if it has to be ripped from a large block and sawed to size. The sawing is sometimes just as expensive as the stone. However you can often pick up odd pieces from local stone cutters; or where buildings are being torn down. When I am in Maine, I pick up rocks along the road and in gravel pits. These rocks are particularly beautiful in color and texture, but I would not advise a beginner to do this because such stones are most difficult to work.

The marbles mostly used for sculpture in the past were Carrara, Pentelic and Serravezza, all white marbles and comparatively soft. Pentelic marble is quarried from Mt. Pentelicus near Athens and was the marble used in most of ancient Greek sculpture. It has a crystal texture and is harder and more durable than Carrara. Most of Michael Angelo's carvings were done in Carrara; it has an even and compact consistency and cuts fairly easily.

There are various colored marbles; like Botticini, a lovely flesh colored stone, very brittle and difficult to work. "Youth" was carved in Botticini. Beautiful colored marbles are also found in France and Spain. The warm

Hound, granite. William Zorach
Courtesy Downtown Gallery

colored Florida Rosa in which I carved "Mother and Child" is a Spanish marble.

There are many fine native American marbles such as Pink Tennessee, Georgia, and Vermont. "Artist's Daughter," at the Whitney Museum, is in Georgia marble. Then there is a greyish marble called York Fossil which polishes black; "Affection" is carved in York Fossil. As for granite, there is a great variety of beautiful granites quarried in Maine, Vermont, Wisconsin, and Texas. "The Cat," Metropolitan Museum, was carved in Swedish granite; and "Torso," in Labrador granite; the "Head of Christ" was cut in a Maine glacial boulder, one of the very hardest granites.

It is advisable for a student to make a serious study of the stones used by sculptors, in museums and in monuments out of doors, to see the finished results and study how each holds up under weather conditions. I am constantly examining stones in graveyards, in museums, and monuments, to find out what appeals to me and to find out what effect climatic conditions have on them.

In carving a small piece of stone, it is advisable to fasten it to a larger stone by embedding it in a mass of plaster of paris so that it will not move around while working. For granite boulders, a barrel filled with sand makes a solid and practical place to work. If you use a bench for working, it must be very strong and solid, made of planks and 4"x4"s. Sturdy, well built stands are important for stone carving. A carpenter can build them or the sculptor himself. They should be of various heights, of thick, heavy construction, well reinforced and bolted together, not nailed.

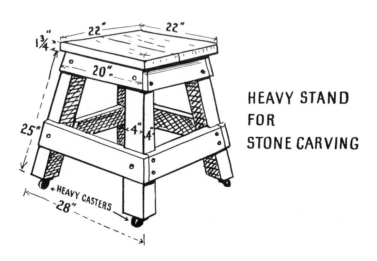

HEAVY STAND
FOR
STONE CARVING

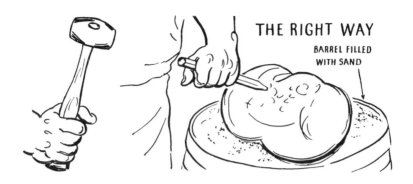

THE RIGHT WAY

BARREL FILLED
WITH SAND

General procedure.

Carving is the reverse of modeling in that the sculptor has an idea in mind that he wishes to carry out in stone and to accomplish this he must cut away the superfluous material. This cutting away develops a sense of form that expands. In carving one is afraid of cutting away too much because one cannot put back tomorrow what one has cut away today. The result is an expansion of the form one has in mind, whereas in building up the form on an armature with clay, the tendency is never to put on enough clay which results in a diminishing of the volume and a tightening of the form. Also there is the instinctive realization of the weight and fragility of the stone which develops the tendency to keep as much as possible of the natural form and mass of the stone. Michael Angelo is supposed to have said: "As the stone shrinks the form expands." The expansion of the volume of forms is a very important element in sculpture. As the form expands, the undulations of the valleys and mountains have space to flow in rhythmic sweeps in and out and around.

The process of roughing out either granite or marble is very similar. After the first roughing out with the point, <u>marble should be cut</u>, more or <u>less as one would cut wood.</u> Granite has to be pounded or pulverized with a bush hammer, after roughing out with a blunt point; the final surface then cut with a sharp chisel. Marble is a solid substance whereas granite is composed of an infinite variety of particles which have to be separated and dislodged. To dislodge large chunks, one has to have a very perfectly tempered, blunt pointed chisel. To rough out big forms and masses, the chisel must be held with a firm grip pressed against the stone at an angle and dealt a terrific blow with the heavy striking hammer. The point must be held at an angle in order not to drive directly into the stone but to

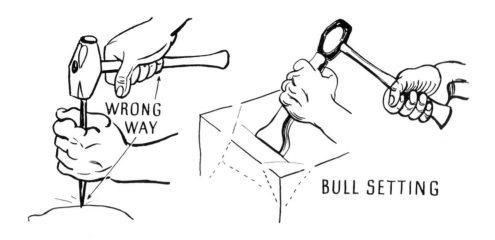

WRONG WAY

BULL SETTING

chip off lumps and protrusions created by working. If you drive directly into the stone you are apt to break the point of your chisel, as well as bruise and fracture the stone. Great care must be taken at first or a broken knuckle or a crushed thumb may result before you acquire an effective working rhythm. Do not hit with the hammer, swing with a relaxed movement; let the hammer do the work. Cut grooves or furrows, very much as a farmer ploughs his field; and from them chip off lumps or projections.

Chipping off large corners of marble or granite blocks is called "Bull Setting." Corners and edges are broken off quite evenly, as in the diagram, by placing the Bull Set at an angle and giving it a hard blow with the striking hammer. The corner breaks off evenly and saves time in roughing out. Large pieces can be broken off and rocks split by drilling holes about 2″ to 3″ apart and 4″ to 6″ in depth according to the size of the block. Insert iron shims and wedges into each hole, tap gently on each wedge in succession, back and forth until the stone splits.

From the outside edges you gradually work in, developing a semblance of the form or mass of the figure. The idea is not to work too fast—but to chip off small pieces while you develop a consciousness of the problems of volumes and directions and the image of the ultimate form grows in the mind. You must resist all temptation to develop detail until the larger forms are completely realized. Beginners always want to put in the features before they have found the basic relationships of the forms in the head. As the form develops, the sculptor's blows become more subtle and the chisels he uses naturally are smaller.

After the rough silhouette is created from all four sides, the sculptor proceeds to study and develop the form, carrying the work as far as possible with the pointed chisel, sometimes alternating with the bush hammer to pound the masses into simplified planes. But the more completely you can work your stone with the point, the quicker as well as the more creative will be your result. Personally, I feel that almost all the carving until you reach the surface should be done with the point. This also keeps you from becoming involved too soon in details and keeps the larger relationships of form constantly in your mind. Also unless you practically complete your carving with the pointed tool, you will find there is a tremendous waste in broken tools. Near the end, a very fine point is used until the surface resembles crosshatching, or a fine scratching.

The final development of the surface is done with a fine-toothed chisel followed by a round nosed chisel, finishing with a sharp, plain flat chisel. The tooth chisel is useless on granite as it will not grip the stone. In developing delicate parts such as the nose, eyes, and ears, the form must be

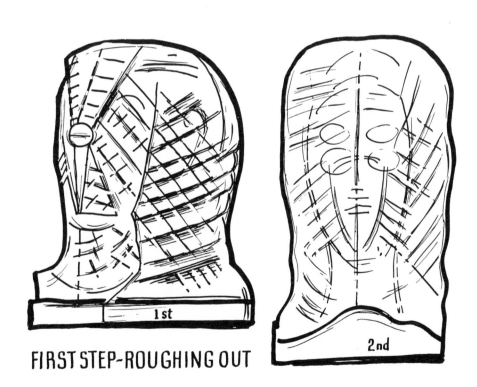

FIRST STEP-ROUGHING OUT

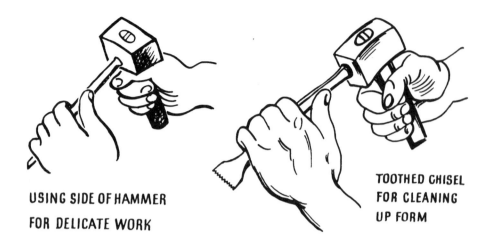

USING SIDE OF HAMMER FOR DELICATE WORK

TOOTHED CHISEL FOR CLEANING UP FORM

cut on a bevel, each form is developed on the order of a pyramid supported by a larger mass at the back.

Intricate and elaborate forms have been cut in marble, usually by drilling; but stone is not really suitable for such work. The most beautiful carvings are the most simple--where the stone is held in one complete mass, designed without projections. Michael Angelo is supposed to have said that a piece of sculpture should be able to roll down a hill without breaking.

In working marble the final finish can be developed by cutting the surface delicately with a sharp, flat chisel, finally not using the mallet at all but just pushing the tool back and forth over the surface with slow pressure. This chiseled surface is slow work but is much more alive than a surface developed with rasps, files and sandpaper. If the surface is to be polished it is important that the surface be chiseled as smooth as possible and all surface imperfections cleaned up.

Polished surfaces have their value. The stone always remains clean and they are very appropriate where one wants to bring out the beauty and color of the material. The one thing that fascinates the layman in sculpture is a polished surface. He feels that real accomplishment has gone into the work; it is finished. To the artist the real creative work and skill come before the polishing; yet even polishing should be done with great feeling and patience. Planes and edges should be held. The forms, if merely rounded off, are destroyed and the sculpture weakened.

If a high polish is desired, the marble is rubbed with fine carborundum stones, followed with lump pumice and finally, with hones. The final rubbing is done with thick Mexican felt and putty powder (tin oxide). In polishing granite, the process is similar, except that half a dozen grades of carborundum—from very coarse to very fine—are used. The longer you rub with the finest grade, the easier it will be to attain a high polish. The last two stones used are, first Scotch hone, and finally, Black hone. Without these last two stones no polish can be obtained with the final rubbing of Mexican felt and putty powder.

For details, stones and hones are broken into small pieces of any shape or size desired. For places difficult to get into, I have found it helpful to glue small pieces of carborundum, or hones, to a stick of wood with Duco cement. These pieces, if glued to wood and pressed in a vise over night, will hold until rubbed down to the wood, if care is taken not to get the wood wet. Also you will find a plain stick of wood very useful in polishing crevices. This stick is used with putty powder as one uses the felt.

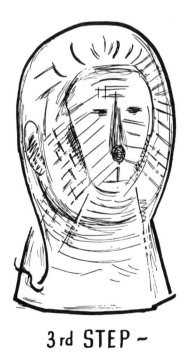

3rd STEP ~

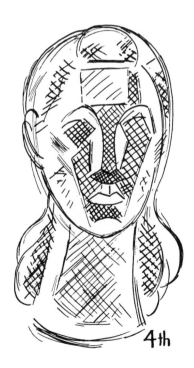

4th

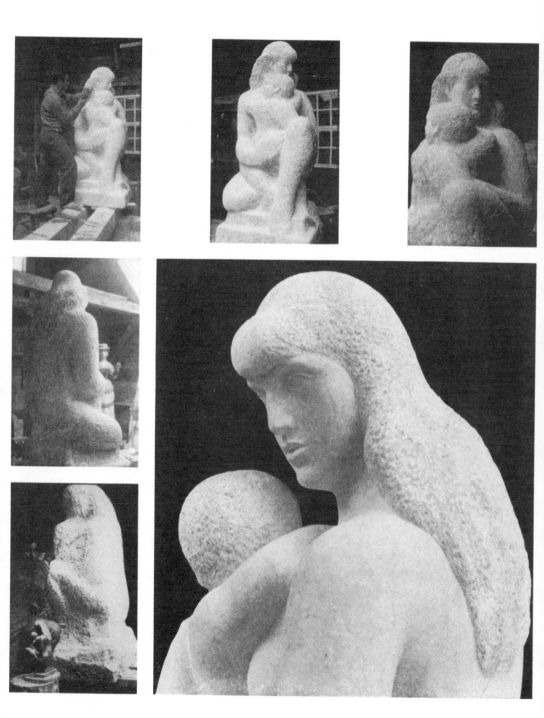

Carving of "Mother and Child" in various stages and finished detail.
Direct carving in marble by William Zorach

It is important to realize that it is the friction and heat caused by pressure of rubbing that polishes. Also that small areas are worked over at a time, not the whole surface at once. Putty powder should be used sparingly and not too liquid. In polishing it is advisable systematically to rub for a long time first with the roughest grade of carborundum. Rub small areas at a time until the whole surface is gone over, then proceed in the same way with the next grade, until you have reached the final and smoothest grade of carborundum available. Then rub for a long time with Scotch hone, and finally with Black hone until every possible surface scratch is eliminated. By wiping the stone now and then with the thumb or palm of hand, with pressure, the quality of surface arrived at will be visible. At this stage the stone should have a beautiful honed surface. Sometimes this honed surface is preferable to a more highly polished surface. If a high, mirror-like surface is wanted, now use the putty powder with felt. Each stage takes a long time, days or weeks to accomplish, and requires much patience and perseverance. I find rainy days in the country ideal for polishing—where there is no rush and the element of time does not enter.

Machine tools.

I believe carving by hand is the only method for students to use. A student should never use a pneumatic chisel, at least until he has had a number of years experience carving by hand; not only because of physical hazards but the artistic hazards as well. Most people have a false idea about the pneumatic or electric chisel. This tool is useful only for drilling holes and for final surfacing or finish. All creative work such as roughing out and blocking should be done by hand. The pneumatic hammer is useless for chipping off any quantity of stone at a time. In carving granite, the pneumatic hammer is useful for bushing and surfacing after the form is roughed out; some stones are so hard and brittle that it is almost a necessity. The pneumatic hammer should be used only for short intervals. The vibration causes a paralysis of the nerves and blood vessels of the hands; what stone cutters call white fingers. This can be very serious; some people are much more affected than others. This condition is usually not bad during the summer, but causes great discomfort during cold weather as the blood leaves the fingers and they turn white and the hands get numb. Permanent injury to the hands may result.

The pneumatic hammer is used extensively by professional carvers who do architectural and monumental work or copy plaster models for sculptors in marble or granite. To them, where the element of time is im-

portant, it is a very valuable tool. They can drill holes to the depths established by the pointing machine and rip away the superfluous stone very rapidly. There is, of course, no creative element in this procedure. It is a mechanical process of copying. These men work on a daily pay basis or on an estimated price and the element of time is very important to them. In creative work, time should not and cannot be taken into consideration. A creative work is never finished until the artist feels that he has achieved, to the best of his ability, what he had in his mind to express; time cannot enter into this.

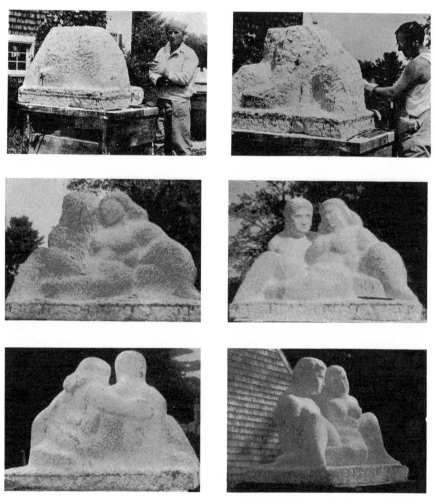

Various stages of work on "Youth"

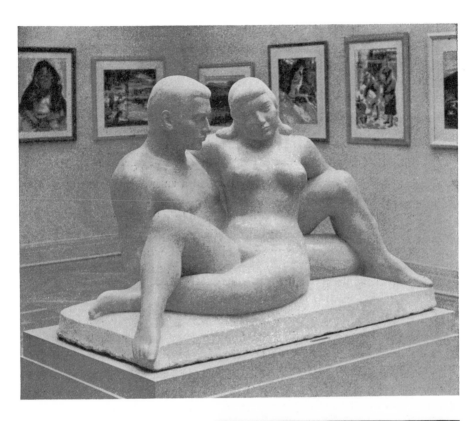

Youth

William Zorach

Collection Norton Museum,
West Palm Beach, Florida;
photograph McClellan

Detail photograph
Walt Sanders, Black Star

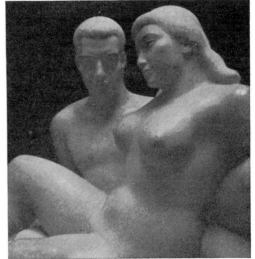

I have no set rule of procedure in carving. Sometimes I let the stone suggest its possibilities. Sometimes I work from drawings. Sometimes I make a small rough model in clay; this gives me a three dimensional design, directions of planes, and allows me freedom to develop my final form. I always feel free to change and follow the development of the forms as they grow. A small sketch in clay will give a sense of dimension and depth of direction of planes going in and out and around. I feel this allows a greater range of expression than cutting into a stone without a preliminary sketch. The latter produces interesting effects, but too often it results in a four-sided silhouette or an engraved relief on a rounded form, too closely bound to the original mass of the stone.

I believe in continual observation and study of nature, not from the point of view of copying but from the point of view of form relationship and form development. Like the mythical giant who has to continually contact the earth to renew his strength, the artist, to keep from becoming sterile and repeating himself, has to continually contact and study nature. You have to work long and hard at a thing for the inner form to reveal itself. You should only work where you feel work is necessary, leaving those parts alone that you do not know what to do with; eventually, as the form grows, the solution of the problem will come to you and you will know exactly what to do. The form will reveal itself to you.

People always ask: "What do you do if you cut away too much?" The answer is, you don't. Cutting is a constant balancing of form against form. If an unavoidable accident occurs because of a flaw in the stone, it is not as if you were copying a model where an accident would be ruinous; you are the master of the situation and make adjustments in balance and design. I remember working in a sculptor's shop once when one of the apprentices asked the foreman: "What do you do if you have an accident?" The foreman yelled in a voice that raised the roof: "Young fellow, in this shop there are no accidents."

Pointing—or copying plaster models in stone.

For the past few hundred years, practically all sculpture in stone has been done by pointing up from plaster models; never by carving directly. Pointing is a purely mechanical process based on a system of measurements. Two points are fixed at the base on the front of the model, and one on top. Then the indicator of the pointing instrument is set to the required depth, beginning at the highest projection of the plaster model. The pointing instrument is then transferred to the stone where three exact points

are established similar to those on the plaster model and a hole is drilled until the indicator reaches to about one fourth inch of the required depth. First the most protruding form is roughed out and finally thousands of small holes are drilled to the corresponding depths and the whole surface is cut away to within a fraction of the surface of the plaster model. If the workman is an expert craftsman, he often finishes the work completely. Then again, the sculptor can and often wants to finish it himself. There is always the question of whether it is advisable for the sculptor to finish the work, supervise the finishing or let the craftsman do it.

Enthusiasm is something that is built up by an inner drive plus imagination and illusion. Once it has been expended it is very hard to recapture. In direct sculpture, the illusion, the imagination and inner urge go into the working of the stone and the reading of meanings into the stone as the work progresses. The sculptor naturally takes advantage of the various elements that unfold and makes changes and the work grows and develops accordingly. Now if someone hands you a thing roughed out and ready for the final finish, the element of exploration and discovery is gone. There is no enthusiasm to stimulate the imagination. It is simple, the hard work is done for you, there is nothing to do except finish. Why even finish? Why not let the craftsman finish the job unless you feel you can recapture some of the creative spirit that went into the model. As a warning, I would say to anyone who is going to have anything carved from a plaster model; give the craftsman a very complete, smooth and finished model. Do not hope or expect him to complete what you have not done or make improvements. And do not expect to make changes as he works. It is not possible; you will only confuse him and he will feel you are just wasting his time. It can't be done. Best of all, carve your model in a soft material and then let him copy it in marble or granite. If he is a good craftsman he will make an excellent copy; if he is not, it's just too bad.

Pointing is a practical necessity in architectural work. Architectural and monumental works have to depend upon basic design for their power and not on personal expression or execution. Personally I believe pointing is all right as a method of copying work already done. But since it is a purely mechanical process, it is detrimental to creative development for students. The too easy way of making a small model and turning it over to a workman to enlarge and point up, results in blown up miniatures and a kind of sculpture devoid of content.

To me, direct sculpture is greater than modeled sculpture; its problems are greater and its possibilities of creative expression are deeper; more

goes into it, not just in time and work, but in creative thought and feeling. In direct carving, the artist is the sole master of his material from the very first conception and roughing out to the final details and perfecting of the form. After all who but the creator really knows what to do with a piece of creative work.

The important thing is not whether a thing is carved or modeled but how much art content went into the work. Some artists think that if they merely rough out a rock or scratch a piece of stone, they have a work of art. There is the basic idea of freeing the form imprisoned in the rock that the sculptor visualizes. But it is not enough to just suggest the emerging form the sculptor evolves in the early stages of carving a stone. This stage is always fascinating with its suggestion and promise of accomplishment. It is a temptation to leave the work at this stage. But it is an evasion of the true problems of developing and completing the form to its full power of expression. How often artist friends have come to my studio and seen a thing in the roughed out, unfinished state and exclaimed; "Don't do any more; leave it just as it is." That may be all right once or twice, but it is not the solution of everything. There are always those who start things and never finish them, and there are those who cannot stop even when they know the work is finished and who continue to fuss over it, destroying its life. The true artist has to see his work through to the fullness of its expression and know when it is finished.

There can be worthless direct carving as well as modeling. So much depends upon what the artist has to contribute, that any individual work stands on its own merit whether carved directly, pointed or modeled. But no sculptor can possibly appreciate the range of expression in sculpture and the possibilities of the relation of form and mass, unless he has had a good deal of experience in direct carving.

CHAPTER 23.

HANDLING STONE

Never try to lift heavy stones. Even small stones are heavy. A life size head weighs about 100 lbs. and is all a man should try to lift. Never lift anything with the arms outstretched, always bend the knees and lift against the body. Blocks of marble or granite should be moved by balancing or leverage. You must learn to handle stone so that the stone walks and lifts itself, so to speak. These things you will probably have to learn by watching experienced people. I will try to give you a few simple principles to follow.

Heavy stones must be lifted in place by chain blocks hung from a steel beam or suspended from a tripod. When I am in the country I cut three trees about five inches in diameter at the base, cut them about fifteen or twenty feet long, and construct a tripod upon which I suspend a $\frac{1}{2}$ ton chain block. Stone can also be lifted in place by tipping it from lower blocks of wood to higher ones step by step and very carefully. Never do this alone; always have two men. You must learn to sense the weight and balance of stone. Stone can be rolled up an incline on planks with the aid of iron or wooden rollers. If you work outdoors on a stand or bench about the height of a truck it is very simple to roll the stone into a truck for moving or shipping.

Once the stone is in place on the stand, it can be tilted by one man. If you wish to raise it, a wooden wedge is driven under one edge and a crowbar used under the stone; but always have a piece of wood between the crowbar and the stone. Never use iron next to the stone; you will chip the edges; and never drop or contact stone on stone. By using a block of wood under the crowbar as a bite you can move the stone about. When the stone is up a few inches, slip a small piece of hard wood about an inch square and $\frac{1}{4}$ inch thick under the stone at the exact center. This piece of wood is called a mill and will act as a swivel; almost any weight of stone can be turned on it with slight effort. When the wood wears out it can be re-

placed. Stones can be raised by slipping plank or pieces of joist under first one side and then the other; then under front and back; repeating and gradually building up to the desired height. If you want to tip a block of stone over always have blocks of wood arranged to hold it when it falls; and let the stone down slowly by removing these blocks one by one.

For carrying stone, build a cradle so that it is carried as on a stretcher by two or four men.

Great care must be taken in crating sculpture. Marble is very fragile. Freight and express companies are not too careful in their handling no matter how well marked the crate. And while they are willing to insure your work, it is very difficult to persuade them to pay for damages.

Large marble figures should never be placed in a box and packed around with straw or excelsior; they will shift and break. A crate must be made for any figure over 1,000 lbs. The base should be made of two thicknesses of plank, cut to size, about 4 inches wider and longer than your marble; the plank running lengthwise on the bottom for rolling and crosswise on the top for strength. They must be well nailed with spikes. Drive spikes at

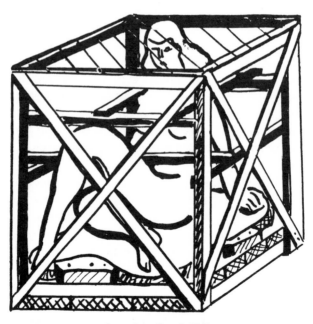

MARBLE IN A CRATE

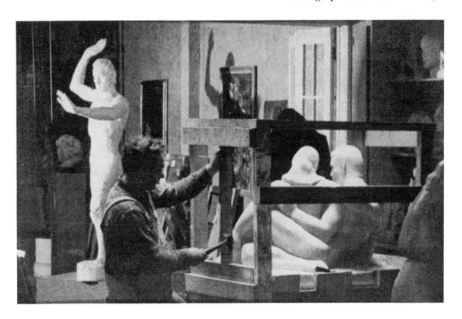

an angle and drive the heads well into the wood. Place statue on the base and build a framework around it. Figure out which parts of the stone are good and solid. Nail 2x4 cross-pieces to the framework securely to hold it at these points, placing pads of felt or excelsior under the crossbar where it touches the figure; press these pieces as tight as possible when nailing to the framework. Never put pressure on the head of the figure as it is liable to break at the neck. The stone must not shift; it must not be able to move in any direction even a fraction of an inch. The base of the figure is made secure by driving wedges and shingles around it. The outside of the framework can be boarded up with ordinary boards. The address should be carefully lettered on top, the box marked fragile, the top designated and instructions for unpacking written and enclosed inside the crate.

When uncrating a marble, never hammer and pull spikes. Saw all cross pieces and supports in two. This will avoid any possibility of fracturing the stone.

I have given directions above for crating heavy marbles. I will also describe how to pack a marble head—or small figure—for shipping.

PROPER CONSTRUCTION OF STRONG BOX
FOR SHIPPING STONE OR PLASTER MODELS

Measure the piece of sculpture and construct a box allowing two or three inch space around all sides for excelsior packing. Wrap the head in a clean muslin sheet or cloth and tie it up very securely with strong rope or clothesline. This is done because the head has to be lowered into a box with only a few inches between it and the sides of the box and it also has to be lifted out when unpacked.

A good bed of excelsior is packed in the bottom of the box and the head lowered in carefully. Excelsior is packed around it, first by hand and then with a stick of wood. Push excelsior well down and around the head. The box must be so packed that the head will not move under any conditions. After the sides are packed solidly, excelsior is heaped on top, the lid pressed down and securely nailed.

Observe diagram of how to make a strong box.

The end of the box has to be made secure with cross-pieces of wood and the boards of the top, bottom, and sides cut to go all the way to the outer edge. Nails driven into boards on end of the grain do not hold well, so see that sides are securely nailed to boards against the grain. If cleats are not nailed to end boards, the box is apt to split open if dropped by truckmen. It is advisable to nail two straps all around the box.

The lid should be secured with long screws to avoid hammering and breaking up of box when opening.

Cleaning stone sculpture.

Marble will inevitably get greasy and dirty when handled. There is nothing so discouraging as to see a beautiful piece of sculpture exhibited, all dirty and stained from handling. Marble can be cleaned by scrubbing it with a soft brush and Bon Ami or Dutch Cleanser. Any mild ordinary soap can be used but soap leaves a greasy look to marble.

Marble can also be cleaned by using Javelle Water in combination with a soft abrasive such as marble dust or whiting. In case of bad stains you can make a poultice by moistening whiting with Javelle Water; spread this over the stain and allow it to set for a time until dry. This should draw out the elements that caused the stain. Certain types of stain can be removed with lemon juice combined with a fine pumice. It is very dangerous to use any acids on marble. Anything that is used to clean marble must be thoroughly rinsed away.

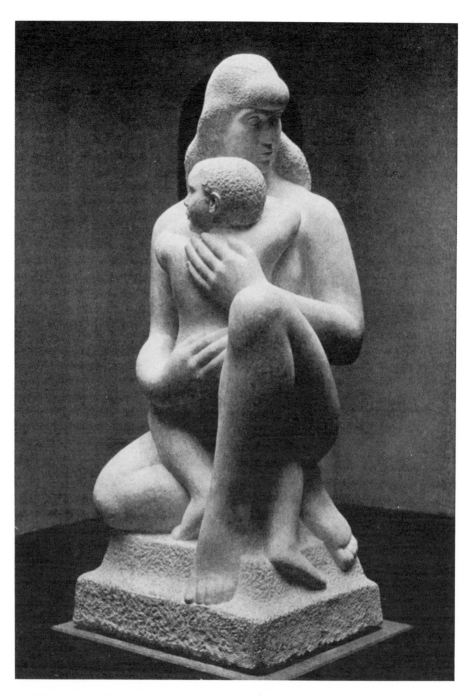

Mother and Child; 1927–1930. Direct carving
in Spanish marble. William Zorach

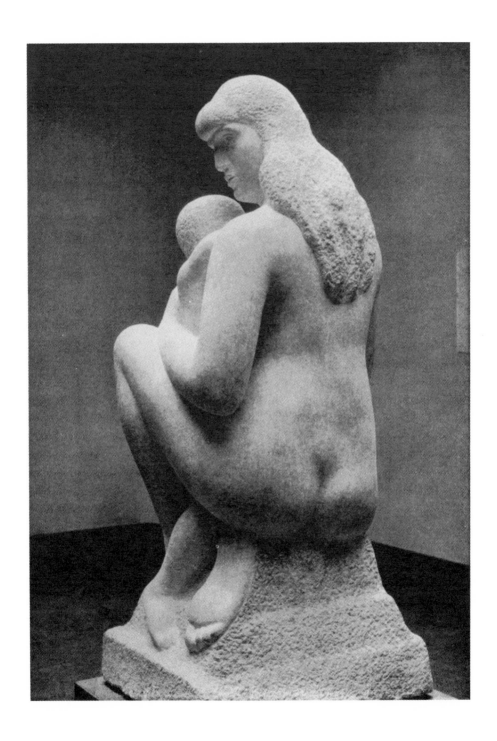

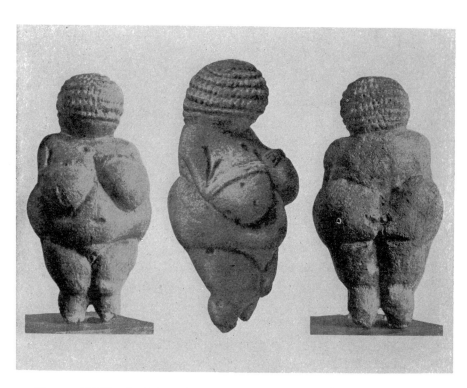

Venus of Willendorf. Austria, paleolithic

CHAPTER 24.

SCULPTURE IN STONE

We have covered the technical process of carving in stone. Let us look at some of the finest examples of stone sculpture that we have inherited from the past and try to analyze their qualities.

Man being a creature of nature naturally inherits the instinct of creation. The power to create exists in all men, to a greater degree in some than others. From the beginning of time there was this consuming power or urge; this restlessness, this emotional reaction to the harmony, the beauty, rhythm or whatever we may call it, which is life. If the artist is charged with this flame he will be endowed with the power to create or recreate in some permanent material, a projection of himself and his world into timelessness.

It is interesting to study one of the earliest efforts of man that has been preserved for us, a little figure of a woman carved in stone, from the stone age, late Paleolithic. In the early dawn of mankind someone carved this little figure of a woman. She is not exactly our ideal of beauty—we have come to admire the promise of youth rather than the fulfillment of the urge to creation. Yet to primitive man woman was what she has always been and always will be, fertility, the earth, voluptuous, sensuous, the fruit from which life draws its nourishment and the bearer of the seed that perpetuates the race. Expressed crudely and primitively, here it is projected into time from a forgotten and unrecorded past, yet expressive and complete. The qualities of art expression are inherent in it.

In the Easter Islands, we find art records of a forgotten age and people, huge heads and figures of men cut in great slabs of stone, rising stark and solitary from the earth, the planes and structure well hewn and defined. Eternal monuments to man—the projection of his strength and will and defiance—giving himself to the sun and stars: "I give myself back to you, O God."

It is amazing that man in his earliest sculpture realized the use of planes and plane relationships of mass to create powerful and mysterious images.

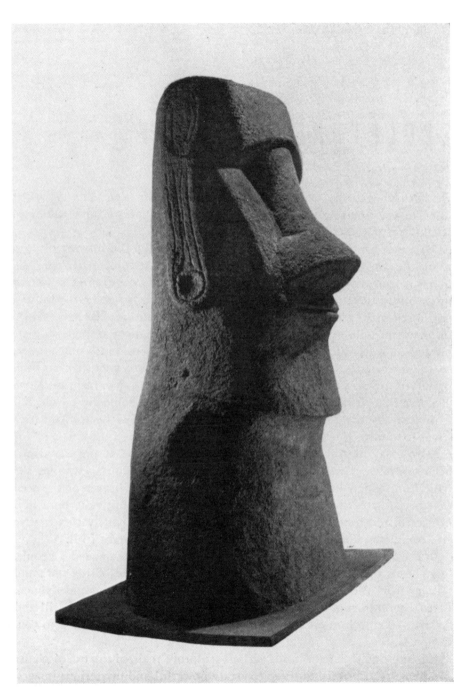

Profile of plaster cast of Easter Island statue
Courtesy American Museum of Natural History

It reveals to us the fundamental reality of the development of sculpture through the ages.

The American continent produced an art of its own; an art of savagery, power and death; an art that included the austerity of a Chacmool and the mystic fear, savagery and decoration of the Coatlicue, as overwhelming and uncontrolled as the jungle which gave it birth. Pre-Columbian art is an art of power and lust and terror—man's attempt to equal the ferocity of nature and thus nullify its terrors. We may call it barbaric, horrific, terrible in its conception of life, but it is no more terrible than some conceptions of life that exist today that we do not choose to express in art forms.

I do not select the Coatlicue because it is one of the great expressions of the soul of man in stone but because it is an extraordinary revelation of the indomitable spirit of man beyond comprehension and because it is using sculptured stone in a way that reveals the heights and the depths of terror and power. It is titanic in its ferocity, horrific in its intensity, lascivious with the most gruesome and amazing conglomeration of detail and ornamentation. Yet it is stupendous in its inventiveness of design and mystical symbolism. Here we have embroidered in stone the head of a fanged serpent, the hands of a peasant, the breasts of an old hag, the skull of death, the feet of a monster, the rattles of a snake, fruits, flowers, feathers and tassels. A volcanic symbol of birth and death, maggots and fruition, in a

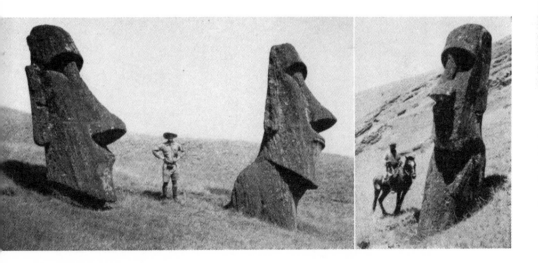

Easter Island Heads

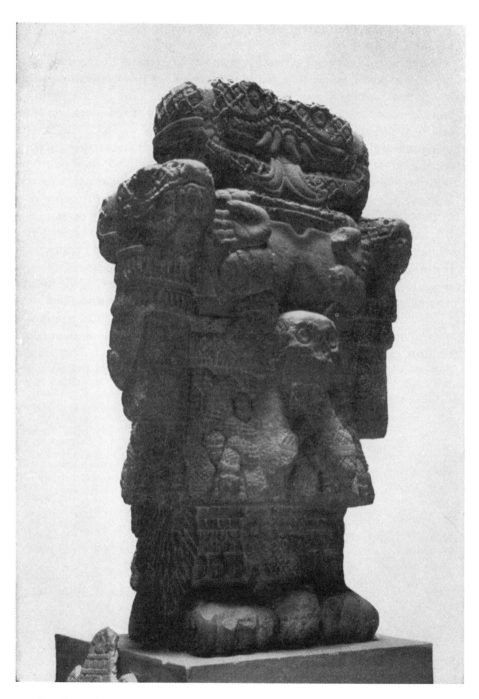

Coatlicue. Aztec

Courtesy Magazine of Art; photograph Manuel Alvarez Bravo

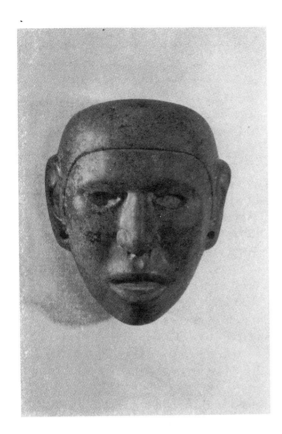

Mask. Mexico
Courtesy American Museum of Natural History

nightmare of complexities.

Much of Pre-Columbian sculpture is conceived within the rock; as if the living form, emerging in its embryonic state, pushes itself free from the confining limitations of the stone. When the horrific is not stressed, it seems to me they indulged in a grotesque humor. I do not think this humor is a reaction of our minds. I feel sure that it is an intrinsic part of their expression and appreciated by them as such. We find this humor in the small stones carved in human or animal form and in stone and clay utensils. It is the only human element we find in their art that does not express man's desperate effort to adjust himself to nature and life.

The Pre-Columbian masks, heads and small figures carved in stone sometimes hardly more than etched, sometimes completely freed from the stone, have a distinct interest, a bold simplicity of design and a fierce emotional

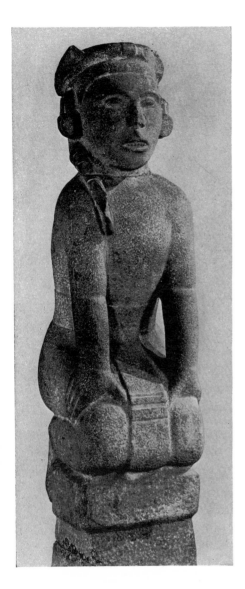

Seated Figure. Mexico

Courtesy American Museum of Natural History

content, an education for death. Although basically abstract, we find among these, pieces of sculpture amazingly realistic in our Western sense of realism; a way of looking at nature not found in any other primitive art.

The Chacmool is one of the finest and best known examples of this art; a reclining, sacrificial God, mysterious and grave. Here is savage, intense power, held in the simplest, compact design. The expression culminates in the powerful thrust of head and neck, defiant, awe-inspiring; foreverwaiting, facing eternity.

I have written at length about this art because it attains in a more intense form than any other art, a directness and pure power of expression that is of great value in art and which we too easily lose.

Artists today are apt to think that they have just arrived at a true understanding of the essence and simplicity of form. Instead it is part of a constantly returning cycle of human consciousness and awareness. Look at the Goudea statue in diorite created in Mesopotamia 2500 B.C. It is true realization of simplicity and power expressed in the hardest stone with what must have been very limited means. There is the most beautiful undulation of form and understanding of the solidity and strength of the arms and shoulders. How beautifully and with what simplicity the drapery and hands are treated; obviously arrived at by rubbing with stones and abrasives. What power and strength is retained in the great simple column. Study the treatment of the drapery, see how alive and

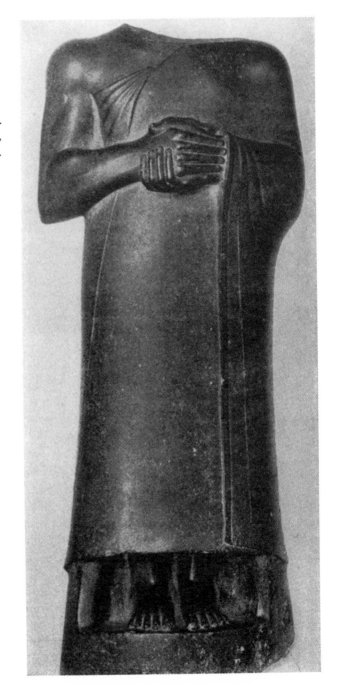

Goudea, diorite.
Mesopotamia,
about 2500 B.C.

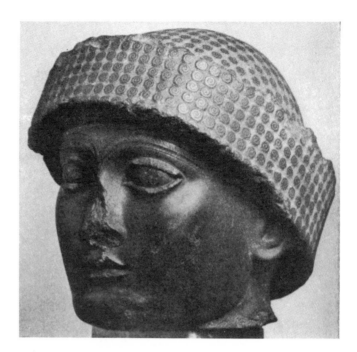

Head of Prince
Goudea, diorite.
Mesopotamia,
about 2500 B.C.

flowing all the forms are and still held in a powerful unity. With what understanding and restraint the few stylized details are treated. How alive the whole surface! This is real sculpture in stone—no extraneous projection of forms to destroy the compact mass.

Egypt.

Looking at the sculpture of Egypt makes us wonder why sculpture? What quality is it in the soul of man that made a whole people for thousands of years create monuments in the hardest granite on a scale and grandeur never again attained by man? What does this flood of sculpture mean? Does it mean putting restless hands to work or is it a language recording man's history, achievements and aspirations—or is it the desire to attach oneself to the future and become part of the continuity of life—or is it all of these? The stream of life takes certain directions. Today it is education, science. We value labor saving devices, things of the moment to be forgotten tomorrow, and we never question for what purpose we are saving labor. Yesterday it was religion; all good and evil was included in it and

Queen Hat-shepsūt, marble. Egypt, about 1485 B.C.
Courtesy Metropolitan Museum of Art

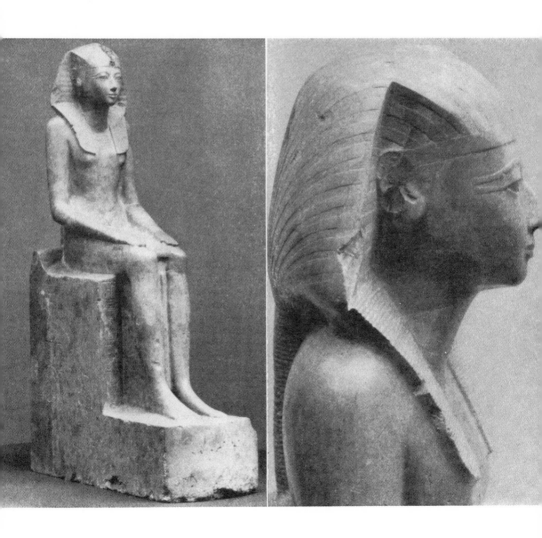

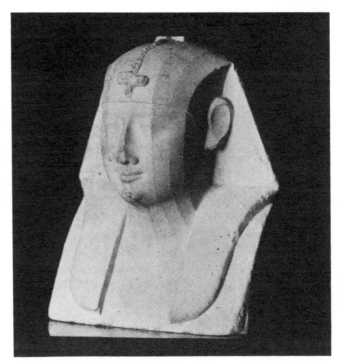

Method of
Egyptian carving
Courtesy
Metropolitan Museum
of Art

measured by it. In Egypt man and life were to be eternal and the permanence of life was held in the hardest stone. The mountain rising above the earth—the energy that man draws from the sun—man takes a stone and moulds it as a tribute to creation.

The statue of Queen Hat-shepsūt.

To me the statue of Queen Hat-shepsūt is one of the most beautiful and completely satisfying pieces ever done. It can be seen in the Metropolitan Museum in New York; although much of it has been restored, there is enough of the original to see the quality of art that was there. It is carved in a brittle, light, warm colored marble. There is a marble named Jaune Nile, similar to Botticini, which seems to be the same and I think we may assume that the stone was quarried in the vicinity of the Yellow Nile. The stone is very brittle and difficult to work as it flakes more like flint than marble.

We have examples of small studies showing the methods of carving used by the Egyptians. To a sculptor familiar with carving, it is obvious that the stone was cut to size in a rectangular block; probably silhouettes were drawn and cut and the general mass cut away to within a safe distance of the final forms. According to the small models preserved in the Metropolitan Museum, the large planes were then blocked out and the final planes were all cut up and down the form vertically; the whole thing done very systematically and requiring thoroughly and competently trained sculptors. Although the design is symmetrical, there is no more beautifully conceived sculptural pattern designed throughout the ages.

Here we have pure form as understood in the modern sense—not just a fragment, a head, a torso—but a whole figure, each unit beautifully conceived and welded into a perfect whole. The limbs and torso are as pure in form as any abstract sculptor ever visualized form and at the same time, all the reality and quality of living, natural form is retained. Look at the beautiful and delicate translation into stone of the soft material of the head dress without weakening the power of stone or solidifying the quality of soft material. Look at the exquisite thinness of the arms and legs and torso—the relaxed loveliness and delicacy of line—the crystallization of this in the still head, profound and eloquent, looking into space with clear-cut eyes of mystic serenity—the sensitive nose, the wide mobile mouth, full of tender gravity. Here is the exquisite beauty of live, sculptured surfaces. Here is nobility and intensity of inner life completely overwhelming formalized convention.

Greece.

The art of the early Greeks embodied all the finest qualities of simplicity and development of form with the purity and direct expression of all primitive art. It is an art expression of a gentle, kindly, full-blooded people; without desperate fears and complexes, full of tender gravity and vitality.

One of the finest and most sensitive pieces of Archaic Greek sculpture handed down to us is the Maiden in the Acropolis Museum. This small figure has all the charm and loveliness and purity of form of this early Greek art and all that could be desired in any art of any time. It is the true wedding of reality with abstraction. It retains all the high qualities of sculpture and all the love of a beautiful human being. Here is a maiden, not mythical but human, yet retaining the qualities of a goddess. Here young womanhood was loved for youth, for charm, for freshness.

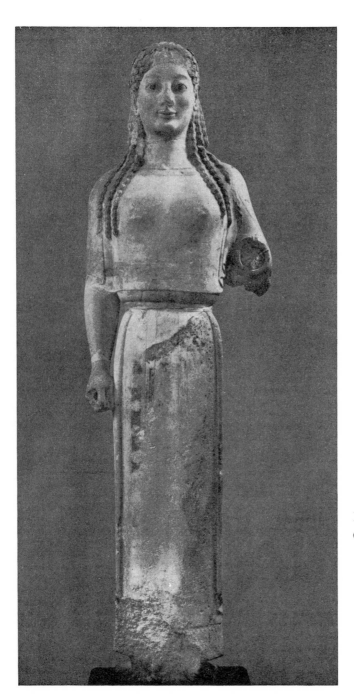

Maiden and detail.
Greek, sixth century B.C.

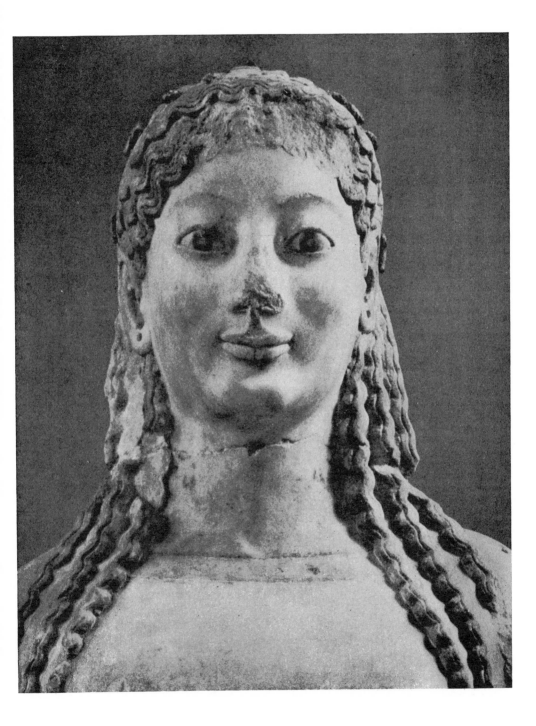

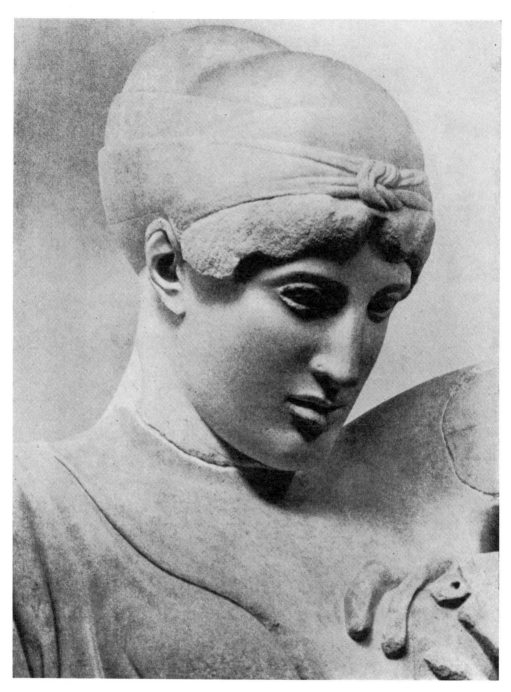

Stone head. West pediment, Temple of Zeus at Olympia. Greek, 460 B.C.

Sculpturally the stone is simple and beautiful. It is designed with restraint and clarity. The lovely undulations of form in the head, the beautifully alive and characteristic smile, the simple treatment of drapery as part of the basic form, the heavily indented locks of hair so well planned to relieve the simplification of the general form. This Maiden lives through stone for all time, a personification of maidenhood—a symbol of the beauty and purity, charm and perfection that is possible to the human race.

The Temple of Zeus at Olympia—5th century B.C.

This is the period of development and transition in Greek art. Here we have a fine art applied to architecture but still not purely decorative, still retaining the true quality of sculpture—masterfully and beautifully executed with superb skill. Stone is still sculpture, not anatomy. Life is here, gracious, beautiful and very conscious of its charm. Simplicity and volume are still valued; but sculpture is becoming a vehicle to tell a story, and not a direct expression of man's soul. Here is the pageant of man in his struggle with the elemental forces; but the story is told sweetly, gently, and gracefully; not powerfully or savagely. Here the Greeks destroyed their Gods by making them in the image of man.

The late Greeks.

The later Greeks became more and more enamored of the human body and concerned with developing a convention of physical perfection until their sculpture ceased to be creation through observation and knowledge and feeling for the nobility and expression of the human form. It became an art of studying models, of calculations and measurements which set a precedent for all the realistic sculpture that followed. The tabulated and formulated can always be followed and taught; the creative must evolve through inner personal consciousness and reaches continually into the unknown.

It is said that we have little conception of the qualities of Greek sculpture. Our ideas have been based on legend and on Roman copies of Greek bronzes no longer in existence. The original Greek marbles—always in fragments when found—have been terribly corroded by time and the elements. We only know them as resurfaced by restorers, which may have little relation to the original surface modeling. Even though Greek art had lost the nobility of spirit in its worship of physical beauty, we can assume that this discovery of physical beauty was still an adventure and that a life and art quality were in the art. This was completely lost in the Roman copies.

The Gothic.

After the fall of Rome and before the Renaissance, there were two periods of great art activity in Europe; the Romanesque, colored by the East and Rome, and the Gothic, an art out of the North. Both were primarily arts of the people, folk art related to architecture in which the workmen of the community took part. Sculpture was the stone-cutter's job. Each man had his place to make beautiful and he was not only the stone-cutter but the creative artist.

Human beings are tremendously conscious of and influenced by each other and when working together with a common idea, the influence is intensified. It was this that produced the unity of design and execution that makes Gothic cathedrals so magnificent and at the same time gives a wealth of creative variety. It is the art of a people in the grip of religious emotion and carried beyond themselves by an idea. It is the work of a young race, done from an instinctive knowledge and translated into a given space and material. It is not overstrained or intellectualized, there is religious emotion and also the element of playfulness and fun. Forms were elongated and changed to fit the architectural scheme. The work was done simply and directly as the old wood carvers cut figure heads; every stroke counts, it is not contemplated or modified—the work goes right ahead, but a spirit prevails—a culmination of enthusiasm, a mass imagination welds a heterogeneous force into a single vision.

A Gothic cathedral designed by an architect today is a travesty of art. All the life and variety which is its beauty vanishes when the carving becomes the carrying out of the design of a single architect. It is basically false and can only result in sterility. When a tremendous work is done collectively by groups of people, it can only be done by giving each liberty, each piece conceived and executed separately, compiling the whole by slow stages until the cathedral emerges. The unity cannot come from a single brain but from a mass mind in the grip of a great passion.

Romanesque and Gothic art are extraordinarily beautiful in the richness and complication of design and form. Fundamentally it is nearest to the art of India in its folk production of a whole, made up of infinite individual pieces. A saint may be removed or a head broken off and mounted and it is a beautiful piece of sculpture in itself but fundamentally it is part of a mass and related to the whole architectural scheme.

Renaissance.

No period in the history of art has been more written about, more propa-

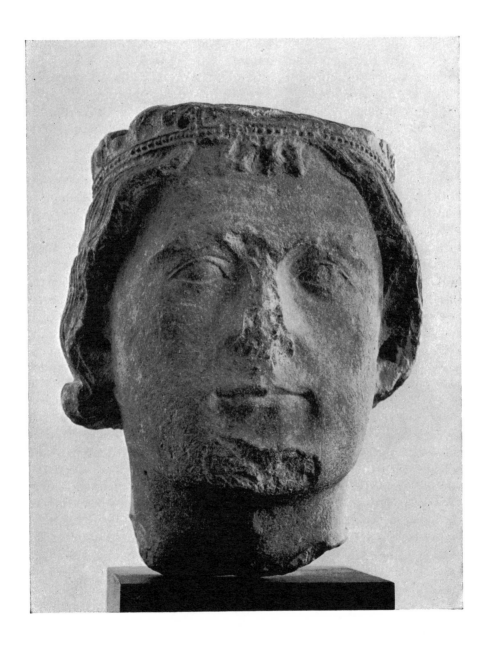

gandized than the Renaissance. In most histories of art written during the past five hundred years, it has been hailed as the great revival of art and as its highest development and achievement. Today, with a broader conception and knowledge of art, we find this very questionable. Renaissance art was not an art inspired by a religious enthusiasm but by a new medium, painting in oil—and at the same time, sudden consciousness of the existence of antique Roman sculpture.

The invention of oil painting changed man's vision. He no longer saw the world about him as static form but visualized it as color and movement. Before the Renaissance, painting was almost another form of sculpture and related to architecture. With the Renaissance it became independent and individualized and sculpture began to take on the qualities of painting. Sculpture became lively and full of movement, exuberant and theatrical. Sculptors were carried away by an enthusiasm for anatomy. Although the Greeks were very appreciative of the play of muscles in the human body, their study of them was from the living movements of athletes; the forms they developed were living and sculptural form. But during the Renaissance sculptors reveled in the study of corpses, dissection of muscles and realistic copies of these muscles. The more strained and tortured and violent the movement, the more fascinated they were. Sculpture no longer expressed the suffering and torture and exaltation of man but the strain and torture of muscles on the human form. Religious subjects became an excuse for portraying well organized groups of people wearing marvelous clothes and costly jewels. Sculpture became fluid and full of movement. Flesh began to look alarmingly like meat. Sculptors were interested in what suffering and torture did to muscles and not in what suffering and torture did to man.

Yet the Renaissance was a great period for artists and produced some of the greatest known figures in art history. Of these Michael Angelo was the most outstanding. The great quality of Michael Angelo's sculpture is that throughout his work he was always master of his medium. He selected his material, created his ideas, cut his own stone, and was always in communion with his idea and his material. Assistants were to him merely assistants, not workmen who carried out his work for him. His art is true sculpture in that throughout one feels the throb of the creator's soul and the warmth of the creator's hand. Here is a turbulent, dramatic power, heroic and monumental; continually expanding form—and yet with this power and strength, his figures are sometimes strangely effeminate in posture.

The Renaissance also produced Donatello. His sculpture, although

highly developed and understood anatomically and realistically, is imbued with an impersonal art quality very few Renaissance sculptors attained.

Later a distinct decline set in. Sculpture became florid, theatrical, agitated and elaborate—an art of expert craftsmanship, without art content. These craftsmen were interested in superficial excitement, and over-elaborate details, expert jewelry designs on a large scale. Later still it became a mannerism of academic and effeminate poses which were supposed to express grace and beauty as opposed to the static power and restraint of the earlier arts.

Applied to architecture this sculpture was particularly objectionable. It is the antithesis of the Gothic where every sculptural form was subordinated to the architecture of the whole. Renaissance sculpture was always an individual conception without the slightest regard for the building it was supposed to embellish.

There was a life and reason for this character of sculpture in its time but it is the source of all the bad taste in sculpture that has dominated Europe up to the present day. Its influence is seen in the host of imitations and elaborations which followed in Europe and America and which still dominate academic sculpture.

China.

Chinese art reached its full power while art development in Europe was still in its infancy. Our art development followed down through Greece from Egypt, bringing us a certain changing background but also leaving us a certain understanding of these ancient arts. Chinese art and civilization developed to its heights without contact with our Western world. Theirs was a separate cultural development. We were also committed to our own cultural development when the two civilizations became conscious of each other. It was very difficult for us to comprehend the mind and spirit of China and to understand her art forms. But basically art is a universal language and once the selection and arrangement of forms loses its strangeness for us, we can appreciate and enter into its spirit.

Art in China reached such nobility of mind and spirit and such a high quality of workmanship that every tiny piece of craft and useful object made by the lowliest craftsman was permeated with art quality.

The old art of China is dead. Before our time the spirit had left the hand of the artisan and the brush of the artist. But the skill remained and the tradition of art expression remained, so that an aura of ancient beauty still lingered over Chinese crafts and arts. Not until quite recently has the

poisonous influence of Western commercialism had its destructive effect upon China. This has penetrated even to the lowliest craft until what is produced there today is a travesty of her art.

Look at this Bodhisattva of the seventh century Tang Dynasty, one of the most beautiful figures ever carved in stone and preserved through wars and pillage. Here is the spirit of China; greatly human, greatly intellectual, greatly spiritual; a perfect balance of the great qualities of humanity expressed in stone with great art, simplicity, and beauty. The head is accentuated before the form of the body, but the body is appreciatively and lovingly designed. Here is great nobility of spirit and transcending love and tenderness, beautifully and rhythmically designed. This is not a primitive art but the art of a people in the flower of their cultural development.

Study the simple underlying rhythm of the swing down the right arm and up and around the back of the head and down; the lovely gentle movement of the torso and limbs; the beautifully proportioned base, which gives the figure the height it may lack from our Western standards.

Here is a stone that exudes great humility and great poise. It forces nothing on you, neither power nor emotion. All is contained within itself and perfectly adjusted to life.

The flowing surface patterns follow the basic form without a disturbing element. How simply and with what marvelous restraint the stone is carved. There is no question of what reality was to the Chinese. To them mind and spirit were the greater reality. They expressed their worship through form not tragically, or sensuously, but with tenderness and serious piety.

India.

The art of India is an art of love and acceptance; a developed consciousness of the oneness and inviolability of all life and the acceptance of life and death without fear and without qualifications.

The fecundity of Indian art is beyond belief. Her temples are mass architecture akin to the Gothic; but not dedicated to the salvation of man's soul in a sinful world; expressing instead the unceasing movement of life and love and death. Architecturally, the temple is overwhelmed by the decoration. The endless sculptured figures become no more than a pattern breaking the surface in design. But the individual carving is always greater than the design as a whole and almost any figure or segment removed from the whole takes on a life and sculptural importance of its own.

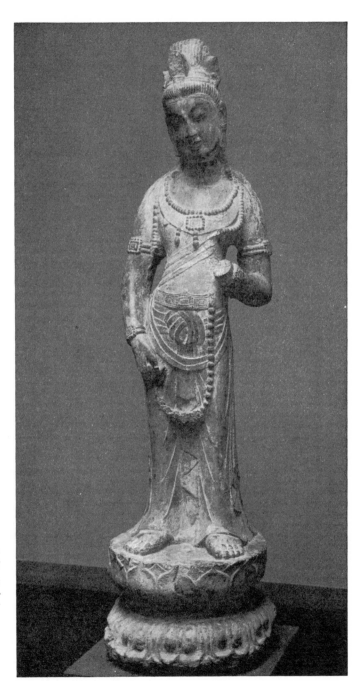

Bodhisattva, stone.
Chinese, seventh century

Courtesy
Freer Gallery,
Washington, D.C.

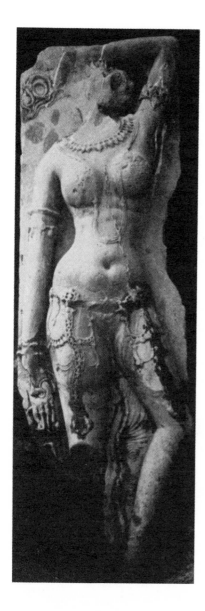

Rukmini, sandstone.
India, about 1000 A.D.
Courtesy Ananda K. Coomaraswamy

The art of no other people expresses the voluptuous and sensual as does the Indian. The accentuation of the volume of shoulders and hips, the round and slender waist, the expanding roundness of bodies, the sensitive carving of limbs and breasts, the warm tenderness that passed from the sculptor into his work, the beautiful realization and appreciation; these are the qualities that live for us in the beauty of Indian art.

Cambodia.

Surrounded by India and China and Java, partaking of all of the forms and qualities of their arts yet distinctly individual, is the art of Cambodia. The quality of the art of Cambodia is the quality of the people themselves. These were a gentle people, not deeply concerned with religion or the state of their souls, not overwhelmed spiritually by the jungle which surrounded them and finally overwhelmed them physically. Perhaps the jungle was to them a sanctuary from predatory neighbors. They were a sturdy and upright people going about their daily tasks without fear and without preoccupation of thought. They loved the good things of life without being sensualists. They especially loved the dance.

This we know when we look at their sculpture. It is almost all we know about them. It is one of the unbelievable mysteries of the world that in our day, we should discover in the jungles of Indo-China, this art of an unknown civilization—a not too ancient civilization—yet

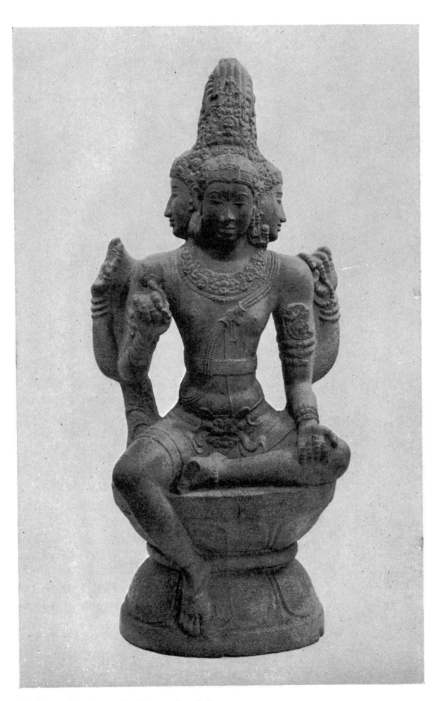

Brahma. Southern India, 15th–16th century
Courtesy Museum of Fine Arts, Boston

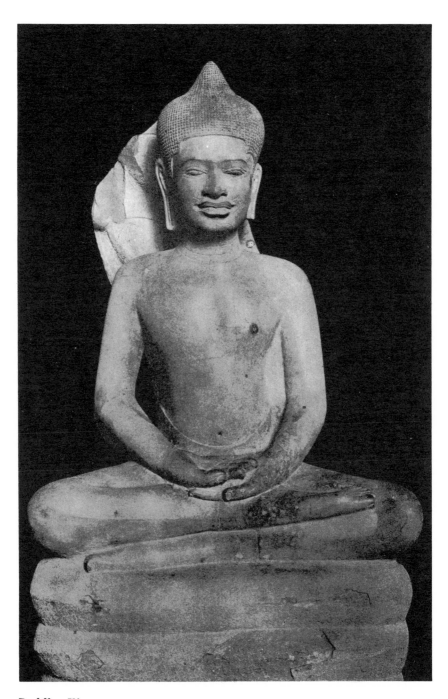

Buddha. Khmer

one that flourished and vanished without the surrounding world being conscious of it or recording it. No one knows anything actually of this civilization except its art.

It is an art of fine integrity and simplicity. Such simplicity without emptiness is rare in art. The interesting and strange features, the marvelously drawn full, wide lips, sensitive rather than sensual, the expressively carved eyes, character expressed in its most highly simplified terms; the exaggeration of ears, evidently a type of personal adornment practiced and expressing beauty to these people—and the stylized types of representing hair, characteristic of all art—for hair seems to excite the decorative instinct in man. These are the forms the Cambodian artist evolved from his life and the world about him.

The stylized treatment of hair in Cambodian sculpture seems to intrigue modern sculptors; but used by them it becomes purely decorative and superficial. In Khmer sculpture these conventions are a perfect compliment to the severity of the handling of form and must have been more than a decorative element to the sculptor.

All these sculptures of ancient peoples were carved directly in stone. All the creative impulse and imagination of the sculptor went directly into the work. He gave the stone expression and warmth and life from within himself.

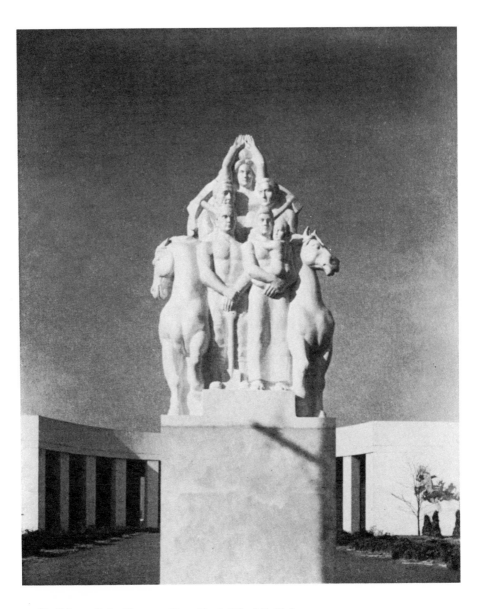

Builders of the Future, New York World's Fair.
William Zorach

Photograph Underwood and Underwood

CHAPTER 25.

SCULPTURE COMPETITIONS

Small sculpture is beautiful, enriches our lives and is a constant pleasure in our homes and museums. But sculpture is basically a monumental art. To really convey its message, sculpture should be on a grand scale. This does not mean large sculpture necessarily expresses grand and profound ideas. Small sculpture can be monumental in feeling and monumental sculpture can be trivial. But essentially sculpture is a natural means of expressing the feelings and aspirations of mankind on a grand scale and the power of expression increases with the scale—within limits.

In planning architectural or monumental sculpture, the ideal is collaboration between the sculptor, the architect and the landscape gardener at the inception of a project. But just as Michael Angelo had to fit his great works into unsuitable spaces where there was no way of even seeing them properly, so sculptors today cannot wait for the perfect setting if they want to do their work. They too have to place them against walls where they become reliefs, in settings never meant for sculpture, and on buildings never meant for or needing sculptural decoration.

I suppose it is good practice for a young sculptor to enter competitions, to set himself to solve the particular problem involved, to measure his work against others. I would like to say however that no young sculptor has any business entering a competition until he is working entirely on his own. No student's work is his own while he is working with a master; it is a combination of himself and his instructor. Only when he has removed himself from this environment and is creating his own forms and solving his own problems, has he any business sending to exhibitions or entering competitions. He is living in a false world and flattering himself with a sense of attainment and accomplishment which is not his, which makes the final severing of the umbilical cord which binds him to the instructor more painful and often disastrous. He thinks himself something he is not and what is more presents himself to the world in that light. It is

better to arrive quietly and on your own power.

In entering competitions, scale is most important. You may make a good piece of sculpture but it is wasted effort if it does not fit the scheme or is impractical. It is always wise to make a scale model of the setting and place your sculpture in its proper relationship and study it. If the sculptor does not take into consideration his monumental proportions when making the small model, his enlargement will look like a blown-up sketch. It is very important to visualize how a monument will look from eye level. A small model may seem to be perfectly proportioned and still look all wrong when enlarged. Remember that if the sketch is enlarged four times, and the hands are small, they will be four times as small; if the head is big, it will be four times as big. All unplanned relationships will be exaggerated. To sense this thing, a complete enlargement will show you just what you have attained in the small model and just where you have failed. I would also like to say, never try to make something you think a committee will like or that will attract a jury. Always make the very best thing you are capable of doing and take your chances on that. At least you will have something in the end whatever the decision.

Competitions are a form of sweepstakes even for the most accomplished and experienced sculptors. They are not necessarily genuine, and the award depends upon human judgment and human considerations and prejudices. For a young sculptor they have a value as problems to be solved and a trying of his mettle. But he should never allow himself to become involved in the illusion of winning competitions to the point of taking his mind and his hand from the absorption in doing his own work for himself which is his true development. I have the same feeling about fellowships.

Theoretically a fellowship is a wonderful thing and gives the young person freedom from financial worry while he concentrates on his work. Actually trying for fellowships can become so absorbing and time-consuming that the sculptor has no time to think seriously about his work or do it. It is the old game of something for nothing and a ticket in the Irish Sweepstakes would be much less harmful. One cannot have one's energies and mind absorbed in another direction than the accomplishment of art expression without the work suffering.

Sculpture is an expensive occupation but there are always two means of supplementing his income open to a sculptor—teaching and portraits. Teaching is often educational and occupies the mind only for the immediate time devoted to it. The only danger is in absorbing your own teaching, by this I mean, thinking of problems from the point of view of

a student and not as a mature artist. The problems and values are different. Portraits, if done occasionally, and sincerely, have no unfortunate effect upon one's art. I do not approve of commercial art as a means of supplementing income because the point of view necessary to do commercial art successfully is very harmful to a serious artist. Nor do I approve of trying to make a living outside of art and still do sculpture. One cannot so divide one's energies successfully, unless lucky enough to have some minor means of support that requires little or no thought and not too much time.

Bronze. Jacques Lipchitz
*Collection Museum of
Modern Art, New York*

CHAPTER 26.

SCULPTURE TODAY

To me this age is an exciting and interesting one in sculpture. A consciousness of world art from an art point of view and not from an historical point of view, a consciousness of the possibilities and directions of art development, and a deeper understanding of the language of sculpture; all of this has developed in our age and has stimulated great art activity.

It is an age of adventure and experimentation in art. Sculptors find their expression in carving directly in stone and wood, in experimenting with materials; in simplifying natural forms into abstractions, in creating abstractions without any evolvement from natural forms, in trying to take sculpture beyond the natural limits of the medium and into other fields, and in seeking new and exciting forms to express their interest and feeling for life.

I would not presume to analyze or evaluate contemporary works in sculpture; I am too closely involved and besides, only time can do that. I cannot attempt to be inclusive or do justice to the work of the many sculptors working today. I am reproducing a few fine pieces of contemporary sculpture, selected primarily for their interest to students. In this selection, I have attempted to give an idea of tendencies and directions in art. Fortunately all talents do not run in the same direction. A student looking at an exhibition or at a book of sculpture will be unmoved by one work and excited by another because of some innate personal sympathy and appeal—some response to the feelings and directions and abilities that are inherent in him.

I have tried to be sufficiently inclusive so that the student, whoever he is, can find work and directions with which his natural talents are in tune, work which might be an inspiration and show the possibilities of a road he might naturally want to travel. Do not misunderstand me, I am not suggesting that a student copy any style, adopt any formula, or follow in the footsteps of any master. But no one lives and develops in the world

Emerveillement. José de Creeft

Courtesy Metropolitan Museum of Art

Head, granite.
John Flannagan
Collection Chaim Gross

today without influences. It is important to have a choice of influences and then to be sure that they are only influences to you, not patterns. I have tried to be as inclusive as possible in presenting the various sculptural ideas alive in the world today and in the past.

Most of the younger sculptors do more or less direct carving, both in stone and wood. I am showing a work by each of four sculptors here in America who have a lifetime of work and accomplishment in direct carving behind them:

"Emerveillement" by José de Creeft, for its fine craftsmanship and design.

"Head" by John Flannagan, for the sensitivity to the art quality of the emerging form, imprisoned in the rock.

"Figure" by Oronzio Maldarelli, for its fine human quality, its warmth and fullness of expression.

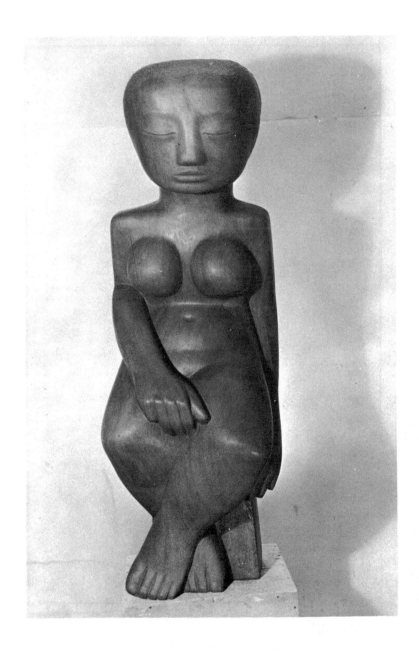

"Figure in Mahogany" by Raoul Hague, for its direct, simple statement through modern form.

There are other interesting directions in sculpture expressed today, not always in direct carving. I am including a few of them:

"Portrait" by Chana Orloff, for its interesting stylization of form in the modern idiom.

"American Miner's Family" by Minna Harkavy, for the sympathy and understanding of human problems as well as a sensitive quality of expressiveness.

"Invocation" by Hugo Robus, for its very personal direction towards fantasy and a strange inner nostalgia.

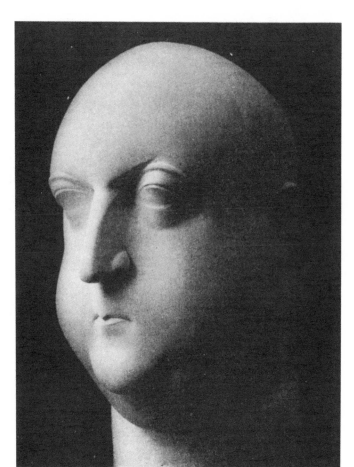

Portrait of
M. J.-E. Laboureur.
Chana Orloff

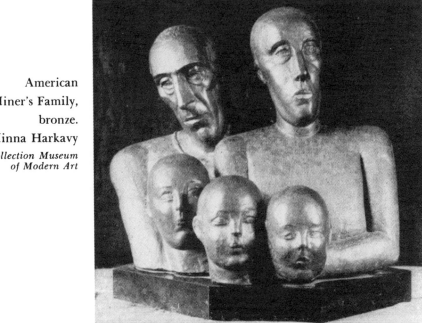

American
Miner's Family,
bronze.
Minna Harkavy
*Collection Museum
of Modern Art*

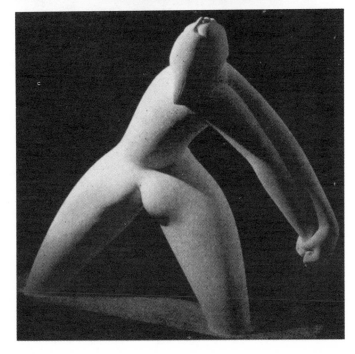

Invocation.
Hugo Robus

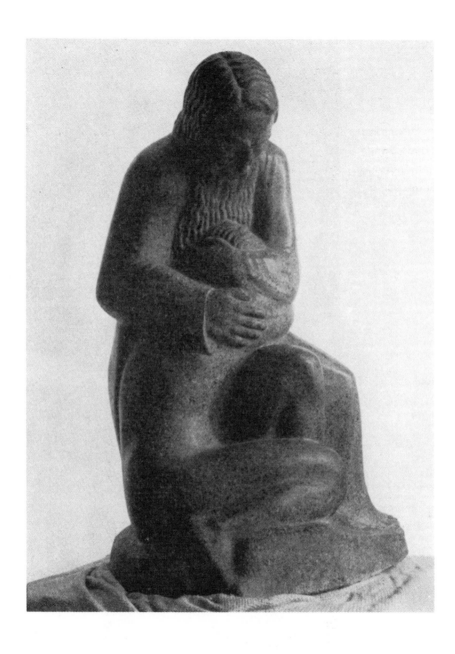

"Prodigal Son" by Heinz Warneke, for its emotional pathos and human quality stated in simple direct terms in hard French granite.

"Torso" by Beniamino Bufano is a simplified yet highly developed form in Egyptian Porphyry. It is based upon a realistic conception of the human form yet has a highly abstract sculptural quality, contained and static.

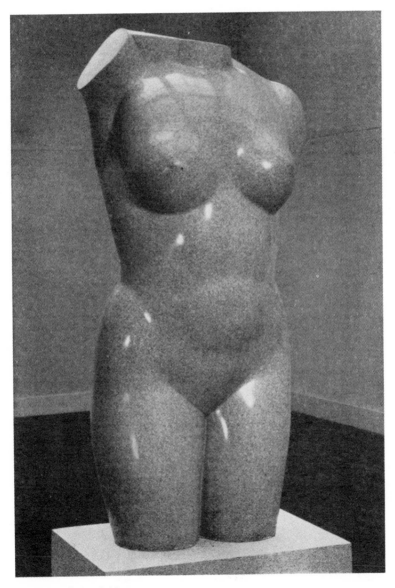

Photograph Ansel Adams

"Crucifixion" by Charles Umlauf, for his concentration on the dynamic and explosive qualities of form. He retains the freshness and power of expression of the first impact of the idea.

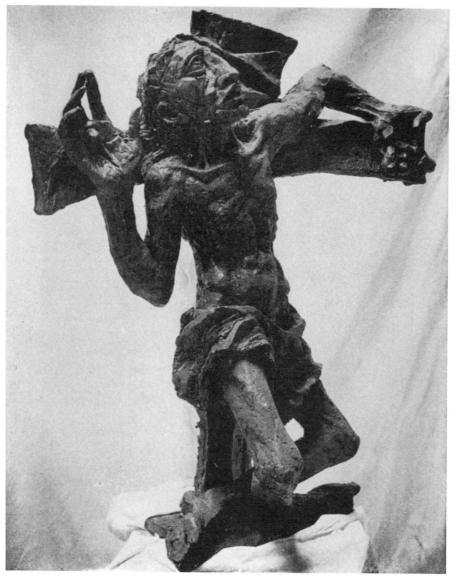

Photograph John Huber

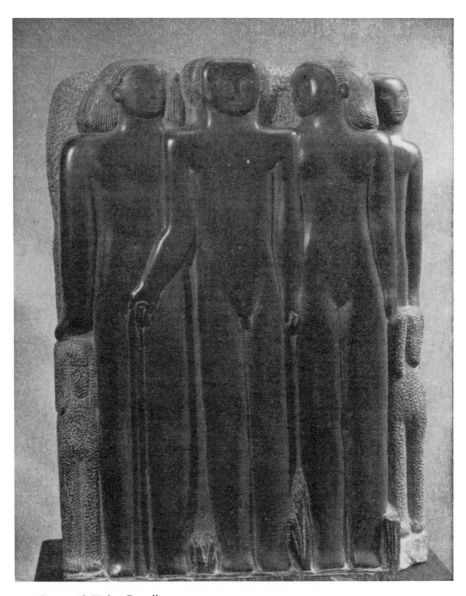

Photograph Walter Russell

"A Group of Young People" by Marion Walton, for its unusual and monumental quality and its interesting conception of form.

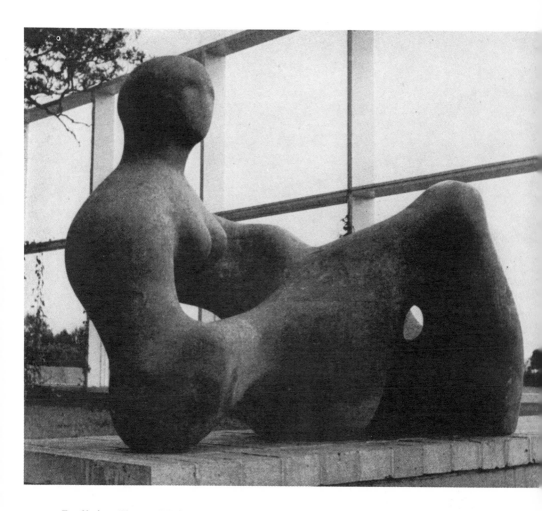

Reclining Figure, Hornton stone. Henry Moore
Collection Tate Gallery

In Europe the one man who has devoted himself to direct carving in stone is Mateo Hernández. He is an amazingly skillful carver. He is primarily interested in animals and birds; these he knows as others know the human figure. He carves directly in the hardest stone, never modeling in clay. There is no feeling of the form having been imprisoned in the rock and emerging under the sculptor's chisel, but rather the stone has been cut to conform to the sculptor's preconceived idea. Hernández has a keen understanding of design and the rhythmic flow of planes; he organizes them beautifully and powerfully. He delights in a high finish and in bringing out the form concisely and completely.

There are certain Modern Europeans I would like to mention for the interest of their directions and for their sculptural power of expression:

Lehmbruch, for his elongated and expressive forms. There is a sober calm and at times a tender gravity in his work, devotional and solemn.

Bourdelle, as an architectural sculptor, for the boldness and flamboyant quality of his designs.

Carl Milles, for the fantasy and decorative quality of his fountains.

Jacob Epstein, for his powerful and savage work in stone, as well as his bronzes.

Henry Moore, for his simplification and modern use of form, and for the living quality of his work.

Maillol, for his stone monuments which have great beauty and a classic simplicity. I particularly like the idea that when Maillol made a monument to Cézanne, he created a beautiful figure as homage to the man. How wonderful to be commemorated by a fine and inspiring figure rather than by a costume portrait that destroys our appreciation of the art by which a Cézanne would naturally be remembered.

One of the most dominant characteristics of an artist is his unquenchable curiosity. This curiosity often leads into strange channels and at times, into blind alleys. After the complete absorption with realism that has dominated Western art all these centuries, there is today a revulsion against realism among large groups of artists and a turning to complete abstraction among many of them. It is very expressive of the mind and character of the age we live in. But art is as varied as races and people; there is no last word in art except to the man who is so preoccupied with what he is doing that he can see nothing else. There has always been abstract art and representative art. Neither will ever succeed in eliminating the other because both are inherent parts of man's nature. We will always have both and we will always have those who can only see one.

In a larger sense, abstract form is only a new realism. It is realism in that its counterpart exists in nature. It is the artist's nature to discover, to find, to see; nature is full of infinite abstract forms. As I said early in this book, the base of all art is abstract. Without the abstract base of proportions, rhythms, design and balance, the most realistic art falls to pieces and is meaningless. The abstract artist discounts the realism as we call it and works with these abstract qualities as ends in themselves. These relations and directions can be expressive in themselves; they can also be very intriguing regardless of art content. Actually art is not divided between realists and abstractionists, there is every conceivable combination of the two.

As an artist I am not interested in the various psychological interpretations of abstract art or non-objective art. At least the psychological expression is clear and obvious. The analysis of its meanings and expression is fascinating to the people who indulge in this analysis and to those who listen to them. It has little to do with the art itself. Much abstract art is merely arabesque and design—industrial or otherwise—or it can be just playing with shapes without art content. Art is only art when created by an artist.

As an art form the meaning and reason for the development of abstract art are very clear. It was in Paris—may we say, at the time of the Revolution in art—that Matisse, Picasso, Archipenko, Duchamp-Villon and a host of others (many of them already forgotten)—artists who were aware of the senility and decadence of the art of the times, became conscious of the possibilities inherent in art expression. They were excited at discovering again the abstract basis of art. They were fascinated with the recent discovery of the art qualities of Negro sculpture. They began to paint pictures and do sculpture, rearranging geometric forms; first as equivalents of nature, later as compositions in themselves.

Brancusi, Archipenko, Duchamp-Villon, even painters like Matisse and Picasso, began to experiment with abstract arrangements in sculpture—first as rearrangements of naturalistic forms; and later, in Duchamp-Villon and Archipenko, with purely abstract conceptions. (This is an outline of what took place between 1908 and 1915.)

This movement excited and appealed to the young artists but it never took hold in America until after the Paris Industrial Design Exhibition in 1925. American architects and industrial designers, who had denied any value to "modern art," saw in the various displays of the new ideas, commercial and industrial possibilities. It captured their imagination. They immediately applied all the new ideas to their architecture; sometimes in

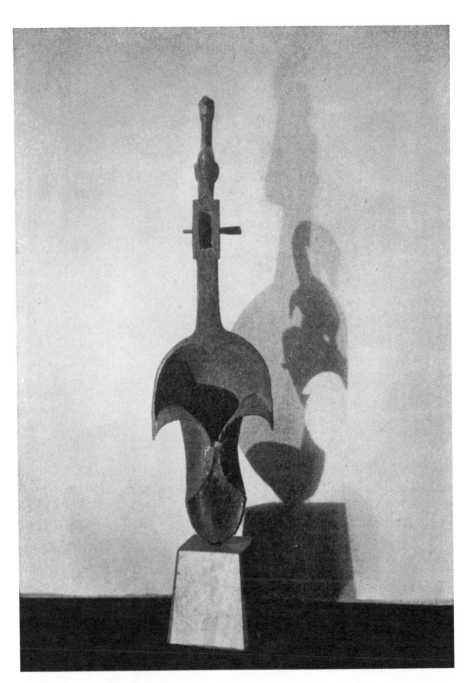

African musical instrument

Photograph Charles Sheeler

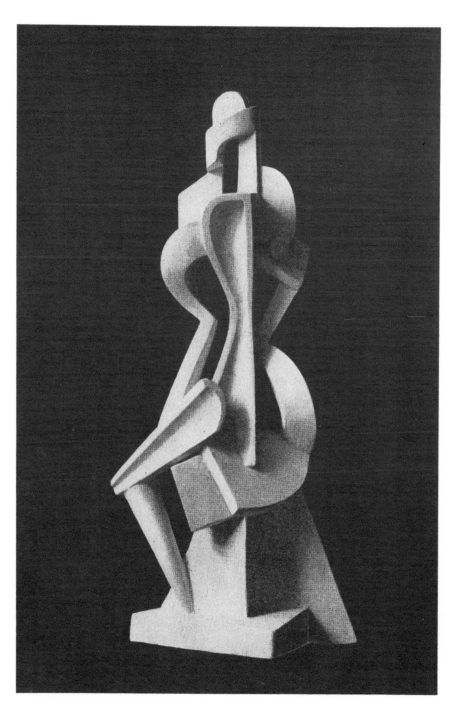

Seated Woman. A. Archipenko

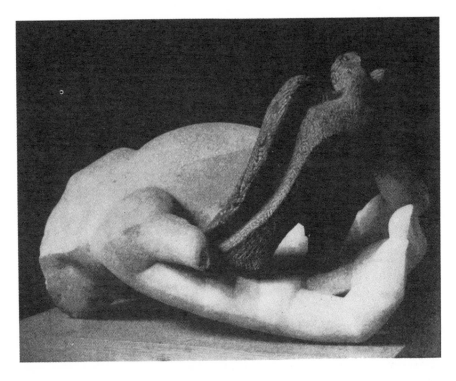

bastard forms, sometimes in pure form. Industrial objects were transformed into modern shapes and designs; everything from the fine to the most commercial.

Serious artists were not happy at the commercializing of their ideas and to think that the fine spirit of modern discovery should take this form. But abstract art, through museums as well as commercially, has had great publicity and backing. A new generation of artists and followers have appeared to whom abstract art is the only art. Some of these abstract artists are meaningful, some are not.

This is the background of abstract art. It is here to take its place as an art form. Some of it will live, most of it will die with its generation like any other art.

In my chapter on design I think I have explained very clearly the basis of abstract art. In Brancusi it takes on an emotionalized purity of form simplified to the ultimate degree. In Duchamp-Villon it becomes a

dynamic and explosive force arrived at by a powerful readjustment and rearrangement of the elements of the composition, in and out and around. In Archipenko and Zadkine, a rearrangement of obvious natural forms is used to show the beauty in the juxtaposition of convex and concave forms and planes. In Lipschitz, an arrangement of simplified circular and cubic patterns and in a later phase of his work, a moulding of natural forms into a conglomeration of vinelike and globular forms. Some abstractionists have deviated entirely from sculpture and gone into the byways called "constructions" such as Henri Laurens and more recently, Calder's "mobiles."

For the student abstract art holds infinite possibilities of experimentation, invention and discovery. But there is this important point to realize. Art is a language of expression. An artist can express himself with clarity, simplicity and power. He can understate what he has to say and he can overstate. His expression can take the form of caricature and it can also reach the point of absurdity and a vacuum. Nor can he depend upon innovation to make him an artist.

Sculpture is a life's work. Someone has said that almost anyone can write one book, paint one picture or make a piece of sculpture; and these things will be interesting because they are unexpected and usually contain a pure and personal feeling. This is lost when they try to repeat the experiment. Modeling a figure or two, or carving a piece of stone does not make one an artist. Much more has to go into art than that—a lifetime of developing the power to speak through art forms and to have something to give out through these forms—that is what it means to be an artist.

CHAPTER 27.

WELDING AS A CREATIVE ART

*I*ron has been heated and rendered malleable through the art of forging since the Iron age. This ancient method has been used by man for shaping weapons and tools and for creative and decorative purposes for thousands of years. The blacksmith at his forge has always been considered a craftsman. Today welding is considered a creative art and is classified as sculpture.

The modern welding torch is an excellent tool and a necessity for those interested in working directly in iron, steel, bronze and other metals and alloys. For the young sculptor the expense of bronze casting in this day and age makes it almost prohibitive to have his work cast in bronze; and a work in clay or plaster has almost no value because it is not in any permanent form. By welding metals the sculptor creates his work in permanent form with a modest expenditure for material and equipment. The very process and material of welding opens up new ways of expression and new possibilities of form.

Welding is a comparatively inexpensive method of working directly in metals. In addition to the equipment it requires courage, patience, a good deal of practice and average intelligence. Also one must obey the rules, otherwise it can be very dangerous. In most places the law requires a person practicing welding to have a permit because of the fire hazards.

Written instructions on the technique of welding and cutting metals and on the necessary equipment and its use are very important. The Airco-DB-Welding and Cutting Apparatus Instructions booklet, put out by the Air Reduction Sales Co. of New York, is a very concise book of instructions. But equally important for the beginner is personal instruction and criticism along with the practice necessary to acquire skill so that the welding torch may become a creative tool.

Winslow Eaves, the sculptor, has written the following analysis of welding. An expert welder himself, he is most aware of the problems confronting a sculptor wishing to use this method and technique.

W. Z.

WELDING—OXY-ACETYLENE METHOD
by Winslow B. Eaves

Welding is the fusion of metals by the melting together of the various pieces at certain points. To accomplish this a great deal of heat is required at the points of fusion; enough heat to melt the metal at that point. With the oxy-acetylene method the heat required is supplied by the burning together of two gasses, oxygen and acetylene. The temperature of the flame of the oxy-acetylene welding torch ranges from 5,500 F to 6,300 F at the tip of the white cone in the flame. Most metals melt between 600 F to 3,000 F.

The best source for welding equipment and supplies is the nearest welding supply company. Some of the large hardware companies, automobile supply companies and department stores sell welding equipment and supplies. I purchased my first outfit from Sears Roebuck and Co. As part of my welding outfit I received "The Oxy-Acetylene Welders Handbook" by T. B. Jefferson, published by The McGraw-Hill Publishing Co., Inc., New York, N. Y. This manual is one I would recommend. A complete manual on oxy-acetylene welding recommended by a welding supply company should be purchased and studied. Anyone who desires to go into welding should first get to know as much as possible about the equipment and materials so they may be handled safely with intelligence.

The oxy-acetylene welding equipment includes two regulators each with two gauges; one tank of oxygen gas and one tank of acetylene gas. The equipment also includes welding torch, cutting attachment, tips of different sizes, a torch lighter, welder's goggles, wrenches, flux, welding filler rods, hose and hand truck for tanks.

Facilities should include a well ventilated fire-proof work area with bench, vise, pliers, hammer, hack saw and fire brick to weld on. One should never weld on wood or cement. Cover floors with sand, brick, or asbestos board. Always have a fire extinguisher handy while working. Never smoke while welding or setting up equipment.

Personal attire should include long work trousers, long-sleeve work shirt,

Man, Space and the
Unknown, welded steel.
Winslow Eaves

high leather shoes, gloves, and work cap. Women should tie up and cover hair.

The principle sources for metals that may be welded are metal supply companies, scrap metal companies and junk yards. The prospective welder should start with mild steel or iron under $\frac{1}{2}''$ in thickness. (Stainless steel, cast iron, non-ferrous metal and metal alloys such as copper, aluminum, bronze, brass, nickel, monel and cast metals in general should not be attempted until one has acquired the skill necessary to weld ordinary steel and iron.)

Setting up the equipment properly is very important. With the purchase of welding equipment, instructions and manufacturers specifications should be received. Study and follow these carefully.

The tanks of gas should first be tied on a hand truck made to carry the tanks. Remove valve protecting caps on tanks and open slightly to blow out dirt or dust then close quickly. A special T wrench is used to open the acetylene tank. *NEVER* under any circumstances use oil or grease on any connections or parts of welding tanks, tools or equipment. Be sure gloves are free of oil or grease; as an explosion is possible if they are not kept away at all times. Attach oxygen regulators to oxygen tank. Right-hand threads are used on oxygen equipment. Turn pressure adjusting screw counter clockwise until loose. This stops flow of gas through regulator. Attach green hose to oxygen regulator. (The connections on the hose should be put on by an authorized experienced person at the welding supply company or place of purchase.) Open oxygen tank slowly at first so needle moves up slowly and stops, then open all the way. To clean attached hose place finger over open end of hose and open pressure-adjusting screw of oxygen regulator clockwise until pressure is from 5 to 10 pounds; remove finger 3 or 4 times to blow out dust, then close pressure-adjusting screw by turning counter clockwise. The gauge nearest the tank shows pressure in tank when tank valve is open. The gauge nearest hose indicates, when torch valve is open, the pressure in use. *NEVER* stand in front of gauge faces when opening cylinder valves. Always leave T wrench on acetylene valve so in case of fire or accident it may be quickly closed. Attach acetylene regulator to acetylene tank after blowing out tank valve same as with oxygen tank. Acetylene equipment has left hand threads. Loosen regulator pressure-adjusting screw counter clockwise. Open tank valve slowly until gauge hand stops; then an additional 1 and $\frac{1}{2}$ turns. Blow out acetylene hose with oxygen. Never blow out hose with acetylene. Acetylene hose is red; attach acetylene hose to acetylene regulator. The welding torch (some-

Spectre of Kitty Hawk,
welded and hammered
steel brazed with
bronze and brass.
Theodore Roszak

*Collection Museum of
Modern Art, New York*

times called the blow-pipe) has two openings at one end; one for oxygen hose and one for acetylene hose; attach hoses to torch. Tighten valve stem packing nuts with wrench. Usually these nuts are left loose for shipping. Test all connections on tanks, gauges, hoses and torch with soapy water (use non greasy soap such as Ivory). To do this screw in gauge valves until pressure reads 10 pounds for each gas. Apply soapy water to connections with brush. Run hose through bucket of water and watch for bubbles indicating leakage. If any trouble develops with equipment take it back to dealer for repairs. It is unsafe to use faulty equipment.

There should be included with new equipment a chart showing what size tip to use for metal of a certain thickness and the corresponding correct pressure settings. *Always use the manufacturer's recommendations. All welding outfits are not the same.* The tips usually come numbered 1 to 9. The lower numbered tips are used for thinner metal, for thicker metal the higher numbered tips. First learn to weld thinner sheet metal up to $\frac{1}{8}''$

thick and rods up to $\frac{1}{4}$" in diameter. Tips numbered one to three would be good to start with.

Lighting the torch.

Select correct tip and attach to torch by hand. Only use wrench to tighten tip if recommended by manufacturer. Set correct gauge pressure for oxygen by first opening torch oxygen valve 1 full turn and then turning the oxygen pressure adjusting screw on oxygen gauge clockwise until the correct delivery pressure is reached. Then quickly shut torch valve. Do the same to set the correct acetylene delivery pressure. Now — Hold spark lighter face up and pointed away in one hand. Hold torch in other hand so tip is about 1 inch from lighter flint. Open oxygen valve on torch until it can be heard leaving the tip. Then open acetylene valve one-half turn and quickly strike sparks with the lighter. Torch should light. Put welders goggles on. Keep hands away from the tip or they will be burned. *NEVER* light torch with a match or cigarette. Open acetylene torch valve until there is a slight roar at the tip. If the flame jumps from the tip an inch or so close torch valve slowly until flame returns to tip and open again slowly until the roar is produced. Now open oxygen torch valve very slowly until the flame changes from a yellow to a blue. There will be an inner small cone brilliantly white. At first this cone will have a feathery edge but by slightly increasing oxygen or slightly decreasing acetylene this inner cone will become clear and rounded at the tip. This is called a neutral flame and is the one mainly used when welding. With a slight increase of oxygen an oxidizing flame is produced, the cone becomes shorter and necked in. When the flame has an excess of acetylene and the inner cone has the feather it is called a reducing flame. Both the reducing and the oxidizing flame usually adversely affect the strength of a weld and should be avoided.

To Weld.

Take several welding rods $\frac{1}{8}$" to $\frac{1}{4}$" in diameter and cut some short pieces 2" to 6" and place in interesting arrangement on some insulating fire brick. With the lighted torch in one hand and a thin (slightly thinner than the rods to be joined) long welding rod in the other hand (goggles on) heat the two rods to be joined where they are touching, holding the torch so the inner cone is about $\frac{1}{2}$" to $\frac{3}{4}$" away from the rods. There is a near vacuum in front of and close to the inner cone and that is where the best welding is accomplished. The cone should not touch the metal being

Cockfight: Variation,
steel. David Smith

*Collection Whitney Museum
of American Art, New York*

welded. Hold the long welding rod in the flame and heat at the same time
the shorter ones are heated. As the rods being welded turn red and begin
to melt at joint, melt some of the long rod in to re-inforce the weld. Welding
rods of thin size takes only a few seconds. One has to be quick, skillful and
always alert. If the metal melts away too fast use a smaller tip. Coordinating
of torch and filler rod to the work to be welded is all important. One needs
good reflexes and understanding of equipment and material. A moment's
hesitation or misjudgment can spoil a weld or cause an accident. With a
few hours of practice one should be able to join two pieces of metal together
properly. A good welded joint is stronger than the parent metal. If it can
be easily broken apart it is not a good weld. When welding two pieces of
different thickness the torch should be directed a little more toward the
thicker section so both parts reach the melting point at the same time. One
should develop the skill to weld with the torch in either hand and the filler
rod in the other. More complicated work has to be held in place sometimes

with C clamps, clamp wrenches, with wire, props of fire brick or asbestos board, so both hands are free to handle filler rod and torch. When a student has developed his ability to handle his tools and materials and has the creative imagination, the possibilities for fine welded sculpture are unlimited.

Cutting Torch.

The cutting torch is used to cut alloys of iron. On the end of the cutting nozzle there are four holes for flames and one hole for the ejection of pure oxygen. The flames do the heating to a red color and then with the stream of oxygen the cutting is accomplished. First attach the torch and set the correct oxygen and acetylene pressures according to the manufacturers specifications. For average light work (cutting metal up to $\frac{1}{2}''$ thick) I use 4 pounds of acetylene to 15 pounds oxygen. The standard cutting torch has an oxygen valve on one side and another on top as a lever. To start with, torch valves should be closed. Open oxygen valve on torch handle nearest hose all the way. Slightly open oxygen and then acetylene. Light the same as with the welding torch. The oxygen valve on the side of the torch is adjusted to provide neutral flames. For adjusting acetylene use valve nearest hose. Hold torch so inner cones are very close to metal and heat the edge of the metal where the cut is to be started. Guide lines may be drawn with chalk. When metal is red press lever and a stream of pure oxygen will be ejected and burn almost instantly through the iron or steel. Move torch along steadily as cutting continues. Hold the torch as straight as possible but never pointed toward yourself. The area is showered with sparks and dripping molten metal. Never use the cutting or welding torch without goggles or near anything that might burn.

Before one tries welding copper and copper alloys, aluminum and aluminum alloys, different kinds of castings, stainless steel, or in fact any metal or metal alloy, one should study in a welder's handbook or technical book on oxy-acetylene welding the welding characteristics of the particular metal to be welded. Each metal has different characteristics and must, for the best results, be welded in a particular way. For instance it is best to use a reducing flame when welding aluminum, for copper a neutral flame. Castings must receıve special treatment. For each metal or alloy a special filler rod is used.

Before attempting to weld on one's own, work with an experienced welder. There is no substitute for experience.

INDEX

ARTISTS, COUNTRIES AND PERIODS